BODY
AS
EVIDENCE

BODY
AS
EVIDENCE

Mediating Race, Globalizing Gender

JANELL HOBSON

Cover art is a production still from the film *Her* by Ayoka Chenzira

Published by State University of New York Press, Albany

For information, contact State University of New York Press, Albany, NY
www.sunypress.edu

Production by Ryan Morris
Marketing by Fran Keneston

Library of Congress Cataloging-in-Publication Data

Hobson, Janell, 1973–
 Body as evidence: mediating race, globalizing gender / Janell Hobson.
 p. cm.
 Includes bibliographical references and index.
 ISBN 978-1-4384-4400-0 (pbk. : alk. paper)
 ISBN 978-1-4384-4401-7 (hardcover : alk. paper)
 1. Human body—Social aspects. 2. Women in popular culture. 3. Popular culture
and globalization. 4. Feminism and mass media. 5. Ethnicity on television.
I. Title.

HM636.H63 2012
306.4'7—dc23 2011047987

10 9 8 7 6 5 4 3 2 1

To bell hooks who showed the way
and to my students who will carry the light

Contents

Illustrations

Acknowledgments

This book is the culmination of years of critical thinking, critical research, critical teaching, and critical conversations. I am deeply grateful for those who've remained in my life or who brushed against it to plant and germinate various seeds of wisdom. Such individuals include my mother, Jeanette Hobson, who reminds me of how my knowledge is grounded in the wisdom of my family and community, and various friends who assure me that our raced and gendered existence in the world can only enhance and make vivid that knowledge. I am grateful to Ime Kerlee, whose intellect and support I deeply respect and which helped me to develop key ideas and concepts expressed in this work. I am also grateful to Sylvia Roch, Vivien Ng, Stefanie Samuels, and Meredith LeVande, who have contributed to the critical conversations I needed to have in shaping this book.

I am thankful for Andrew Kenyon, who supported my manuscript through different stages of review, as well as Larin McLaughlin, who quickly saw my manuscript's potential, and Beth Bouloukos and Rafael Chaiken, who helped usher this work into print. I am also grateful for the detailed criticisms and praise provided by the external reviewers and the editorial board at SUNY Press, as well as by the reviewers for *Signs* and *Feminist Media Studies*, who commented on specific essays that have formed key chapters in this study.

I would also like to thank my Women's Studies colleagues Virginia Eubanks and Barbara Sutton at the University at Albany, who read and commented on various drafts of the book chapters, as well as Cassandra Carter, Praba Pilar, Juan Luis Lopez Fons, and Ayoka Chenzira, whose enthusiastic review and contributions to my work are deeply appreciated. I am also grateful to Mark Anthony Neal for supporting and promoting my work. I am especially thankful for the different audiences at such academic conferences as the annual National Women's Studies Association meeting and the bi-annual Collegium for African American Research, who commented on my work at different stages. Other audiences, such as the one at SUNY Plattsburgh, eagerly responded to a paper that I presented the day after President Obama's historic election, which became the foundation for one of my chapters.

Finally, I wish to thank my University at Albany students, to whom I dedicate this book along with bell hooks. It was my constant integration of teaching, writing, and research, and the realization that my students needed an update to the black feminist cultural criticism that bell hooks had modeled in the late twentieth century, which led to the writing of this book. May this work contribute to a new century of black feminist theory, praxis, and education.

Prelude: Haiku

This is my body
distorted and recolored
birthing the nation

Introduction

Black bodies surface quite spectacularly in twenty-first-century media. Consider the following:

Scenario #1
On January 20, 2009, Barack Obama was inaugurated as the first black President of the United States of America. To mark the historic moment, several black churches in the area where I lived organized bus trips to Washington, D.C. I chose instead to avoid the freezing cold and watch that moment on TV from the warm comfort of my home. I shared the moment with friends, some of whom reached me on the phone or the Internet. In sharing this televised event together, we remained conscious of our history: not just in the election and inauguration of Obama but also in how we were not that different from the post–World War II generation of black folks who used to call each other long distance to announce the appearance of someone "colored" on TV, since such representations had remained marginal, and therefore that much more precious, in the early years of television. We were still uncertain about how our lives and our representations as black people would change (if at all) with a black man emerging on the world stage and a black family residing in the White House.

Scenario #2
In the days leading up to this historic inauguration, I kept a hair-braiding appointment and witnessed firsthand the "Obamamania" of my hairdresser, a Liberian immigrant, who routinely interrupted her work on my hair to jot down every bit of information on the latest Obama merchandise being advertised on TV. For her and other African immigrants, President Obama epitomized the "American dream" and the global rise of the African continent with this "native son" at the center of the world stage. Sometime later, she played a DVD of the latest movie offering of what is known as "Nollywood," a film industry based in Lagos, Nigeria, that caters to Africans on the continent and throughout the African Diaspora. It

3

was my first introduction to a movie system that had already dated nearly twenty years and which had become the second-largest film industry in the world, following behind "Bollywood," India's Hindi cinema, and just ahead of Hollywood. The African body—through Obama, Nollywood, and hair braiders in U.S. urban centers—had dramatically entered into U.S. politics, culture, and society, subtly closing the geographical distance between the global North and global South.

Scenario #3

Six months after the inauguration of President Obama, Michael Jackson died on June 25, 2009. And once again, just as we had all spilled onto the streets in jubilee at the election of a black U.S. president, the world returned to the streets in collective nostalgia to engage in mass moonwalks, flash mobs, tributes, and vigils in honor of another black man. The Hollywood gossip Web site, TMZ, leaked the news first, the social networking site, Twitter, crashed with the breaking news, and I sobbed on the phone while talking to my mother. Days later, I had attended the Michael Jackson Tribute at the Apollo Theatre in Harlem and was struck by the diverse crowds—multiracial and intergenerational—that came out in honor of Jackson. This spontaneous outpouring brought so many strangers together in camaraderie, as many of us even jokingly admitted we would not wait in line for hours over the death of a relative. We waited for more than nine hours to enter the Apollo Theatre and at one point in pouring rain, no less. But we had all come to reminisce, dance, and celebrate the man who had given us the musical soundtrack to our lives.

Scenario #4

Six months after the death of Michael Jackson, Disney studios released *The Princess and the Frog* in theaters, billed as the first African American princess featured in a Disney animation and a return to 2-D hand-drawn animation to counter the trend in CGI animation. Despite a number of controversies— from changing the name of the movie (originally titled *The Frog Princess*, which sounded like a slight on this princess's looks) to the name of the protagonist (from Maddy, which sounded too much like "Mammy," to Tiana) to the profession in which she worked (from a maid to a waitress) to the racial identity of Prince Naveen (some objected to a non-black prince for the first black princess, given the troubled relationships between black women and black men)—*The Princess and the Frog* received both critical acclaim and respectable box office. However, it didn't do nearly as well as previous Disney animation movies, thus prompting Disney executives to not only shift the

focus of its next "princess" movie about Rapunzel to a "gender-neutral" story, retitled *Tangled*, but to also put an end to producing more fairy tale princess movies in the foreseeable future since "girls' movies" don't seem to sell as well as "boys' movies."[1] In sad irony, the "first black Disney princess" ushered in the last of its genre, although movie executives were careful to reduce the issue to one of gender instead of race, all the while preparing yet another "princess" movie showcasing white women's long tresses (not just in the blond hair of *Tangled* but also in the flowing red curls featured in the trailers and ads for Pixar's first female protagonist–driven animation feature, *Brave*).

These different scenarios from the last year of the first decade of the twenty-first century highlight the ways that media have become an intimate part of our everyday lives, framing our ideas about race, gender, national identity, global connections, and "niche markets." The rise of an Obama and the demise of a Michael Jackson remind us of both the possibilities and the limits of transcending the racial meanings transcribed on our bodies. On the other hand, the marginal success of a film such as *The Princess and the Frog* illuminates the gendered challenges to rewriting and repositioning black bodies in empowerment narratives, as well as its marginal status in the mythical "center" of world cinema. At the same time, the meteoric global rise of Nigeria's film industry indicates that there is a seismic shift in who now occupies the cultural center of the world.

In thinking through the implications of such twenty-first-century media narratives, this book is concerned with a certain set of questions: What do millennial narratives reveal about race relations, gender dynamics, and class and status mobility? How is the body positioned to make new or recycled meanings of race and gender? Does the hyper-visibility of black bodies make legible the claims, successes, and struggles of marginal communities? Or, does it render such communities *invisible* through the promotion of certain narratives and imagery? And how do these representations shift meaning when crossing national and transnational borders?

RACE, GENDER, AND "PROGRESS"

The specific millennial scenarios that I referenced complicate what Frantz Fanon termed the "facts of blackness," in which the racialized body creates "dialectic with the world." As he once mused: "I discovered my blackness, my ethnic characteristics; and I was battered down by tom-toms, cannibalism, intellectual deficiency, [fetishism], racial defects, slave-ships, and above all else . . . 'Sho' good eatin'" (Fanon 1967, 112). If Fanon's body recalled

this complex historical and sociopolitical reduction to racial stereotype, then we might want to question whether or not the millennial black body—sixty years after Fanon's writing, which is to say "post-Civil Rights" and "postracial"—is similarly "sprawled out, distorted, recolored" (Fanon 1967, 113), albeit in quite different and supposedly "progressive" ways beyond the stock stereotypes.

Because of postmodernism's insistence that, as Jean Baudrillard has argued, our media-saturated world has created "less and less meaning" of our signs and images, there has been a significant push to declare categories of race and gender *meaningless*. However, such pronouncements of "postracial" and "postfeminist" societies seem less to do with envisioning the "planetary humanism" that poststructuralist thinkers such as Paul Gilroy advocate, in which we readily "leave the century of the color line behind" (Gilroy 2000, 335), and more to do with the dismissal of identity politics and political movements, along with their function in creating social upheavals and cultural shifts that better position the less powerful. Is it possible to build a twenty-first-century future beyond "the color line" without such movements, or are we simply content to glimpse only a mirage of the postracial, if indeed we agree that the election and inauguration of a black U.S. president represents a society and world "beyond race"?

As a nation, even as a world, we were ecstatic that the "unthinkable"—a black president—had come to pass. However, our narratives about the black body betray our shortsighted understandings of how a black political leadership would function—and how racial justice would be meted out via that body—so satisfied are some of us by the mere representation of blackness as the "sign" of progress. This was dramatically captured on the February 2, 2009, cover of *The Nation*, which imagined the ghosts of black and other civil rights leaders in the past standing on the steps of the U.S. Capitol as they ushered in a supposedly new era of black liberation with Obama sworn in as our U.S. president (Fig. I.1).

By contrast, arguments for a "postfeminist" society claim that women are no longer concerned with achieving equality. In their anthology *Postfeminism: Cultural Texts and Theories*, editors Stephanie Genz and Benjamin A. Brabon remind us that the "post" in postfeminism stems from a general impression that feminism as a movement had become "less tangible and distinct" (Genz and Brabon 2009, 53) and thus, from an outsider perspective, unnecessary. This is certainly reiterated by Rebecca Walker, who once identified in the nineties as a "third wave" feminist and who had bemoaned the lack of recognition of a new generation of feminists who organized "around a particular issue, profession, or shared experience, and thus . . . [became]

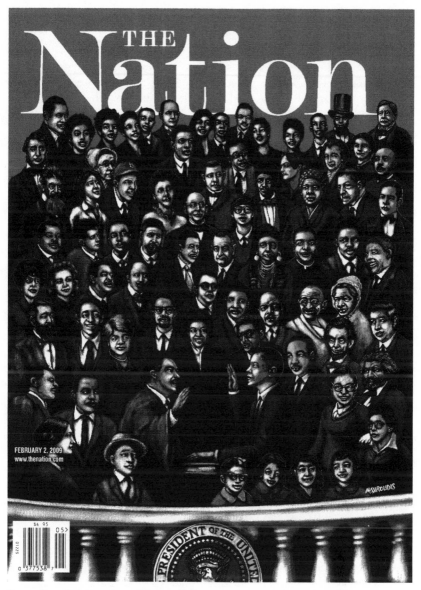

Figure I.1. "Nation Cover." Reprinted with permission from the February 2, 2009, issue of *The Nation* magazine. For subscription information, call 1-800-333-8536. Portions of each week's *Nation* magazine can be accessed at http://www.thenation.com.

vulnerable to the idea that the mythical movement of 'real' feminists is somewhere else" (Walker 1995, xvii).[2]

Not only are "real feminists" perceived as existing elsewhere (usually in the past) and not among the grassroots activists on the ground—activists who incidentally had become constrained by the "nonprofit industrial complex,"[3] which had transformed social justice movements into nonprofits, think tanks, and fund-seeking interest groups—but the lack of a visible and unified mass women's movement suggests that the work for gender equity is no longer viable. Of course, by the time issues of race and gender came to a head during the 2008 U.S. presidential campaign in which candidates Hillary Clinton and Barack Obama competed in the Democratic primaries, certain feminists argued that there was less progress made on gender issues in comparison to race. This was evidenced in Gloria Steinem's *New York Times* editorial, "Women are Never Frontrunners." Not only did Steinem argue in this editorial that black men had it easier than white women in this presidential run, but she employed the black female body in framing her argument, positioning an imaginary figure she called "Achole Obama," whose gender, more than her race, Steinem implied, would have prevented her from achieving the same level of success that we witnessed with the election of President Obama. Steinem was later taken to task by feminists of color, most notably Melissa Harris-Perry, who accused Steinem of ignoring the white heterosexual privilege of the former first lady while positing sexism as "more oppressive" than racism.[4]

In other words, while the early-twenty-first-century discourse of "postracial" and "postfeminist" often declares the loss of meaning attached to race and gender, I find that their definitions have become even more entrenched in the body politic. Far from reflecting a world in which race or gender no longer restricts the upward mobility of certain bodies, I argue in this book that the global scope of our media-reliant information culture insists on perpetuating raced and gendered meanings that support ideologies of dominance, privilege, and power. Undeniably, these meanings have attached to certain bodies to provide "evidence" of the hypersexual or the sexually innocent, the beautiful or the ugly, the ignorant or the advanced, the illicit or the legitimate, the victimized or the liberated, the deviant or the normative.

That a select few can rise to the ranks of political, economic, and cultural power—as represented by President Obama and the pop cultural dominance of the late Michael Jackson, Oprah Winfrey, Beyoncé, and other celebrities of color—only proves the exception, not the rule, camouflages the overwhelming masses who have not attained the same level of success, and reiterates the hegemonic system of power that depends on racial and sexual

hierarchies. Subsequently, these "success stories" undergird what Patricia Hill Collins terms the "new racism," which posits a "color-blind" approach to race, including the denial of racism, while perpetuating age-old and systemic racial inequalities (Collins 2004). Moreover, the cross-border flow of media has expanded and shifted these meanings in global and transnational contexts. In essence, this media-driven illusion of inclusion invites masses of women, sexual minorities, people of color, the poor, and non-Western citizens to dismiss their own lived experiences of sexism, racism, classism, and imperialism in exchange for the mediated vision of "progress" advanced in social and political representations. Nonetheless, these representations also exist to *suggest* the possibility of success, which thus holds its own subversive power.

IMMEDIATE HISTORIES, DIGITAL FUTURES

That such symbolic power finds an outlet in our media necessitates a nuanced analysis of how these cultural narratives perpetuate old ideologies through new forms, as our digital culture—which currently defines the early twenty-first-century world—continues to evolve through the latest high-tech gadget. Even as I define the early twenty-first century primarily through an understanding of media, I in no way wish to ignore the ways that media have driven all of our different eras. As Fredric Jameson observes, "It is because we have had to learn that culture today is a matter of media that we have finally begun to get it through our heads that culture was always that, and that the older forms or genres, or indeed the older spiritual exercises and meditations, thoughts, and expressions were also in their very different ways media products" (Jameson 1992, 68). Indeed, these older forms of media determined whose stories got told (the narratives of those in power), which bodies *produced* media (often male bodies, which still dominate fields of science and technology today), and how bodies get positioned (often women, colonized, and people of color get reduced to objects and commodities).

While the media of the twenty-first century seem "upgraded" compared to older forms of media, the belief systems perpetuated are not. The bodies seem "new and improved," though closer inspection reveals that old systems and social representations are merely "remixed," to invoke that contemporary hip-hop practice of sampling from dominant narratives to insert and assert a marginal perspective. However, this same remixing sensibility reminds us that various mediated narratives are not simple stories of oppression and resistance, of victims and perpetrators. The very act of the remix preserves complex dialogue between the powerful and the powerless. Furthermore, the fluid and hybrid identities articulated in the previous era of postmodernism and

poststructuralism have enabled us to disrupt such dichotomous constructions while complicating texts and contexts.

As feminist historian Gerda Lerner has observed about our information-overloaded contemporary moment: "[T]he record of images gets more and more voluminous, larger and larger, filling walls and shoe boxes and video-screens, but it lacks context, and therefore it lacks meaning. . . . A meaningful connection to the past demands, above all, active engagement" (Lerner 1997, 200–201). Because of the increased volume of information, so much of which has become lost due to computer upgrades and the obsoleteness of our recording data—from VCRs to floppy disks to CDs to instant coverage, courtesy of the Internet, rendering forty-eight-hour-old news as "passé"—I find it imperative that we analyze the contemporary scene as *immediate history* and one that requires our "active engagement" in preserving its multilayered narratives. The very study of media and popular culture already requires that such texts and scenarios be viewed in historical terms since, by the time of this writing, popular culture has already changed, and new trends replace old ones.

And yet, popular culture—including movies, television, music, literature, art, live performances, advertising, material ephemera, and the Internet— provides enough "information" that must be given "meaning" since it encapsulates zeitgeist, the values and anxieties of our times. As cultural critics bell hooks, Mark Anthony Neal, and Daphne Brooks have argued, popular culture deserves our critical attention because of its public record of the personal and political sentiments that public figures and narratives, and the audiences that either affirm or condemn them, have articulated about the contemporary experience, which is to say the immediate history experience.[5] Tied to this are the ways that corporate media, or what I also refer to as Big Media, filter which narratives receive the widest audience.

I use the term *Big Media* in reference to the increasing consolidation of media through media company mergers, in which diverse media are owned by the same corporation.[6] This trend, which started during the Reagan administration in the 1980s, when the FCC began to be deregulated, escalated under the Clinton administration with the 1996 U.S. Telecommunications Act. This legislation allowed for such company mergers, which then expanded in 2003 to increase media consolidation. Such policies allowed for media monopoly ownerships; as such, we find diverse media—book publishers, radio and TV stations, music labels, and film distribution companies— operating under the same umbrella company, while major Internet sites, such as YouTube, Google, and Facebook, have created similar synergies. The result is an increasingly homogenized presence of multimedia pushing similar

dominant and corporate narratives while squeezing out independent voices and alternative media.

On the one hand, digital culture—a subject explored in depth in chapters 4 and 5—which has created "do-it-yourself" spaces on the Internet for various consumers, has empowered numerous individuals to start their own blogs, upload their own music, videos, and artwork, or interact through diverse social networking sites. On the other hand, that this individual impetus has led to social trends now enables the expansion of Big Media onto the Internet—a corporate foundation on which "independent media" is built (so many levels of irony here)—and new inequalities have emerged in the information age between those who can access digital technologies and those who cannot. Moreover, there are still cultural hierarchies in place in which the Internet blogger or video maker or audio podcaster still longs for more "legitimate" means of cultural gatekeeping, as well as financial success, as represented by publishing a book, signing with a major record label, getting one's film distributed by a major film studio, or having one's art featured in an established gallery or museum. Such Internet users also engage in "monetizing" their blogs and Web sites, and Web 2.0—which enabled the social interactivity of such users—is fast evolving into Web 3.0, in which the computer itself can track, surveille, and market to individual consumers. In these ways, Big Media still dominates and curtails how information and the "popular" gets mediated to a mass worldwide audience.

GLOBAL CURRENTS

To be sure, Big Media constantly grates against resistant media and other narratives from the margins and is constantly ready, as Jameson posits, to appropriate counterhegemonic narratives in order to *maintain* hegemony. However, the periphery also pushes back against the center or even from within it. When we examine the phenomenon of Nollywood, for example, we might recognize how arguments of a "Global Hollywood,"[7] which view U.S. and Western culture from a stance of cultural imperialism and the dominant global cultural center, assume that cultures on the periphery of the West are only on the receiving end of cultural domination by the West instead of viewing such cultures as producing complex dialectics and synthesizing relations with colonizing narratives.

Through this lens, as Ella Shohat and Robert Stam argue, the "Third World" is perennially cast as " 'undeveloped,' or 'developing,' as if it lived in another time-zone apart from the global system of the late capitalist world" (Shohat and Stam 1994, 292). This same global system that provided us with

late-twentieth-century and early-twenty-first-century video technologies led to
the establishment of Nollywood, as did the transnational consumption of
and counternarrative responses to other international entertainment systems,
including Bollywood musicals, Brazilian telenovelas, Hollywood blockbusters,
and Hong Kong's Kung Fu action movies—all underscored by booming
soundtracks mixing African popular music with African American R&B and
hip-hop. With their low-budget productions, melodrama, and African-centered
morality tales that alternate between secular romance and violence and
sacred contests between Christian fundamentalism and indigenous African
cosmologies, the popularity and dominance of Nigerian cinema indicate that
this is more than a "niche" market. We now live in what journalist Fareed
Zakaria calls a "Post American World."

Even when we operate from the "American" center, certain bodies play
to and subvert dominant ideologies. For instance, Michael Jackson achieved
global domination in the late twentieth century and reemerged onto the
twenty-first-century scene in the wake of his premature death. He simultaneously
represents U.S. "cultural imperialism" with his commercial success on six
continents while also depicting resistance to that culture via his black (though
"whitened") body and the ways in which he engages in transnational antiracist
resistance narratives. We see this in his Spike Lee–directed music video for the
1996 single, "They Don't Care about Us," filmed in a Rio de Janeiro favela.
Despite his bleached appearance, his musical interaction with the local samba
music group, Olodum, reframes this antiracist song within a collective diasporic
discourse of black oppression and invites a global reading and comparative
analysis with his other music video for the same song, set in a U.S. male
prison and intercut with images of South African and African American racial
struggles—including the infamous 1991 Rodney King video.

As such, Jackson creates a paradoxical relationship between cultural
imperialism and cultural resistance. At the same time, Jackson has also played
with militaristic imagery to suggest his global dominance: His "History" video
indeed features a gigantic and quite bombastic Stalinesque statue of himself
at a time when he became the first U.S. superstar to tour in the Eastern bloc
after the fall of the Iron Curtain. Nevertheless, one might recognize through
this egoistic gesture an artistic attempt by a black musician to transcend his
racial body and write his own history—writ large (quite literally)—when it
often becomes threatened by Big Media narratives that seek to undermine and
delegitimize his cultural importance: as had occurred with Jackson's musical
fallout with SONY's music executives and with widespread media coverage of
the lawsuits that charged him with child molestation. However, Jackson may

not have too much to worry about with regard to his legacy, for millions have created memorabilia documenting his cultural contributions: most notably in the "Eternal Moonwalk" Web site, produced by Studio Brussels, which invites countless viewers around the world to upload videos of themselves attempting to dance Jackson's signature dance move, which are then presented in a transnational, file-sharing video loop of the never-ending "moonwalk." The world is thus digitally connected to the memory of the liberated black dancing body.

GLOBALIZING RACE AND GENDER

If both music and interactive media can globally circulate the body of Jackson in ways that allow him to transcend race, then U.S. cinema seems more limited in similarly presenting black bodies. As previously mentioned, Disney's attempts to commercialize an African American animated princess fell short in achieving the same level of global prominence as other Disney films. However, gender seems to interact with race in such a way that localizes, rather than globalizes, the body.

This is seen in the way our titular protagonist, Tiana, is visually positioned in the narrative of *The Princess and the Frog* to right the wrongs of Disney's racist and sexist past, as the studio worked overtime not only to address the various controversies raised by its African American critics but to draw its animated characters so that they bore no resemblance to Disney's early animated history of offensive and dehumanizing black cartoons. It also linked Tiana's body to the city of New Orleans and its surrounding bayou habitat, whether in her laborious transformation of an old sugar mill (symbolic of the slave past) into a Café du Monde–like restaurant or in her transmogrification into a frog. These fantasy depictions also work to erase the horrific oppression of black women in the South, both in the 1920s time period of the storyline and in its present-day manifestation, as recalled by the media narratives of stranded and beleaguered black New Orleans residents in the wake of Hurricane Katrina in 2005. Such cinematic representations ensure that the black female protagonist will resonate more for a U.S.-based audience that would appreciate the "progress" narrative for this "first" of Disney's "black" princesses (and most likely the last) than for a global audience weaned on white and Western narratives and, therefore, less familiar with the New Orleans racial and cultural references or even with the artistic homage in the animation imagery given to such Harlem Renaissance artists as Aaron Douglas or to the legacy of modernist black

women restauranteurs such as Ada "Bricktop" Smith in Paris, a black icon of the jazz age and café culture, and New Orleans' celebrated local chef Leah Chase, a direct influence on the character Tiana.

When it comes to white female bodies, however, globalization efforts are far more successful. We need only look to Hollywood's cinematic history for a lesson in global circulations around raced and gendered bodies—a history founded on what film theorist Richard Dyer recognizes as an imperialist "culture of light" that promotes white visibility through film lighting technology and through what Laura Mulvey calls the "to-be-lookedatness" spectacle of white femininity (Dyer 1997, 103; Mulvey 1975, 11). In globalizing whiteness, Hollywood cinema reframed foreign sites through white female bodies. One example is Brazilian icon Carmen Miranda of 1940s fame, whose on-screen caricatures of Latin American womanhood heightened white masculine U.S. supremacy in the Americas while simultaneously promoting "Good Neighbor" policies between North and South America.

The very costume that made Carmen Miranda iconic as "the lady with the tutti-frutti hat" was based on her mimicry of Afro-Brazilian market women, who carried the fruits that they grew on their heads and sold these produce on the agricultural market. Their colorful floral headdress and jewelry, used in Candomblé religious ceremonies, also inspired the different floral, bejeweled style that Miranda co-opts for her performances. What we witness through this spectacle is the whitening of the black female body. As Cynthia Enloe reminds us, not only do we have a corporation such as the United Fruit Company displacing black female farmers within the global economy through the Carmen Miranda–inspired Chiquita banana logo representing their banana plantations, but these women's bodies, cultural practices, and fashion values are further commoditized *and* invisibilized for global entertainment (Enloe 1990, 128).

Relating to these exotic representations, marked spectacularly on the white female body, are the more typical examples of white assimilation in which women of color are encouraged to "whiten" or Anglicize their identities. Light-skinned black performers such as Lena Horne were encouraged to "pass for white" or, in her specific case, as an "exotic Latin American," while genuine Latin American actresses such as Margarita Carmen Cansino were encouraged to change their names and public image (hence her transformation into Rita Hayworth). When Horne refused to identify as anything but African American, her film career was cut short; whereas Rita Hayworth became a movie star—a stark reminder of how race, when intersecting with gender, determines whose bodies can cross or grate against the color line and the national border.

Curiously, in our own times, we see similar racial restrictions in global circulations of women's bodies. In Brazil, as scholar Erica Williams notes, sex tourists from Europe and North America seek out black and "mulata" women—regularly advertised in hypersexual tourist imagery—while international model scouts seek out white Brazilian women for the global supermodel industry (Williams 2010). Even in this "racial democracy," color hierarchies abound in which white women's images are globally circulated to represent beauty, while women of color are locally positioned for sex.

This same global beauty industry promoting white femininity reverberates in today's Hollywood film industry, as exemplified in the all-white spectacle of up-and-coming Hollywood stars on *Vanity Fair's* March 2010 special issue cover of "A New Decade, A New Hollywood." That some of the actresses featured on the cover hail from other nations, including Great Britain, Canada, and Australia, is an aspect of globalization in entertainment and the transnational construction of "white American womanhood" that we mostly ignore in conversations around gender, race, and nationhood. The irony of the "new Hollywood" issue, of course, is the way that its vision of whiteness does not reflect its physical location in Los Angeles, one of the most multiracial and multiethnic cities in the United States, a city where white Americans actually constitute a racial minority. Such "national" narratives rely on transnational bodies that migrate to uphold ideologies of race and gender. In mediated narratives of race, gender is mobilized through global processes to create an idealized body for the nation.

However, significant projects exist to refute such representations. A counterpoint to the *Vanity Fair* special issue is *Vogue Italia's* fast-selling "Black Issue," which premiered in July 2008 and devoted most of its pages to black fashion models and to challenging the claims that white femininity is the only model of beauty that could generate international sales and "universal" appeal. In a similar vein, Cameroon-born fashion photographer Mario Epanya conceptualized in the spring of 2010 several imaginary magazine covers for a "Vogue Africa" on his Facebook page, thus calling international attention to the missing fashion and beauty market from the African continent (Fig. I.2).

Considering *Vogue* magazine's global reach in Asia, Europe, Australia, North and South America, Epanya sought to reframe the black female body within a recognizable and global aesthetic. On the one hand, he subverts through his photographs the Euro-American ideal of beauty; on the other hand, he reinforces the white, Western aesthetic by relocating African women's bodies within the parameters of *Vogue* magazine and its fashion hierarchy. That Condé Nast, the corporation that owns *Vogue*, has rejected Epanya's proposal for "Vogue Africa," and its Italian magazine filled its "Black Issue"

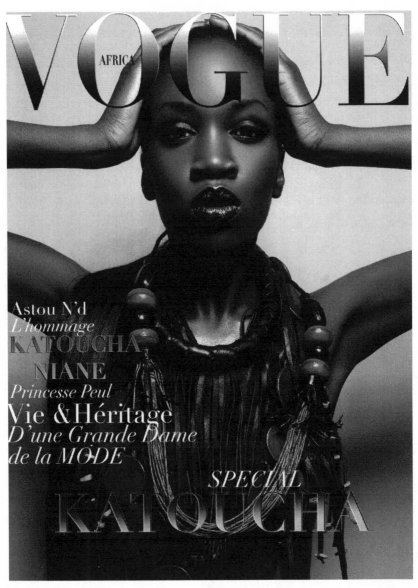

Figure I.2. Mario Epanya, "Vogue Africa," 2010. Permission of the Artist.

with white hegemonic ads and images of exotic blackness, reminds us of the continued struggle to redefine the black body on its own terms and beyond a global white imperialist gaze.[8] As such, it remains to be seen how mediated narratives of race and gender will reposition bodies in such a way that successfully demonstrates that these categories *have* lost their meanings.

CONCLUSION: AN OVERVIEW

In sum, these diverse narratives shape the wider historical context for much of this study. It is a story that I wish to engage from a global black feminist perspective, framed by prose and interlaced with poetry. Part I, "Text Messages," is essentially about "texts" and their "messages" in twenty-first-century media. Each chapter in this section explores the centrality of the black body in generating complex discourses that intersect popular culture with politics: from black female vocality framing the musical spectacle of *American Idol* in chapter 1 to Beyoncé and the Obamas destabilizing blackness in chapter 2 to the Duke Lacrosse rape scandal racializing sexual violence in chapter 3.

Part II, "Geo Trackings," includes chapters addressing digital cultures and global networks. Chapter 4 examines science fiction films, which reinforce racial narratives of the "digital divide," hence conceptualizing bodies along racial lines of the "civilized" white body with access to technology and the "primitive" black body lacking such access. Chapter 5 provides a feminist theorizing of digital culture, the global economy, and the space for feminist engagement within these networks. Expanding on the subject of twenty-first-century feminism, chapter 6 analyzes the representations of non-Western women in U.S.-based and Western feminist narratives, which often reduce women around the world to "exotic" stereotypes, and calls for a more inclusive and radical articulation of global feminism. Lastly, I close this study by providing rumination on the "apocalyptic" visions and religious discourse that have surfaced in millennial popular culture and suggest possibilities for imagining a hopeful digital "future" that can move us toward cosmic liberation.

The story of the early twenty-first century is thus a story of emerging media and how those powerful vehicles mobilize images, words, sounds, and digital files across the globe to articulate raced and gendered meanings stamped onto spectacular bodies. Mostly, it is a story of how these meanings have shaped our worldview and our sense of being and living on this planet. It is this story, overloaded with information, which deserves our careful attention to its multilayered narratives.

Part I

Text Messages

Chapter 1

Pop Goes Democracy

Mediating Race, Gender, and Nation on *American Idol*

Parallels between presidential elections and the hit TV series *American Idol* are not hard to make. Indeed, they had become punch lines in comedy routines: from Comedy Central's Stephen Colbert complaining that it took too long to determine the next American Idol (in a gag that had audiences assuming he was referring to the next U.S. president) to ABC's Jimmy Kimmel quipping that, after watching the vice presidential debate during the U.S. presidential campaign in 2008, he "voted four times for Sarah Palin and six times for David Archuleta," in reference to the popular Republican vice presidential candidate and *American Idol's* frontrunner contestant that year. Interestingly, movie critic Roger Ebert mounted criticism against Palin for being "the American Idol candidate," in which he argued the following:

> I think I might be able to explain some of Sarah Palin's appeal. She's the "American Idol" candidate. Consider. What defines an "American Idol" finalist? They're good-looking, work well on television, have a sunny personality, are fierce competitors, and so talented, why, they're darned near the real thing. There's a reason "American Idol" gets such high ratings. People identify with the contestants. They think, Hey, that could be me up there on that show! . . . My problem is, I don't want to be up there. I don't want a vice president who is darned near good enough. I want a vice president who is better, wiser, well-traveled, has met world leaders, who three months ago had an opinion on Iraq. (Ebert 2008)

Ebert's observation that Palin's appeal relies on the same charisma as *American Idol* contestants is not necessarily revelatory. However, he has pinpointed a concern for how an image of "reality" has pitted ideals of ordinariness against values of exceptionalism.

Both entities of the presidential election and the reality TV show are predicated on ideologies that we have learned to accept about our public figures—celebrities and political leaders—as well as on media manipulation of their image. Because the presidential elections and *American Idol* both rely on "popular votes" to determine a winner, I find it fruitful to intersect our popular culture with our politics. In fact, I would argue that the construction of "reality" vis-à-vis entertainment, regular Americanness, multiraciality, and myths of meritocracy and democracy—as offered through the spectacle of *American Idol*—encourages the belief that, if anyone could become the "next American Idol," anyone could also become the "next American president," thus enabling the kind of atmosphere that made it easier for Americans to vote for an African American man with a name that signals the dreaded Other, which we had come to identify in a post–September 11 "war on terror" world of immigrants, racial difference, gender norms and deviations, and global conflicts. Added to this is a raced and gendered presentation of popular music constituted by marginal bodies.

In this chapter, I explore the political, social, and cultural contexts of *American Idol* and consider how its musical representation was shaped by a black female vocality in its earliest seasons. I further analyze how the show has mobilized such American values as democracy, multiculturalism, meritocracy, and capitalism, which then get reduced to a "national sound." Although the show creates a number of illusions, the "hyperreal" setting of this reality TV program has superimposed onto the national imaginary a political and popular discourse on race, class, gender, sexuality, and nationality. However, just as the election of Obama conceals the realities of race relations in the United States, so too does *American Idol* distort national narratives on racial, ethnic, and gender inclusions. What follows is a rumination on how a reality TV show articulates our collective desires for and anxieties surrounding political participation and social inclusivity.

THE RETURN OF THE HYPERREAL

It is no coincidence that a show such as *American Idol* emerged in the wake of our collective disenfranchisement in the Presidential Elections 2000 debacle and after September 11, 2001. Both events built a need within the national consciousness to believe our votes can count for something and to also believe

in something trite and fun, such as a talent competition. Itself a spinoff of a British hit TV show, *Pop Idol*, created by music producers Simon Cowell and Simon Fuller in response to decades-long talent shows in European culture, such as *Eurovision*, and reality shows that have dominated nineties television, *American Idol* came to U.S. television programming at a time when "reality TV" offered low-budget opportunities in which screenwriters and actors were replaced by unscripted amateur talents. These "real-life" characters proliferated in a culture shaped first by the popularity of drama-filled TV talk shows, then later by MTV-based youth programming that constructed "real world" and "road rules" entertainment, and, finally, by a digital high-tech culture that routinely blurs the lines between privacy and the public through MySpace, Facebook, Twitter, and YouTube sites that have trained an entire generation toward exhibitionism and instant celebrity status.

As academic John L. Jackson Jr. comments in *The Chronicle Review*:

These days, acting is considered a kind of faked sincerity, and faking sincerity, no matter how stellar the performance, is hardly enough anymore. We want "the real thing," not its well-performed simulation: real tears, real anger, real oddity, real sex. . . . It is this unquenchable thirst for "the really real" that drives paparazzi's flashbulb frenzies. Celebrity is predicated on it, this backstage access, this pretending of transparency. (Jackson Jr. 2008)

The pretense of "transparency" has much in common with what Baudrillard called the "hyper real," which becomes "more real than the real, that is how the real is abolished" (Baudrillard [1981] 1994, 81). Here, Baudrillard uses Borges's absurd story of a map of an empire as illustration of this phenomenon.[1] We may recall that, in this story, the map became so huge in its attempts at "exactitude" that it actually took over the "real" territory it represented, with only brief glimpses underneath the wear and tear of the map of the "desert of the real."

In the context of reality TV, we may recognize how this "hyperreal" construction of reality surrogates for real world events, real people, and real lives. On the other hand, in the "real world" sense, we have become constant actors with so-called unscripted lives, except that we are under constant high tech surveillance with omnipresent cameras; therefore, we are constantly "ready for our close-ups." Shows such as *American Idol* rely on this belief of constantly being on the lookout for the "next American Idol," who could be "you," the average TV viewer. All "you" need is a great voice, and if "you" don't have that, "you" may stand to gain five minutes of fame by making a

spectacle of yourself—should "you" be so lucky to be featured during the
auditions segment of the show, in which those *without* talent receive the same
level of attention as those *with* talent. Indeed, auditioners such as William
Hung and General Larry Platt—whose ditty "Pants on the Ground" became
an Internet remix hit—capitalized on their publicity as comedic untalented
Idol contenders. Incidentally, both Hung and Platt are men of color, thus
lending themselves to the racial spectacle that *American Idol* has often relied on
in its promotion of "diversity" and "inclusion," albeit through stereotypical
buffoonery, as these examples illustrate.

On the other end of this constant unscripted yet fabricated reality
of "ordinary citizen becomes a Hollywood star in the course of a TV
season" is the spectacle of the viewer. This particular marketing strategy is
one that I recognize as "hyperreal democracy," through which a TV viewer
is transformed from passive watcher to active participant and democratic
voter: taking part in the unscripted script and, subsequently, being granted
absolute power in determining a superstar celebrity in the making by simply
casting a vote (or numerous votes) through a phone call or text message for
the viewer's favorite contestants. These contestants eventually advance week
after week in the competition before they are either voted off the show—for
receiving the least number of votes from the public—or succeed in capturing
the *American Idol* title during the season finale. Some TV viewers take this
"popular vote" to the next level of democratic participation: from generating
Internet campaigns on Facebook and YouTube for their favorite contestants
to purchasing go-phones that facilitate texting and dialing across different
time zones, to even subverting the show's objectives by voting for undesirable
contestants, best represented by Web sites such as *Vote for the Worst.*

This aspect of the TV show is perhaps its most brilliant tactic, as it
utilizes various forms of mass communication technologies, mainly provided
by its sponsor AT&T, to literally draw TV viewers into the show by breaking
down the imaginary fourth wall that is the TV screen and shaping the drama
of choosing contestants week after week. Indeed, *American Idol* boasts of
creating the contemporary trend in texting among our youth. It has since
spawned other viewer-voting reality TV talent shows from *America's Got Talent*
to *So You Think You Can Dance* to *Dancing with the Stars.*

Not surprisingly, the show became an instant success, and with the
superstar makeover of the first *Idol* winner, Kelly Clarkson, the show proved
to be credible when its winners began dominating the music scene. Not long
afterward, this item of pop frivolity became its own institutional power (a
New York Times article called the *Idol* franchise a "schoolyard bully" with regard
to its domination over TV ratings)[2] and, later, a force to be reckoned with

in the music industry, as established artists began clamoring for opportunities to perform on the show as guests. Beyond its mainstay status in popular culture, its cross-marketing efforts with various phone and cable companies and other major corporations have created an entire consumer culture that has become obsessed with text messages and go-phones. It is important to note this mobilization of social media was also a significant force behind the Obama presidential campaign in 2008.

Interestingly, philosopher Slavoj Zizek commented in his essay, "Welcome to the Desert of the Real," that the September 11 event exposed the "unreality" of reality TV, but I would argue that *American Idol* distracted us from contemplating what this exposure means for us culturally by returning us to the hyperreal. As Zizek ruminates:

> It is when we watched on TV screen the two . . . towers collapsing, that it became possible to experience the falsity of the "reality TV shows": even if these shows are "for real," people still *act* in them— they simply *play themselves*. . . . Of course, the "return to the Real" can be given different twists: one already hears some conservatives claim that what made us so vulnerable is our very openness—with the inevitable conclusion lurking in the background that, if we are to protect our "way of life," we will have to sacrifice some of our freedoms which were "misused" by the enemies of freedom. This logic should be rejected. (Zizek 2001; emphasis in the original)

Zizek reminds us that the September 11 event introduced the most unexpected and unscripted televised moment of horror, which should have ushered in the "return to the Real." Instead, the media spin cycle, which scrambled to narrate an acceptable storyline that simplified the events into an "us versus them" rhetoric, with easy lines dividing the American from the un-American, the Good versus the Evildoers, enabled us to actually return to the hyperreal and, specifically, to a reality-TV version of our American ideals wrapped up in the freedom of leisure (vis-à-vis TV viewership and talent shows), the freedom of the vote, and, of course, the "free market" of capitalism predicated on our consumer culture. That *American Idol*, itself a British import, would expand into different national versions across the world—*Canadian Idol, Australian Idol,* even *Iraqi Idol*—indicates the continued global expansion of Western consumer culture.

Such a return to the hyperreal makes possible "a world where there is more and more information . . . and less and less meaning" (Baudrillard [1981] 1994, 79). In other words, even as *American Idol* reinforced traditional

American values, the very nature of the parade of citizens aspiring to be celebrities offered a remarkable spectacle of our multiracial society, which is more and more indicative of the globalizing world in which we live, since the late twentieth and early twenty-first centuries have witnessed a huge increase in immigrant populations in the global North. While the "war on terror" highlighted anxieties about American nationality and immigration issues, *American Idol* itself highlighted that the "average American" was no longer typically white.

In the first decade of the twenty-first century, beginning with the show's debut in 2002, *American Idol* only featured three white male winners, and 2008 was the first time—through heavy manipulation of media spin, I might add—that the show's finale included two white male contestants competing against each other. Even then, one of the contestants, David Archuleta, was of Latino descent, practiced a marginal Christian faith, and freely admitted to the influence of black female soul singers on his vocal style. Over time, however, the show's contestants who made it to the finals had become increasingly white, thereby suggesting a voting TV audience either increasingly invested in whiteness or reflective of a specific race, gender, and class demographic that continues to vote for contestants (or perhaps who votes maniacally through multiple text messages) while others have either ceased their interest or cannot keep up with the latest digital communication technologies that facilitate the voting process. These patterns also shed light on what constitutes the "Americanness" of an *American Idol*. In the remaining segments, I explore the raced and gendered narrative of this "Americanness" that shapes our popular music and also how this frames the national dramas that unfold on this show.

TOWARD A NATIONAL SOUND

The main focus of *American Idol* is its musical competition, primarily featuring singing contestants, who compete for a million-dollar recording contract. Judging from ten seasons, between 2002 and 2011, different vocal styles and musical genres have emerged on the show, but for the most part, a standard vocal stylization dominates the competition: it is a style that can be termed *black female vocality*, framed by the show's predominately black female backup singers and also by the current "sound" that prevails in the American popular music scene. Because of its reliance on musical spectacle, as well as its emphasis on a "national" identity not unlike the representational politics of the Miss America beauty pageant, *American Idol* has come to signify a national image and sound. While R&B soul represents a niche market compared to the more mainstream rock and pop music genres, its prevalence in the vocal

styles of *American Idol* singers suggests that it might, indeed, serve as "the sound of nation," to cite musicologist Pavitra Sundar.

Borrowing from Roland Barthes's "The Grain of the Voice," Sundar considers the ways that vocal music has been mobilized to define nationality, and while she concerns herself with Indian nationality, I find this analysis of vocality useful in addressing how American nationality is similarly constructed through musical representations (Sundar 2008, 172). Barthes describes the "grain of the voice" in the following way:

> Something is there, manifest and stubborn (one hears only *that*), beyond (or before) the meaning of words, their form (the litany), the melisma, and even the style of execution: something which is directly the cantor's body, brought to your ears in one and the same movement from deep down in the cavities, the muscles, the membranes, the cartilages, and from deep down in the . . . language, as though a single skin lined the inner flesh of the performer and the music he sings. (Barthes 1977, 181–82; emphasis in original)

How does this voice then become a "national" voice? Moreover, how is this national voice gendered and raced?

If we consider the specific example of the black female vocalist, she is deeply ingrained in American music culture; she is both hyper-visible and hyper-audible. As Farah Jasmine Griffin argues, the black woman's voice is a "quintessential American voice. . . . It is one of its founding sounds, and the singing black woman is one of its founding spectacles. But because it develops alongside and not fully within the nation, it maintains a space for critique and protest" (Griffin 2004, 119). Nonetheless, this marginality, even within the context of its hyper-audibility, reinforces black women's "voicelessness" in cultural discourses on American music heritage and, ironically, in political narratives, since black women are often singing in service of someone else rather than for themselves.

By labeling black women's public discourse as one of "voicelessness," I specifically draw on black feminist theories addressing black women's historical strategies of the "politics of silence" (Higginbotham 1992) and the "culture of dissemblance" (Hine 1995), which discourage any public disclosure of black women's private lives. Although music—especially blues music—allowed black women to articulate a public discourse about their personal lives, it nonetheless created the illusion of openness, when in actuality it "shielded the truth of their inner lives and selves from their oppressors" (Hine 1995, 380). Do their performances reinforce what Evelynn M. Hammonds calls a "problematic of silence," in which "black women's bodies are always already

colonized" (Hammonds 1997b, 171)? Or, as Griffin argues, do their voices—
as extensions of their bodies—transcend colonization to carve out spaces
of social protest? These questions resonate as we witness the continued
appropriation of black female vocality in the dominant culture—especially
on a TV show such as *American Idol*. Because black women's singing is thus a
critical site of struggle between objectification and agency, it also becomes a
site of resistance, which is embedded in the "space for critique and protest"
that Griffin describes.

North American black music is itself a tradition of "protest": keeping
alive a memory of African culture during slavery, when the essence of African
music—the percussion sound—was banned by enslavers. The percussion
eventually became embodied through foot stomping, handclapping, and vocal
improvisation, while spirituals coded the pain of the slave experience and
the slaves' desire for and actual attempts at freedom. Harriet Tubman was
known for singing spirituals and hymns to communicate secret codes during
her rescue missions, thus inaugurating an important chapter in black feminist
musical resistance.

In contrast to Tubman's fugitive slave spiritual singing, her contemporary
Elizabeth Taylor Greenfield, a free black woman and the first African American
female opera singer, employed musical resistance simply based on her ability
to perform in the classical musical genre and in concert halls during the
antebellum period. Consequently, Greenfield distracted her audience, because
she sang classical music from the Western tradition. Her classically trained
voice was outlaw, subversive, and it had to be separated from the very
body that produced it. According to nineteenth-century racial views, her
body should *not* be able to produce sounds so "sweet and pure."[3] As such,
Greenfield's voice transcended her status as a black woman, and it was this
transcendence that some in her audience found threatening. Hence, to contain
her within a white hegemonic framework, her voice was often disembodied
from her blackness—inviting the audience to accept and praise the voice but
to separate it from her black body.

Whether singing spiritual songs or confounding audiences by singing
operatic themes, the black female vocalist functions outside the national
narrative while also shaping it through her "protest songs." How, then, do
black women continue in this tradition of resistance? Can their subaltern
voices of protest be heard, or do their bodies merely function as vessels,
coded in culturally specific ways in which black women's singing already
connotes suffering and, thus, constitutes an appropriate instrument to voice
political and social discontent?

In his essay, "Many Thousands Gone," James Baldwin argues the following:

It is only in his music, which Americans are able to admire because a protective sentimentality limits their understanding of it, that the Negro in America has been able to tell his story. It is a story which otherwise has yet to be told and which no American is prepared to hear. (Baldwin [1955] 1998, 19)

Baldwin identifies a different phenomenon here, which we might call the "problematic of hearing" in the mainstream American reception of black music, which has contributed to black women's "problematic of silence." However, the protest song is communicated subtly, understatedly, even ironically. Such songs derive from the spirituals and blues traditions, which included secret codes—as Tubman already demonstrated—and double entendres so that different audiences would always hear differently. More importantly, I would argue, such "double consciousness" singing, to borrow from W. E. B. DuBois, necessarily shielded black women's private lives from the public view, already inclined to distort their reality.

If we have trouble hearing the black female voice ingrained in American music, then calling it the "national sound" of America might be just as risky. Yet, few would argue that black musical genres—from spirituals to blues to jazz to rock 'n' roll to hip-hop—are anything *but* quintessential American music. And embedded within the foundations of black music is the black female soul singer. Consider the unnamed narrator in Ralph Ellison's *Invisible Man*, who peels away the layers in Louis Armstrong's own protest song, "Black and Blue," to uncover the original source embodied by black female suffering:

> I not only entered the music but descended, like Dante, into its depths. And beneath the swiftness of the hot tempos there was a slower tempo and a cave and I entered it and looked around and heard an old woman singing a spiritual as full of Weltschmerz as flamenco, and beneath that lay a still lower level on which I saw a beautiful girl the color of ivory pleading in a voice like my mother's as she stood before a group of slaveowners who bid for her naked body, and below that found a lower level and a more rapid tempo and I heard someone shout: *"Brothers and sisters, my text this morning is the 'Blackness of Blackness . . .'"* (Ellison [1947] 1995, 9; emphasis in original)

Enigmatically, Ellison's description of the gendered origins of the blackness of blues music—from the "old woman singing" to the "mother's

voice" heard on the auction block, emanating from a naked and mixed-race slave—recalls the sexualized nature of racial oppression, as well as the original text sung first by Edith Wilson, who performed "Black and Blue" in the 1929 *Hot Chocolates* musical by Fats Waller. The song is a lament by a dark-skinned woman who "protests" colorist sexism in which she is overlooked because of black men's preference for lighter-skinned women. That Armstrong could improvise upon and appropriate this specifically gendered protest, which is then elevated to a national lament on black people's suffering en masse under white supremacy, complicates theories of cross-dressing and gender-bending performances; the black male performer becomes the feminine, vulnerable speaker powerless in a world where whites can "overlook" and "pass" him over in a racist society.

Ironically, the "protest" of the original black woman's performance of "Black and Blue" becomes "invisible" through preoccupations with black men's experiences of racism, from Louis Armstrong's rendition to Ellison's signifying text in *Invisible Man*. However, Toni Morrison recuperates the original protest song with her own novel, *The Bluest Eye*, which restores the original concerns of colorist sexism, while Claudia the narrator heralds the power of blues singers such as Bessie Smith, Ma Rainey, and Billie Holiday— captured in her mother's voice—when she proclaims: "I looked forward to the delicious time when 'my man' would leave me, when I would 'hate to see that evening sun go down . . .' 'cause then I would know 'my man has left this town.' Misery colored by the greens and blues in my mother's voice took all of the grief out of the words and left me with a conviction that pain was not only endurable, it was sweet" (Morrison 1970, 26). As is often the case, by the time the expression of suffering, grief, and rage finds musical release, the original "pain" dissipates and becomes a thing so sweet it transcends suffering.

Nonetheless, is this an example of the "subaltern cannot speak because the subaltern cannot be heard" (Spivak 1988, 301)? Even as black women's bodies are "already colonized" in the public sphere, their voices often tell a different story when raised in song, for they complicate the "politics of silence" by presenting a multilayered and emotionally rich vocality that confounds the listening audience as much as it speaks a subaltern language that inspires marginal voices to emerge from their historical void. Once this silence has been broken, their singing becomes an act of resistance, voicing feminist protest and altering the political soundscape. What remains in question is how (and if) these voices maintain their power when they become a musical spectacle on a reality TV show.

RACE, GENDER, AND THE POLITICS OF VOCALITY

The legacy of black women's "protest" singing is long and varied. Whether we point to the quintessential protest song that was Billie Holiday's "Strange Fruit"—recorded the same month that Marian Anderson performed at the Lincoln Memorial on Easter Sunday, April 9, 1939, in the wake of the Daughters of the American Revolution refusing to permit her performance at Constitution Hall[4]—or to Fannie Lou Hamer's televised singing of "Go Tell it On the Mountain" during the civil rights movement, this musical resistance has a rich vocabulary and tonality. More recent protest performances include Mary J. Blige's duet with Bono on U2's song, "One," during the *Shelter from the Storm* Hurricane Katrina Relief telethon in 2005, which Daphne Brooks describes as "a sage, sobering, brutally honest summit between two figures who are iconographically conjoined in America's miscegenated history . . . here rewritten and recast in the voice of black female difference and resistance" (Brooks 2008, 191).

A similar "black protest" can be heard in Quincy Jones and Lionel Richie's remake of USA for Africa's "We Are the World" on the song's twenty-fifth anniversary—both as an updated benefit for victims of the Haitian earthquake on January 12, 2010, versus the Ethiopian famine victims in 1985, and a tribute to the late Michael Jackson. This remake—replete with auto-tuned vocals and a rap bridge—invokes black survival, strength, and national pride: a stark contrast from the pitiable images, conjured by the original song, of emaciated African bodies, thus requiring the imperialist intervention of well-to-do Americans called upon by the chorus of our musical heavy hitters to do our moral missionary duty of charity. On the other hand, never has hip-hop, a musical genre just emerging in the mainstream conscious back in 1985 and known for refuting black victimhood, been put to better use in a popular song than in this remake, which mobilized again for charity toward a black nation.

The aggressive delivery of the rap by the deep, gravelly voices of the black male rappers, followed by the unearthly yelp by Haitian-born hip-hop artist Wyclef Jean, grounds the song in the stark realities of Haitian survivors and bridges the two countries in a diasporic discourse of solidarity. That these black masculine voices are then followed and amplified by black female money-note vocals, offered by the church-trained Jennifer Hudson and the gospel duo Mary Mary, while the chorus builds with another layer of Haitian voices singing the refrain in Creole French, indicates how men and women, African Americans and Haitians, and the global North and global South can

literally build on each other's strengths to create community. What we hear in this remake, then, is a narrative of black power and survival intersecting with multiracial solidarity expressed by others around the world in the wake of disaster. Regardless of the realities that do not reflect this, at least the musical delivery keeps hope alive, as music has always done throughout the black diaspora.

Beyond inspirational music, the sentimental space of *American Idol* would also contribute to similar "protest songs," perhaps best exemplified, some might even say caricatured, in the divaesque anthem, "And I Am Telling You I'm Not Going," in the musical *Dreamgirls*, immortalized by Broadway Tony winner Jennifer Holliday before it was first performed on *American Idol* by Season I fourth place finisher Tamyra Gray and then later aggrandized in the 2006 movie version of *Dreamgirls* by *American Idol* Season 3 contestant Jennifer Hudson, who portrayed the scorned diva character, Effie White. In many ways, the critical acclaim Hudson received for playing this role—including a Best Supporting Actress Oscar—is not only tied to her performance of this "protest" song in the movie but also to her role on *American Idol,* when she was famously voted off in seventh place while other, lesser talented contestants outlasted her.

The TV show deliberately staged Hudson's ouster to heighten the racial spectacle in which she and two other black female contestants, Fantasia Barrino (who won that season) and Latoya London, were the bottom three contestants who received the least number of votes that week. When even pop star Elton John, who had appeared that season as a guest "mentor" for the contestants, decried this state of affairs as "incredibly racist," we might recognize how music becomes a political arena in which race and gender not only have a distinct "sound" but a distinct audience. What do such musical expressions and reception reveal about a "national" sound?

It would seem that black vocality—both female and male voices, but especially and iconically portrayed in the black female vocalist—provides the "rebellious," "suffering," and "survivor" spirit that America proudly heralds as a national persona. However, this spirit is also captured in other "white" musical genres—rock, heavy metal, and country music. Interestingly, soul singing and country music singing are often racially pitted as flip sides of the same coin, perhaps because they both share roots in the blues but also because they represent distinct racially segregated American groups (the "soul" black audience versus the "country" white audience). As such, a soul singer such as Whitney Houston can be positioned in the patriotic display of America's military power with relative ease—as represented by her performance of the national anthem at the militarized sports pageantry of the Super Bowl in

1991 during the nation's engagement with the Persian Gulf War—while the similar placement of the Dixie Chicks at the Super Bowl in 2003, in the midst of the war on terror (and only months before the war in Iraq began), works just as easily in staging a "national sound."

Nonetheless, the raced and gendered expectations for black female "protest" contrast with expectations for white female "acquiescence," which were powerfully dramatized in the blacklisting of the Dixie Chicks after lead singer Natalie Maines infamously expressed "shame" that then president George W. Bush "was from Texas" at a London concert on March 10, 2003, only a matter of months after patriotically singing the national anthem at the Super Bowl. As Katz Claire argues, "The Dixie Chicks were not simply called unpatriotic, they were called 'Dixie Sluts' and 'Dixie Bitches,' terms reserved only for women and, in particular, women who, in almost every case, act contrary to the prescribed passive role assigned to them" (Claire 2008, 151). The Dixie Chicks' verbal protest against the war in Iraq may have proven too strong for their country music–listening audiences, and perhaps would have been better greeted in a song—hence the chauvinistic "shut up and sing" remarks hurled at them.

However, at the core of the outrage against the Dixie Chicks emerging from the conservative, country music audiences—as Claire aptly describes—was an expectation for both "patriotic" and "obedient" subservience from an "all-American" white female singing group, even though the Dixie Chicks have been adept at singing various protest songs—from the murder-advocating anti–domestic violence song "Goodbye Earl" to their unapologetic "Not Ready to Make Nice" in the wake of the censorship they experienced. The imagery of straitjackets, white corsets, and white picket fences employed in the video for "Not Ready to Make Nice" illustrates the ways that the Dixie Chicks are cognizant of their transgression from passive "white American femininity," which made them targets for the rampant misogyny tossed their way.

This is not to say black female vocalists would not be similarly targeted if they made similar "unpatriotic" comments. However, there is a vibrant tradition of protest in black music, as I have already documented, which would position such vocalists as already existing outside the national narrative—to reiterate Griffin's point. When I once taught both Dolly Parton and Whitney Houston renditions of the heartwrenching popular ballad "I Will Always Love You," students invariably described Parton as a "passive victim" in comparison to the "strong survivor" they interpreted Houston as audibly representing. Of course, such interpretations point to the vocal power of Whitney Houston, as her soul-singing spin on the country ballad not only turned the song into an international standard but made it her

signature song, especially when it was heard ubiquitously in the wake of her untimely death on February 11, 2012. These representations of female vocality certainly contribute to our national narratives on the role that race plays in constituting women's bodies.

This too gets dramatized on *American Idol* when Fantasia, who overcame the racial controversy of Jennifer Hudson's ouster, captured the *Idol* title in 2004. She became the second black winner of the show in its then short three-year history, and as a sort of reconciliation, Fantasia sang the coronation song, "I Believe," written by Tamyra Gray, whom many viewers of *American Idol* believed was also ousted prematurely, like Hudson, during her season. Fantasia's gospel spin on the sentimental song salvaged it as a sort of "protest song," in which the lyrics, which spoke of dreams and overcoming obstacles, recast her in the role of a "survivor" of "America's" biased voting, even though her win simultaneously positioned *American Idol* as a legitimate vehicle in which anyone, regardless of one's race, gender, class, and sexuality, could become the "next American Idol."

However, a year later, the next American Idol winner, Carrie Underwood, provided a stark contrast. Unlike Fantasia, who was removed from the markers of white femininity and who was a teenage mother, illiterate, and edgy with her "street cred," country twang, and quirky vocals, Carrie Underwood sang country music with flawless vocals and looked like a blond "all-American" beauty pageant contestant. If, the year before, "America" proved they were not "incredibly racist," as Elton John accused them of being, by voting for Fantasia, they seemed to have shifted from the unconventional contestant that Fantasia represented to the more traditional celebrity-type winner that Underwood appeared to be. Underwood's post–*American Idol* music career, which includes multiplatinum music sales and mainstream popularity beyond the country music audience, also confirms this widespread acceptance of a conventional portrayal of the "all-American" American Idol.

MOBILIZING DIVERSITY AND THE "SOUL SINGER"

During the first seven seasons of the show, black female contestants often ranked highly and placed among the top five remaining contestants. As previously mentioned, during Season 1, Tamyra Gray placed fourth, while the expectation was that she would make the finale with Kelly Clarkson. Some even expected her to win that season. Instead, Kelly Clarkson, perhaps in the tradition of Elvis Presley who was once described as "the white boy who can sing colored," became the "white girl who can sing diva," *diva* becoming the moniker for just about every black female contestant,

whose soaring powerhouse vocals emulated great "diva"-like songstresses, from Aretha Franklin to Whitney Houston to Mariah Carey to Mary J. Blige. Interestingly, after winning *American Idol*, Kelly Clarkson's musical career blossomed once she sidestepped the adult contemporary/ R&B soul genre to pursue the more mainstream rock-pop genre where she would function less as a derivative Celine Dion or Whitney House and, instead, followed a musical path reminiscent of other young white female vocalists, such as Alanis Morissette, Avril Lavigne, and Pink. In contrast, Tamyra Gray had to compete with more established black female vocalists, including Mary J. Blige, Mariah Carey, and Beyoncé, and has had more success on Broadway—curiously, a musical path that *American Idol's* most infamous judge Simon Cowell has derisively dismissed as a legitimate music career. As an aside, Simon Cowell represents a different sort of vocality—he is the speaking, as opposed to singing, voice of authority, whose British accent recalls an imperialist English "father" tongue, which is why, when he passes judgment—in comparison to the other judges (Randy Jackson, an African American musician, and Paula Abdul, a woman of color pop star and then regular judge since the inaugural season)—Cowell's acidic, brutally honest comments hold more weight.

In the wake of that first season, other black female "divas" included Kimberly Locke during Season 2, Fantasia who won Season 3 alongside famously booted-off contestant Jennifer Hudson and Latoya London, Vonzell Williams during Season 4, Paris Bennett during Season 5, the trio Melinda Doolittle, Lakisha Jones, and Idol winner Jordin Sparks during Season 6, and Syesha Mercado during Season 7, who was the last remaining female contestant in a year when the male contestants were wildly popular. During Season 4, the winner Carrie Underwood avoided comparisons to black female vocality by singing country music, which fit with her image of the all-American girl and who met with tremendous success when *American Idol's* management team, 19, turned her over to Nashville's music scene. However, while such contestants are viewed as offering something new and unique to *American Idol*, black female contestants, most notably Season 6's phenomenally talented Melinda Doolittle, a professional backup singer, kept receiving comparisons to Tina Turner, Gladys Knight, and a host of other heavy hitters, and were invariably held to a higher standard. Somehow, they became the measuring stick for everyone else, precisely because such vocals are guaranteed to shore up everyone else's—hence the reason we often find black women as backup vocalists, even on this show.

The first white male winner, the gray-haired and bombastic performer Taylor Hicks during Season 5, was one who appropriated soul singing, hence relying on a voting fan base called the "Soul Patrol," while the first

male winner, African American soul singer Ruben Studdard, recalled an R&B stylization reminiscent of Luther Vandross that allowed him to win Season 2. However, Studdard's image as a heavyset man perhaps hindered his mainstream success, while the white male runner-up, Clay Aiken, enjoyed platinum sales and widespread popularity. Taylor Hicks, on the other hand, is often viewed as a "failure" because he became the first *Idol* winner who did not reach platinum sales with his debut album—an unfair expectation foisted on *Idol* winners in the wake of the runaway success of Idols Kelly Clarkson and Carrie Understood, both of whose gender facilitated their acceptance as winners of a "cheesy" TV show (since female vocalists in general are not taken as seriously as male musicians) while their race and youth enabled mainstream access and acceptance (something that black *Idol* winners Ruben Studdard, Fantasia, and Jordin Sparks have not found beyond the R&B/urban music market). Yet, Hicks's fellow white male finalist of Season 5, Chris Daughtry, dominated music charts with his pop-rock band and persona. Despite the reliance on the musical spectacle of "soul singing" on *American Idol*, the music industry tells a different story with the mainstream dominance of pop music, rock, hip-hop, and country while R&B soul remains either a niche and segregated market or a submerged category under the hip-hop umbrella.

The edgier "rock persona" reflected by Chris Daughtry was crafted onto Season 7's *Idol* winner David Cook, who defeated the very popular and gorgeously voiced David Archuleta. While Cook's more mature image edged out the younger, softer soul-influenced vocal style of Archuleta, his success in the competition was based on his creative rock-based appropriation of soul music. Interestingly, Cook, who won his season by being branded as unique and risky, received this reputation by turning pop R&B hits such as Lionel Richie's "Hello," Michael Jackson's "Billie Jean," and Mariah Carey's "Always Be My Baby" into rock ballads. On a show that featured soul songs as a regular staple, it is not surprising that a white male contestant would then be praised as "edgy" and "original" when he spun black music and rearranged it for a "white" aesthetic (such as rock or emo), while soul-singing contestants such as Archuleta, that season's runner-up, and third-place finisher Syesha Mercado were often dismissed for either sounding "boring" or "bringing nothing new."

In effect, Cook mobilized "soul music" for rock music expression and, consequently, hinted at a troubling history of the "cultural theft" of black music by white musicians. This is especially problematic when we consider how this practice enabled him to triumph over the "soul-singing" contestants. These particular raced and gendered power dynamics are often overlooked

in the competition. However, they do beg the question of what constitutes "difference" and the politics of inclusion. Not only that, but have game changers, represented by the likes of Carrie Underwood and David Cook, subtly altered the chances of another Ruben Studdard, Fantasia Barrino, or Jordin Sparks from winning *American Idol?*

CULTURE WARS AND DIFFERENT KINDS OF "DIVAS"

Complicating this popular body politic is the intersection of race and ethnicity, spectacularly dramatized by the wildly popular and sexually ambiguous Sanjaya Malakar, a charismatic South Asian-American teen contestant during Season 6. Offering a new representation via the brown male body, underrepresented on *American Idol,* Malakar did not exactly represent "model minority" status with his mediocre vocals. Curiously enough, his less than stellar singing voice and his famous long hair met with an abrupt end when he was voted off the show the same week that the Virginia Tech shootings occurred in April 2007. We could say that, during such a solemn week, his shtick was no longer funny, but who knows how much of the Asian identity of the killer also led to Malakar's demise when he placed seventh in the competition (the killer's birthplace in South Korea was played to the hilt in news coverage even though he migrated to this country at age eight and became a naturalized citizen).

Such emphasis on the killer's "foreignness"—combined with our ridicule of Sanjaya Malakar—reinforced how our culture refuses to affirm anything beyond a white-centered concept of Americana, shored up by our fascination with black entertainment, a presence that defines and frames the boundaries of whiteness. Added to this is the reduction of race relations as a primarily black-white issue with everyone else functioning as "illegals" or "foreigners." On the flip side, this same image of ethnic difference can be erased altogether, as illustrated during Season 7 when three of the Top 4 finalists—David Archuleta, Jason Castro, and Syesha Mercado—were Latin@s but whose ethnic identities were neither referenced nor recognized among TV viewers or in the media. Instead, they were cast as either "white" (in the case of Archuleta and Castro) or "black" (in the case of Mercado).

I raise this issue because, the season before, when the Top 4 finalists on *American Idol* included three black girls and a white boy, many headlines queried if we would have an all-black finale for the first time. We did not, and as it turned out, of the four finalists, the mixed-race black contestant, Jordin Sparks, and the white contestant, Blake Lewis, made the finale. And, incidentally, the "all-American" white guy (David Cook) beat out the Latin@s

the following season. Interestingly, Blake Lewis, like David Cook, engaged in musical appropriations of black culture by incorporating hip-hop beat-boxing in his vocal styling, which garnered for him the "original" and "innovative" label, much like Cook.

Maybe race, gender, and ethnicity had a hand in voting decisions, maybe not. However, there does seem to be a distinction made in which blackness is a recognizable "difference" that media calls our attention to and which whites can co-opt for their musical expressions as signs of "innovativeness," while Latinidad is often times made invisible, or "heard but not seen" (if one has an "accent" or speaks Spanish, then Latinidad becomes recognizable). During Season 8, for instance, Puerto Rican contestant Jorge Nuñez's accent became an issue on the show and, as a result, he failed to advance to the finals. However, Allison Iraheta, whose Latina identity was less pronounced, advanced farther as a fourth-place finisher. Talent may shape these results, but how much do these issues bear on our sense of what constitutes being an "American" Idol?

Beyond the spectacle of race and ethnicity is the spectacle of sexuality, and far flashier than Sanjaya Malakar was Adam Lambert, Season 8's runner-up. More than Lambert appearing on *American Idol* as the first "out" gay contestant was the show's amplified script concerning his sexuality. There seemed to have been an expectation that—if Lambert functioned as a gay contestant, simply because of his attempts at gender-bending performances, replete with vocal screeching, painted nails, and eye makeup akin to the '80s glamour rock band era—such flamboyant performances were indicative of what a "gay Idol" would look and sound like. He appeared "different" in a way that generated buzz for the show, even though he had lost the title—after the show's script created the expectation that no one else was worthy to win.

Lambert's "difference" also allowed for a backlash. Not long before the finale during his season, Bill O'Reilly's ultraconservative show—which airs on the same Fox network as *American Idol*—fabricated a narrative about the "culture wars" represented by the final two white male contestants, Lambert and eventual winner Kris Allen, who was billed as a "Christian" contestant from Arkansas (a curious identity to highlight in these "culture wars," considering that the majority of *Idol* winners have always been church-trained and churchgoing contestants but never openly identified as such until this moment) and who became the subject of a "conspiracy theory" in which AT&T sponsored a phone drive in his hometown to generate enough votes for his win. During this time, the popular culture magazine *Entertainment Weekly* also featured Lambert on the cover with the question: "Is Adam Gay?" Such prevalent media discourse suggests that *American Idol* was equally invested in

the spectacle of gayness around Lambert and in the potential backlash that might occur with the more conservative elements of *American Idol* TV viewers.

To some extent, this media spectacle garnered enough interest in the show because numerous conversations occurred that questioned whether or not Lambert lost the *Idol* title because of his sexual orientation. Because such popular voting is difficult to prove, it is safer to point fingers at the TV show for generating interest in this "hot button" issue if for no other reason than to benefit from the spectacle of difference—a spectacle that eventually reverberated in interest in another Fox Network show debuting that year, *Glee*, a TV musical focusing on racial, ethnic, able-bodied, and sexual diversity. There is always a market for "difference," it seems, a lesson that *American Idol* has learned all too well during its years on TV—drawing as it does from an illusory politics of inclusion and "reality."

By the time Season 9 rolled around, however, white male contestants had won the *Idol* title for three consecutive years, thus returning us to a normative representation of "Americanness." Because of this, some in the media have pointed to the voting demographics, suggesting either a rise in "fangirl" voters—including "moms and daughters," to cite music critic blogger Lyndsey Parker—or in the solidification of a conservative mega-church Christian voting base.[5] Indeed, as previously mentioned, a significant number of *Idol* winners and finalists, such as Ruben Studdard, Fantasia Barrino, Jennifer Hudson, Carrie Underwood, Chris Daughtry, Taylor Hicks, Jordin Sparks, Melinda Doolittle, and Kris Allen, all have ties to the church.

If TV voters have changed in this direction, then perhaps contestants such as Crystal Bowersox, an early frontrunner and eventual runner-up for Season 9, no longer stand a chance at winning. Bowersox's appearance on *Idol* had framed the female contestant beyond the conventional portraits of "power belter," "pageant queen," "eye candy," or "diva." She also offered a different spin on blonde, "all-American" womanhood in comparison to the power-belting beauty queen depiction of Underwood. In short, Bowersox may be less the girl next door and more the girl on the other side of the tracks—a role usually reserved for a woman of color.

Moreover, Bowersox embodied a really-*real* contestant for reality TV. She was the singer-songwriter "artist" with a guitar and dreadlocks, suggesting a grungy Janis Joplin throwback with her soulful vocals—the hint of black female vocality—and women's empowerment lyrics. She was also a single mother—like Fantasia—but here white privilege lessened the impact on conversations about Bowersox's ability to be a "good role model" when she admitted to looking for a bigger paycheck to support her musical gig and infant son. Behind the guitar strumming and bluesy voice, one detected

her heartbreak and her working-class struggles in her economically hard-hit hometown Toledo, Ohio. Bowersox also displayed a "survivor" persona as a woman with disabilities (diabetes, in her case) without health insurance, which she unabashedly shined a light on in interviews.

Curiously, Season 9, which was billed as a "girl's year," featured female contestants voted off week after week. Similarly, most of the contestants of color faced the same fate early in the season, thus leaving the impression that "diversity" and the spectacle of difference had run its course after nine seasons. Additionally, the show started to slip in ratings, which is also inevitable after a long run on television. Despite such race and gender discrepancies in the representation of contestants, Bowersox advanced to the season finale on the strength of her talent and performances.

Also relating to these gender representations in the later seasons of *American Idol* is the disappearance of the black female "diva" as a major contender in the competition. As I had previously mentioned, the show was shaped by a black female vocality in its early years. Following Season 7, however, black female contestants were no longer featured among the Top 5 finalists. Because black male contestants such as Michael Lynche in Season 9 and Jacob Lusk in Season 10 advanced in the finals, it became easier to overlook this disappearance since there was still a black vocal presence on the show—even though a contestant such as Lynche admitted that he altered his interests in pop music to fit the R&B persona he was expected to embody in order to advance in the competition, while Lusk's sexual ambiguity and dramatic gospel runs intuited a "diva" presence.

Moreover, the "diva" presence of black female contenders was often relegated to the auditions segments in which significant numbers of caricatured and comical wannabe "divas" proliferated. This too is indicative of *Idol's* reliance on black female vocality, in which the show had become so constituted by this style of singing that it could turn it into comedy. Nonetheless, as female contestants and contestants of color began to be voted off in early stages, viewers of the show had begun to comment on the inevitable "white guy with guitar" *Idol* winner, as had occurred with Season 10's teen country singer Scotty McCreery and Season 11's Phillip Phillips. Considering that black female vocality in pop music had also become either imitative (think of the styles of British pop singers such as the late Amy Winehouse, Adele, and Jenny J) or reductive "hooks" in hip-hop and electronic dance hits, perhaps it was only inevitable that the black female bodies originating this sound, much like the disappearing sixties girl groups after the "British Invasion," would become, once again, marginalized and "voiceless."

CONCLUSION: ILLUSIONS OF INCLUSION

Despite our exposure to *American Idol*–style diversity, our nation's retrogres-
sive responses to various crises featuring racial and ethnic otherness—from
September 11 to Hurricane Katrina to the Duke Lacrosse rape scandal to
the Virginia Tech massacre to Don Imus to anti-immigration rallies—seem to
reinforce the "new racism" of the twenty-first century: a racism that insists
that we are all "color-blind," thus ignoring the systemic racial hierarchies that
continue to advance white supremacy or normalcy while nonwhite spectacle
is always viewed as "different" or "unAmerican." However, if we recognize
the hyperreality of a reality TV show such as *American Idol*, we may note how
the visions created of our multiracial society have reinforced in the public
imaginary a nation that has come to accept "diversity" and the possibilities
for the "best contestant," regardless of color, gender, ethnicity, and sexuality,
to rise to the top. Despite various controversies, a respectable and talented
contestant eventually seems able to capture the *American Idol* title.

 This idyllic construction of our "American Idol" is one that I call an
illusion of inclusion. Yet, this illusion can certainly be superimposed onto
other hyperreal events, such as the voting for a U.S. president. And, while
these public representations do not indicate the progress of the "Real" (that
is, the lived realities of racism and other oppressions in America), they do
lull us into accepting the "hyperreal" of what many like to call a "postracial
society." We must question this imposition of the imaginary map on the
desert of the Real.

Chapter 2

Understanding "The New Black"

Destabilizing Blackness in the New Millennium

Weeks before the historic election on November 4, 2008, of Barack Obama as the first black president of the United States, another phenomenon took place. Here, I refer to the debut of the music video for "Single Ladies (Put a Ring on it)," Beyoncé's second single from her third solo album, *I Am . . . Sasha Fierce*. Not long after the video's October release, numerous copycat videos emulating Beyoncé's dance moves uploaded onto the social network site YouTube, thus beginning what could arguably be called the first Internet-based dance craze.

Significantly, Beyoncé's video premiered on MTV's *Total Request Live*, which ended its ten-year run on television the following month. Giving way to the new demands of digital culture, MTV's youth-influenced show was ironically "killed by YouTube" in a similar way that MTV once bragged thirty years ago of "video [killing] the radio star."[1] That Beyoncé's video found "second life" in cyberspace demonstrates her savvy sense of cultural relevance, as well as Big Media's efforts in marketing pop stars through crossover multimedia platforms.

As part of the origin narrative of the "Single Ladies" video, Beyoncé admitted on the show, *106 and Park*, BET's equivalent to MTV's TRL, that YouTube provided the inspiration for her immensely successful music video. YouTube, a global social network of digital video file sharing on the Internet, begun in 2005, offers a vast repository of amateur videos, archives of film and television programming, popular music videos, and original short features and documentaries. In the vein of communal sharing and participation, YouTube

also allows Internet users to engage in video remixes, audio "swaps," video responses and comments, and inserted annotations.

It is this same YouTube that contributed to Barack Obama's iconic status among the "wired generation" during his 2008 presidential run, from Amber Lee Ettinger's satirical, R&B-inspired "I've Got a Crush . . . on Obama," to the viral video[2] mash-up of Obama's "Yes, We Can" campaign speech offered by Will.i.am of the Black Eyed Peas. This democratized and participatory "free speech" haven, which allows for any and every kind of video sharing—political and otherwise—serves the purpose of highlighting the inclusivity of "You," whoever that universally imagined average Internet user might be. However, it was not long before Big Media began to encroach on this site.

It is worth noting that the "Single Ladies" video became a phenomenon at a time when Google began to enforce copyright laws on YouTube after partnering with big business, which attached advertisements on various uploaded videos and throughout the Web site. The viral video sensation that inspired the choreography in Beyoncé's video includes a remix of the rap group Unk's "Walk It Out" with video footage of Gwen Verdon's 1969 "Mexican Breakfast" dance, choreographed by Bob Fosse, on the *Ed Sullivan Show*. Because the original Verdon video was pulled from YouTube, due to copyright infringement, the viral remix that took its place swapped the original music featured on the show with Unk's song and, thus, combined Fosse's sixties choreography with millennial hip-hop in a way that opened up creative possibilities for vernacular dance and musical reappropriations, which Beyoncé exploited spectacularly. Emulating the Fosse choreography, a leotard-wearing Beyoncé and her backup dancers Ebony Williams and Ashley Everett reframed the moves through Ebonics-style and queer-influenced signifying of black femininity: from neck rolls to "talk-to-the-hand" gestures to signature video-vixen-style gyrations of Beyoncé's "bootylicious" body.

Set against a white backdrop, the three black female bodies on display in this stark black-and-white video more than highlight black female sensibilities appropriated by black gay choreographer JaQuel Knight, who borrows from the J-Setting dance, a then-popular dance among Atlanta's black gay club dwellers, which signifies on the choreography of the Prancing J-Settes, an all-black female dance troupe from Jackson State University in Mississippi. As a result, the video presents the black female body reappropriating black femininity even as it engages in queer subtext. Far from muting creative potential, Big Media redefined its parameters.

The wider context for "Single Ladies" are the dilemmas of the contemporary "single black female" in the United States, who is the least

likely of all adult American women to be married. From Terry McMillan's *Waiting to Exhale* to Lisa Thompson's off-Broadway play, *Single Black Female*, to Helena Andrews's *Bitch Is the New Black* (marketed as a black female version of *Sex and the City*) to the Queen Latifah–produced TV show taking its title from Beyoncé's single, to the single status of high-profile black women— including TV personality and mogul Oprah Winfrey and former secretary of state Condoleeza Rice—the specter of black "single ladies" had become hyper-visible. This figure also functions somewhat as a constructed social "pathology" (both the middle-class "single lady" and her low-income "welfare queen"/ "baby mama" counterpart), either as "unmarriageable" in a white supremacist hetero-patriarchal society or in need of proper instruction within the black heterosexual arena on how to attain legal marital status, as dictated by the mores of what Mark Anthony Neal calls the "Black Bible Belt."[3]

That Beyoncé closes her video by flashing her $5 million wedding ring confirms the video's narrative as the "single lady's" success story on "how to marry a millionaire" while simultaneously calling attention to the highly performative script of the video. Even then, this performative gesture, in which her left hand bearing her "ring finger" is donned in a mechanic glove—hence suggesting a bionic-type hand—might offer a different critique of "Stepford Wife" robotic submission. Enticing her male onlooker with her voluptuous body, Beyoncé as Sasha Fierce quips, "If you liked it then you shoulda put a ring on it," at once harking back to black grandmother wisdom of yesteryear—"Why buy the cow when the milk is free?"—while spinning this wisdom through the counterpoint of feminist empowerment that supports the single woman's right to her own body and her own sexual desires.

Nonetheless, the song's refrain also suggests that marital status, apart from robotic submission, brings with it ownership and property rights, as the song's female protagonist responds to her ex-partner's outrage, upon seeing her with another man, by reminding him that marriage is the surest way to fully possess her body if he is so inclined to "claim" her for himself. In maintaining her respectable offstage persona, the married Beyoncé Knowles-Carter contrasts with her alter ego, the single "Sasha Fierce," a seductive yet sophisticated "video vixen,"[4] whose hypersexual body is something of a palimpsest, her overexposed presence remaining a fixture in the ubiquitous hip-hop music videos that surround the hype and status of rappers, including Beyoncé's husband Jay-Z and others of his ilk. As a result, the intrusion of Beyoncé's giggling and display of her wedding ring at the video's end is a reminder of her ability to transcend the disreputable video vixen's body and, thus, leave Sasha Fierce behind on the stage.

I open this chapter with the scenario of Beyoncé's popular music video, set against a historic moment in our culture, because of what it reveals about our immediate history moment and how prominent displays of black bodies continue to get mobilized in our media, new and old. Certainly, Beyoncé's "Single Ladies (Put a Ring on it)" and other pop culture narratives tap into a number of latent desires and anxieties shared by the collective conscious of the millennial generation. However, they are also shaped by dominant culture's discourse of race, class, and gender hierarchies. Throughout this chapter, I ruminate on how race, class, gender, sexuality, and nationality intersect to frame and destabilize blackness in this new millennial age, creating "The New Black," a term borrowed from the fashion world that connotes the latest trend, used here in the context of race, versus "color," to address contemporary trends in black identities.

DESTABILIZING RACE AND GENDER

To be sure, the "Single Ladies" phenomenon emerged at a time when single heterosexual black women in the United States needed affirmation of their sensuous power, while also maintaining hope that their marital status would change—as symbolized by the promise of Beyoncé's flashing wedding ring and, within the political realm, in black women's collective excitement over the ascendency of Michelle Obama to the rank of First Lady with her family (including her husband, two daughters, and mother) residing in the White House.[5] However, the emergence of copious do-it-yourself "Single Ladies" YouTube videos—from parodies to instructional manuals—speaks to a different articulation of power and appropriation. Most curious in this trend were the number of white male appropriators who emulated the black female sensibilities expressed in the video's choreography, whether we look to Justin Timberlake and his leotard-enhanced parody aired on the November 15, 2008, episode of *Saturday Night Live* or Joe Jonas of the Jonas Brothers offering his own spin on the dance, or most spectacularly in the viral video sensation of Shawn Mercado—dubbed "Heyoncé"—mimicking every step of the choreography while wearing a revealing jock strap in the "privacy" of his bedroom, broadcast on YouTube. Indeed, these conflations of white straight and gay male racial cross-gender performances—perhaps epitomized on Fox's TV show *Glee*, which featured an episode depicting an openly gay white character coaching his straight football teammates on the high-kicking jinks of the "Single Ladies" choreography to enhance their masculine prowess of the game[6]—have destabilized the essentialist readings of race, gender, and sexuality that were embodied in the original narrative.[7]

Various scholars who have weighed in on gender and racial differences often warn of essentialist understandings of these categories and the identity politics that form in response. Yet, it becomes difficult to not "fix" the subject when examining the power dynamics at play. For example, when analyzing the popular trend of white men—gay or straight—appropriating a performance embodied by a black female pop star such as Beyoncé, should we only view the mimicry through the veneer of playful cultural exchange—an ideology of "effacement" that Susan Bordo characterizes as a "new, postmodern imagination of human freedom from bodily determination" (Bordo 1993, 245)? Or, do these bodies fail to transcend their history, political representation, and social power? I am of course referring to how white male bodies operate from a position of privilege and power in comparison to the black female body (regardless of her mainstream acceptance, fame, and economic success)—not just in the historical legacy of slavery, colonization, and legalized segregation, but also in contemporary displays of sexual imbalance. Hence, Justin Timberlake's SNL cross-gender parody of Beyoncé in her stylized, leg-revealing leotard, which also includes a segment in which he playfully pats Beyoncé on her celebrated rump, recalls the legacy of "miscegenation" and white male access to black female bodies, as well as Timberlake's recent stripping of Janet Jackson at the halftime show of the Super Bowl in 2004 and his own disavowal of wrongdoing when he famously blamed the mishap on Jackson's "wardrobe malfunction." How, then, do these playful appropriations reinforce the norms around race and gender?

The very acts of racial passing and cross-dressing are fraught with power imbalance. In his research on the history of blackface minstrelsy, Eric Lott illustrates this through the example of white men's blackface cross-dressing performances of the black "wench" character: a stereotype designed to highlight the impossibility of black women's femininity through their "masculine" assertions, aggressiveness, and undesirability. As Lott argues, "'Acting the wench' was wildly popular not only, I would guess, because of the riotous misogyny it indulged. . . . One might posit here an unsteady oscillation in 'wench' acts between a recoil from women into cross-dressing misogyny and a doubling-back from the homoeroticism that this inevitably also suggested, with the misogyny serving as a cover story for or defense against the homoerotic desires aired in the process of achieving it" (Lott 1995, 164).

Adding to Lott's critique is the obvious racial fear and loathing that complicates this sexual "desire" for the black body—male or female. In mobilizing fantasies of black gender inversions of the heteronormative paradigm, white bodies make their own meanings of gender norms by

reaffirming their supposed racial superiority through their mockery of black "deviance." Updating this performance are black male entertainers who engage in similar depictions of black women's impossibly feminine body, from Flip Wilson to Eddie Murphy to Martin Lawrence, Tyler Perry, and a host of other black male comedians. As bell hooks has argued on the specter of the black cross-dresser:

> They seemed to both allow black males to give public expression to a general misogyny, as well as to a more specific hatred and contempt toward black woman [sic]. Growing up in a world where black women were, and still are, the objects of extreme abuse, scorn, and ridicule, I felt these impersonations were aimed at reinforcing everyone's power over us. In retrospect, I can see that the black male in drag was also a disempowering image of black masculinity. (hooks 1992, 146)

While Judith Butler has taken hooks to task for what she views as a heterosexist interpretation of queer performance, thus urging us to read cross-dressing performances as "internally unstable affairs of [being a man, being a woman] . . . always beset by ambivalence" (Butler 1993, 126), this notion of "destabilizing" identity ignores how these performances exist within a larger context of power and privilege. Hooks could do more to complicate her heteronormative stance, but there is no denying the racialized misogyny and homophobia elicited from these acts.

Consider, for example, not just white male appropriations of the "Single Ladies" video dance, which is another way that bodies in power enact their control over the transgressive, liberated body of the powerless (which the black dancing subject often represents), but also the Internet rumors that surrounded the darkest-skinned dancer in the music video. Accusations that cast Ebony Williams as a "cross-dressing man" erased her feminine subjectivity in ways that reverberate back to the "wench" minstrel show, as well as to Sojourner Truth's assertion of womanhood in her famous 1851 speech, "Ar'n't I a Woman?" in which her "masculine" body posed the question on behalf of white women's gender equality since white women's "ladylike" incompetence required black women's "strength" to advocate for feminist challenges to the gender status quo.[8] Subsequently, if black women's embodied "strength" and "aggression" serve the purpose of challenging gender oppression—via proof of our embodied abilities to counter femininity—then the opposite also occurs, in which this same "embodied resistance" gets read as "embodied failure" to attain womanhood. That Ebony Williams is the most

removed from signifiers of white female beauty in the "Single Ladies" video explains why she would become a target for "rumors" of transgender identity (i.e., "she's not a real woman"). When we connect this problematic reading of the black female body to a history of refuting femininity, especially in blackface and cross-dressing performances, such transphobic interpretations reinforce white heteronormativity.

Months later, such gender questioning resurfaced via another black body, the celebrated South African world champion runner, Caster Semenya. When then-eighteen-year-old Semenya captured the 2009 world championship title after winning the women's eight hundred meter race in Berlin, her competitors, the media, and, later, the International Association of Athletics Federation (IAAF) began to question her gender before subjecting her to a "gender test." These accusations, combined with the medical examination that later confirmed Semenya's "intersex" traits, outraged South Africans, who reacted with charges of racism and neocolonialism. Such international scrutiny on the black female body not only invited a visceral defense of Semenya's womanhood, but also recalled the horrific history of South African cause célèbre, Sara, or Saartjie, Baartman.

As Tavia Nyong'o observes in the following:

> The rush to compare Semenya to Saartjie Baartman, while obvious for nationalistic reasons, misses something crucial. Baartman was exhibited and castigated for what the imperialist eye took to be her [aberrant] femininity. A better comparison here would be to the many trans bodies . . . who have been disciplined and punished for their female masculinity. . . . The offensive but infectious "She's a man" humor all over YouTube . . . doesn't get us very far politically. But as a vernacular response it reminds me less of Baartman than it does of another nineteenth-century "freak," Peter Sewally, who was apprehended in women's attire in antebellum New York. Like Semenya, Sewally was also forcibly submitted to a genital examination to establish his "gender," and prints of him as the "Man-Monster" were displayed for sale, much as images of Semenya now circulate worldwide for cheap amusement. (Nyong'o 2009)

While Nyong'o raises critical points about the spectacle of "female masculinity" and rightly places Semenya within a history of transgender and intersex bodies, her critique ignores the way that the scientific inquiry into Baartman's anatomy—replete with posthumous examination of her genitalia—was also premised on proving her "womanhood," as her rumored

"Hottentot apron" raised questions about whether this "aberrant" feature was more phallic or if it indeed represented an overabundance of female sexuality.[9] Nonetheless, Semenya joins both Baartman and Sewally in a long list of black bodies subjected to a white imperialist gaze that subsequently labels them as "deviant."

DEVIATING NORMS

These controversial representations illuminate the ways that black bodies serve as extraordinary difference, whether this points to race "destabilizing" gender or to gender "destabilizing" race as fixed categories. Mostly, such displays remind us of how black bodies are still positioned as uncontrollable and unstable sites in need of control and surveillance, or what Foucault calls "the hierarchical, permanent exercise of indefinite discipline" (Foucault 1979, 217). Subsequently, if the gender of black female bodies is always in question, then male impersonations of their bodies both heighten their lack of femininity as well as assert a patriarchal gaze that depicts such bodies in need of "correction" and "discipline" toward feminine production.

This is evident, for instance, in the cross-dressing antics of Tyler Perry's popular "drag" alter ego, Madea, an "auntie"/black matriarch figure who occasionally slips out of his drag performance in various Madea stage plays and movies to comically assert with male authority, and by modeling outrageous and outlaw gender behavior through his cross-dressing performance, expectations for black women's behavior in heterosexual relationships that align with Christian virtues embraced by Perry's church-based African American audience. This strategy of "patriarchy in a skirt" is somewhat similar to Dustin Hoffman's cross-dressing turn in the 1982 movie, *Tootsie*, in which white women, rendered hopelessly incompetent in their femininity as they try to assert their autonomy and independence as "modern" women, rely on men "acting like women" to show them how to act with authority and self-assurance. That nineteenth-century white women also relied on the "masculine" Sojourner Truth to model for them strength and autonomy indicates how black women and the cross-dressing man, black or white, are interpreted as one and the same.

These patriarchal intrusions also include the reliance on gay men, who have appropriated the signs of femininity, to teach women how to become "better women," whether in the fashion and beauty industries or reenacted in the 1990 documentary film, *Paris is Burning*, which includes a scene in which the late Vogueing dance expert Willi Ninja instructs New York City women on how to move their bodies in more feminine ways. However,

these particular gay interventions become complicated, not just when the heterosexist gaze renders such gay male "instruction" as relatively harmless and amusing or merely subversive, but also when cultural appropriation takes place. Both hooks and Butler, whom I previously cited, wrote their critiques of cross-dressing in response to *Paris is Burning*, which stirred controversy when some of the film's subjects—low-income black and Latino gay and transgender men from Harlem, many of whom are no longer living—sued filmmaker Jennie Livingston for exploiting their lifestyles without monetary compensation. These battles highlight assumptions of power differentials and solidarity—the film's subjects assumed Livingston received wealth and fame off their backs, and the filmmaker assumed a shared queer identity—while also exposing hierarchies inherent in these politics of representation.

Such hierarchies become even more entrenched when pop stars such as Madonna enter the arena and transform local and subculture expressions into a mainstream phenomenon, as was the case with her 1990 "Vogue" single and music video, based on the Vogueing dance that emerged from the Harlem gay ball culture featured in *Paris is Burning*. Madonna reappropriates the signs of white femininity that formed the basis for mimicry within this subculture. Nonetheless, these power dynamics reassert the primacy of whiteness via Madonna's mainstream body.

To echo bell hooks, Madonna "deconstructs the myth of 'natural' white girl beauty by exposing the extent to which it can be and is usually artificially constructed and maintained" (hooks 1992, 159). However, as hooks further notes, Madonna's attempts at "blonde ambitions" are not so easily recognizable as artifice, due to her white body, in the way that they become obvious via the black body that dons blond hair and other white feminine signifiers—from Beyoncé to Tyra Banks to Nicki Minaj, even to cross-dresser RuPaul, whose "drag queen" reality TV show, *Drag Race*, serves as spinoff and parody of Banks's *America's Next Top Model*. Moreover, irony is at play since, as Dyer points out, "blondeness is racially unambiguous. It keeps the white woman distinct from the black, the brown, or yellow, and at the same time it assures the viewer that the woman is the genuine article" (Dyer 1986, 40), even though the most celebrated blondes, such as Marilyn Monroe, Jean Harlow, Madonna, and Lady Gaga, are natural brunettes. The question remains as to whether or not black bodies can in fact destabilize race and the supremacy of whiteness embedded in their "blonde ambitions" since their racial appropriations more than highlight the artifice of white femininity.

On the other hand, if Madonna's white female body reads less as artifice and more as the "real thing," we might also question whether her heterosexual performance of same-sex desire destabilizes our sexual categories

or reaffirms them. Fast forward from her 1990 "Vogue" posturing to 2003 when she returned to MTV's Video Music Awards show to pay homage to her controversial 1984 performance of "Like a Virgin." Offering a parody of a "first-time" bride in her 1984 routine, Madonna created a scandal by entering into public discourse the subject of female sexuality. By reemerging onto the MTV stage in 2003 via a giant wedding cake, clad in a stylish tuxedo-style body suit and top hat, while the younger pop stars—Britney Spears and Christina Aguilera—stand in as the new "brides" of pop culture (both singers offer their own sendup to "Like a Virgin"), Madonna revisits the subject and subverts the narrative, this time in her burlesque parody of a "bridegroom" in the heterosexual white wedding script. Performing her single, "Hollywood," Madonna calls our attention to gender performativity while also projecting a "female masculinity" reminiscent of early Hollywood film star Marlene Dietrich. Most likely, Madonna's cross-dressing tuxedo and the same-sex kiss shared with Spears and Aguilera signified on Dietrich's performance in the 1930 film, *Morocco.*

The controversy surrounding Madonna's same-sex kiss with the younger pop stars overlooked these more subversive elements. However, the "queer" hyper-visibility reflected in the performance of straight white female pop stars rendered invisible to mainstream audiences the queer body of color represented by hip-hop artist Missy Elliott, who entered the stage right after the infamous kiss and who appeared in masculine attire that heightened the artificiality of Madonna's own stylized "butch" wardrobe. This staged scandal recycles historical representations in which the presence of blackness serves as the subtext for the primary narrative of white sexual transgressions.[10]

We may further note with some irony that Hollywood stars such as Dietrich were rumored to have appropriated such cross-dressing performances from black entertainers in their era, including the cross-dressing, tuxedo-wearing Harlem blues singer Gladys Bentley, a forgotten figure in history who nonetheless became a major influence in black, gay, and modern jazz cultures. As Anne Stavney argues, "Unfixed, uncontained, Gladys Bentley was appealingly disruptive to her white audience at the same time that she spun dangerously out of their control" (Stavney 1999, 143). Perhaps it is no mere coincidence that Missy Elliott interjects her androgynous black body onto the spectacle of white feminine performance to recall this forgotten history that reverberates onto the contemporary scene.

Similar to Missy Elliott, and following in this history of cross-dressing in a tuxedo is quirky hip-hop artist Janelle Monae, who emerged onto the pop music scene in 2007. Wearing an extravagant hair pompadour reminiscent of soul music legend James Brown—and replete with dance moves emulating

the same artist—Monae's accompanying tuxedo is a tribute to the likes of Gladys Bentley and Marlene Dietrich; however, her saddle shoes seem to also pay homage to Michael Jackson during his *Off the Wall* music era, as well as a defiant appropriation of black masculinity at a time when other female pop stars—from Beyoncé to Rihanna to the outrageously femme Lady Gaga to self-proclaimed "Black Barbie" rapper Nicki Minaj—project hyper-feminine and hyper-sexual personas. By playfully donning "masculine" formal attire, Monae challenges her audience to "unfix" her black female subjectivity and to recognize her own musical prowess and predecessors, both in her appearances and in her neo-soul funk remixes. Indeed, Monae's sampling of Michael Jackson's "Rock with You" on her 2010 track "Locked Inside," as well as her "moonwalk" in the music video for her 2008 song "Many Moons," confirm her gender-bending ode to the master gender-bender that was Jackson in all his complex reworking and redefining of the black body.

Monae, like Elliott before her, maintains an aura of sexual ambiguity and artistic eccentricities that follow in the trajectory of other black entertainers, not just Michael Jackson, but also artists such as Grace Jones and Prince. We may even argue that such ambiguities are deliberately constructed to prevent their bodies from becoming "fixed" into raced and gendered categories and narratives. We certainly witness this in the more exaggerated "freakery" of Jackson.

In the wake of Michael Jackson's death, much was made to summarize the meaning of what was viewed as both an extraordinary and outrageous life. Most notably, the reports of Jackson as a "strange" and "bizarre" figure—plagued with child molestation charges, weird collectibles, and violable access to medical drugs outside the reach of ordinary citizens—seemed plausible due to the transgressions of Jackson's body itself, which gradually appeared whiter and more feminine in his later years. As John McWhorter opines in the *New York Times*: "To black people, the bleaching and chiseling was the tragic self-negating behavior of our wide-nosed boy singer with an Afro, grown up and lost. But whites have opened up to blackness to such an extent that they were often just as dismayed by the surgery. 'Cosby' became a runaway hit, Will Smith became Hollywood's biggest star, hip hop went mainstream, America elected a black president—and Michael died looking like Greta Garbo" (McWhorter 2009).

While there may be a kernel of truth in what McWhorter surmises, this fascination is hardly an acceptance of the black body and rejection of what is often viewed as Jackson's self-loathing behavior, which he indulged with his riches and fame. As David D. Yuan argues about his transformative body: "Jackson has constructed for himself a mask that calls attention to the

fact that it is a mask; one does not have to do that if the goal is simply to look white" (Yuan 1996, 379). I myself have not overlooked that it was not until Jackson started looking paler that he began to be vilified as a freak, a pervert, a monster, a pale version of the black bogeyman that has accounted for many primal fears in the culture.

This was not simply a manifestation of a tragic figure that both black and white Americans gazed upon with pity. Rather, the vilification was a visceral reaction to a body that literally transcended the color line, that refused to "know his place" or to "act like a man" in his more feminine transformations. This was a body that served as aspiration to *and* critique of whiteness, as well as an endeavor to destabilize black masculinity. In short, Michael Jackson offered a performative critique of the "passing for white" narrative, in which our "passing" protagonists often dwell among whites and adopt white culture while simultaneously growing more radical and antiracist in their message. It is incredibly ironic that Jackson's "impossibly white" transformations moved in tandem with his more radical expressions as he shifted from the safe messages of racial harmony in songs such as "We Are the World," "Heal the World," and "Black and White" to edgier antiracist songs, including "They Don't Care About Us" and "Stranger in Moscow," which protested racial hatred, dehumanization, and isolation.

During Jackson's heyday in the 1980s, James Baldwin wrote: "The Michael Jackson cacophony is fascinating in that it is not about Jackson at all. I hope he has the good sense to know it and the good fortune to snatch his life out of the jaws of carnivorous success" (Baldwin [1984] 1998, 828). Baldwin was not so much a prophet as he was a keen observer with his hand on the racial pulse of America. Therefore, he knew to be cynical in his response to the mainstream acceptance of Michael Jackson long before that same mainstream wave of love turned rancorous.

Baldwin died before witnessing Jackson's slow transformation from a brown-skinned man into a colorless, wigged-out, chiseled-faced anomaly. Still, the perceived transgression of race, gender, class, and sexuality through Jackson's body contributes to the "cacophony"—whether in the noise of adulatory screams or angry disapproval. However, as Baldwin argued, this too is not about Jackson: "All that noise is about America, as the dishonest custodian of black life and wealth . . . and the burning, buried American guilt." Consequently, the public construction of Jackson's "freakery," while partly of his own making, formed distortions that were designed to contain the subversive black body that dared to transcend its raced, classed, and gendered status.

If such transgressive and ambiguously "queer" black bodies subvert white norms, they also exist to reaffirm it. As Mikhail Bakhtin argues, the

"carnivalesque" body, which has the "right to be 'other' in this world," surfaces to enhance and maintain the status quo (Bakhtin 1981, 159). This is worth noting since black heteronormative bodies appear to be just as disruptive to white heteronormativity as black queer bodies. Here is where I turn to the Obamas.

ROMANCING THE NATION

Much has been made about popular culture creating the climate that allowed us to imagine a black U.S. president, whether in Morgan Freeman's portrayal in the summer blockbuster movie *Deep Impact* or most popularly in Dennis Haysbert's portrayal of President David Palmer in Fox's TV series *24*. Curiously, few have called attention to how—even in fiction—David Palmer was constantly targeted for assassination. Even more curious is the way these fictional black presidents appear to be partnerless, even though our real presidents are constantly positioned with their first ladies. Indeed, in the first season of *24*, David Palmer sought to divorce his ambitious yet conniving wife, Sherry Palmer (portrayed by Penny Johnson), while on his presidential campaign. As he put it to her (and my own) incredulous ears: "I just don't think you're fit to be First Lady."

Such black woman–hating words, interpreted through a historical lens in which black women's ability to be "ladies" is always questioned, combined with this hostile marital breakdown, construct the black heterosexual couple as pathological and "unfit" for social assimilation. We need only recall the 1965 Moynihan Report, which vilified the black family. That Sherry would prove in subsequent seasons to be just as evil as David predicted—indeed, this "angry black woman" was as much a national and international threat as her foreign terrorist counterparts—merely confirmed the racialized and xenophobic misogyny of the show and the culture at large. Hence, we may have been ready for a black president in the popular imaginary but not necessarily for a black First Lady and *definitely* not a unified black couple.

When Michelle Obama emerged alongside Barack Obama, her body fell under constant scrutiny for her fashion choices, which often fully exposed her arms and legs. While Barack Obama's name, Kenyan father, overseas education, and a photographed appearance in a turban frightened white supremacists, Michelle Obama frightened the same group just by her very embodiment. Even the intimate moments of the Obamas would undergo racial spin, such as the "secret gang sign" interpretation of their shared "fist bump" at the 2008 Democratic National Convention.

If black communities celebrated the romance and prospect of a black "First Couple" in the White House, others questioned their visible "threat," as

the controversial July 21, 2008, cover of *The New Yorker* attempted to satirize. Presenting Michelle Obama as an Afro-wearing and gun-toting black militant married to the turbaned and "secretly Muslim" Barack Obama on the verge of destroying American values in favor of a "terrorist"-based Islamic manifesto, the *New Yorker* political cartoon cover offered a poor execution of white liberals poking fun at the racism of their conservative counterparts. However, this caricature specifically mobilizes racial stereotypes that suggest Michelle Obama's fearsome qualities could be reduced to her hair, not to mention the typical de-feminization of the black female body in militant attire. One cannot help but wonder if the "liberals," who conjured this picture, also feared the same thing and merely used right wing sentiments for cover.

Because of this fear of a unified black heterosexual couple, readings of this spectacle must be placed alongside representations of single and/or queer black bodies. Indeed, Cathy J. Cohen, who recalls how heterosexuality mobilized a history of rape and lynching on presumably heterosexual black bodies, subsequently views straight black subjects—most notably poor, young, and incarcerated men and women of color—as "outside heteronormativity" (Cohen 2009, 255). As such, black middle-class aspirations toward sexual respectability, embodied by the Obamas, complicate coalition politics and identities across racial, socioeconomic, and sexual orientation lines in our contemporary moment. If, for instance, the election of Obama to the U.S. presidency coincided with the revocation of same-sex marriage and family rights in California and other states during the same historic night, then coalition dialogue is required to challenge assertions put forth by white LGBT communities that "Gay is the New Black."[11]

These problematic political declarations ignore the intersections of race, class, gender, and sexuality, in which individuals who intersect both communities are erased and in which black communities at large—well before LGBT communities came into political existence—were and continue to be labeled as society's sexual "deviants." As Cohen reminds us, the history of U.S. race relations relied on sexuality to keep economic and racial disparities in place. If institutional rape ensured an increase in slave labor, with racial stereotypes distorting black sexuality, anti-miscegenation laws enabled segregation so as to easily demarcate the slave/"colored" populations and the control of white wealth and privilege. White heterosexual patriarchy created a distinct hierarchy along race and gender lines that rewarded white women, who aligned themselves with the heterosexual ruling class by marrying and reproducing the white race, and that lynched black men if they desired, got involved with, or reproduced with white women. Meanwhile, black women and other women of color lay open to all sorts of men (and women) who exploited their vulnerable positions.

Against this historical backdrop, the romance of marriage and family, envisioned as the backbone of many communities, is exceedingly powerful. So powerful that, post-emancipation, freed slaves reunited with their families, forcibly separated during slavery, and married in droves to assert their "fitness" for equality and U.S. citizenship. So powerful that, in the immediate history moment, LGBT communities are fighting for marriage equality. The romance of marriage and family is the romance of acceptance and respectability, and every marginal community has organized around respectability politics because of the belief that this is the key to equality with those in power. White feminists, who have been raised in families and communities with power, might otherwise question this premise, as they have in the past equated marriage for women with slavery, and even with rape.

It is with this "romance" in mind that I return to Beyoncé. Beyond her popular articulations for the "single lady's" sexual autonomy, Beyoncé also emerged alongside the Obamas for their first dance at the 2009 Inauguration Ball to vocalize this longing for acceptance and satiated love in her rendition of Etta James's "At Last." Long serving as a quintessential wedding song, its placement within the political arena serves a dual purpose. Beyoncé's performance merged the romance of marital love with the romance of a multiracial America finally having "overcome" our troubled racial past through this globally celebrated ascendency of a black First Couple in the seat of power and at the helm of the world's superpower.

Nonetheless, this romance of a "postracial" America conveniently disguises what white antiracist activist Tim Wise calls "Racism 2.0"—a term also coined on women of color blog sites—which includes white denial of the everyday racial discrimination the majority of people of color continue to experience and the acceptance of an assimilable and "exceptional" figure of blackness that the Obamas represent. Running parallel to this uneasy romance is the drama surrounding Beyoncé's Inaugural performance. Having earlier portrayed Etta James in the 2008 movie *Cadillac Records,* Beyoncé ironically refutes the history she depicted of black musical struggle and cultural theft with her Inaugural appearance with the Obamas, as was highlighted when James publicly accused Beyoncé of "stealing" her signature song and, consequently, erasing her musical history.[12] This "dispute" between an aging songstress from the civil rights era and the younger "diva" of the millennial age illuminates how—even among black women—social inequalities are reinforced, despite the prevailing narrative that such inequalities no longer exist. Such conflicts remind us of the continuous work needed to dismantle attitudes, roadblocks, and barriers that keep us divided. We have not overcome "at last," even if we must maintain that "audacity of hope" to arrive at the promised land of equality and liberation.

GLOBALIZING AND NATIONALIZING THE BLACK BODY

My primary focus in this chapter has revolved around U.S. national narratives on race and gender and how black bodies become central to these narratives. However, a main theme of our early-twenty-first-century world concerns the constant movement of goods, peoples, and information across national borders. Needless to say, these movements reflect power imbalances historically framed by such global forces as conquest and discovery, the transatlantic slave trade, colonization and Western imperialism, world wars (hot and cold), decolonization efforts, mass migrations, and corporate globalization. These processes have determined how our current bodies travel across the globe and how they reconstitute the national body politic. Leading up to our new millennial age are the shared stories of wars, poverty, and relocation, from refugees and trafficking to formations of what Aiwah Ong calls "flexible citizenship"[13] in transnational communities to global digital communications interconnecting our lives.

It is within this environment that Barack Obama emerged as "The New Black"—the global citizen who has left behind the nationalistic U.S. past, with its retrogressive worldview of "black and white" race relations, to advance us forward in our multiracial and transnational future. He thus moves us away from the previous Bush-Cheney administration, which returned us to the archaic divisions of "clash of civilizations" rhetoric espoused in the wake of the September 11 attacks, as well as to the imperialist practices that followed: the racial profiling of Muslims and Arabs, the tracking down of undocumented brown bodies "here" and the bombing of brown bodies "over there," and the constant surveillance and incarceration of black bodies. The very embodiment of Obama suggests a "unity" that refutes these divisions with his biracial heritage of a white American mother and a Kenyan father, along with his connections both to the "global North" and "global South." In contrast to Homer Plessy, another "mixed-race" body from another era, whose undetected "one-eighth Negro blood" posed a threat to white purity and, thus, ushered in the legalized period of Jim Crow segregation in the wake of the Supreme Court ruling on "separate but equal" in *Plessy v. Ferguson,* Obama represents the promised reconciliation of these past racial divides.

In global perspective, the joyous reception around the world of President Obama's historic election illustrates how the United States is still positioned as a global beacon of hope, even within this "post-American world." China may export the majority of the world's goods, but the United States remains a major exporter of the world's dreams. The position of the United States as the world's "superpower" (whether on the decline or not)

has given it international significance, shored up by the legacy of global white imperialism.

Having emerged from a troubled and volatile racial history, the U.S. election of Obama corroborates a globally mediated narrative of the United States as a "leader" in civil rights, racial progress, and free democracy where "every vote counts." Of course, many of the votes cast for Obama may have been for reasons that do not go any deeper than "skin deep." As artist and humorist Damali Ayo posed in her manifesto parody, *Obamistan! Land Without Racism*: "Admit it—you didn't just vote for the best guy, you voted for the black guy" (Ayo 2010, 135).

Unfortunately, what President Obama does share with Homer Plessy is the ability to foster racial anxieties in the political sphere, and so we find his "postracial" victorious election followed by what I call a *neo-racist* political climate. It should come as no surprise that a nation, that has been strongly identified with a white supremacist history—comprised of Native American genocide, enslavement and legal discrimination of African Americans, immigration restrictions against Chinese Americans, the internment of Japanese Americans, and the constitution of U.S. citizenry around white masculine identity, which would later be forcibly amended to include black and female citizens—would witness a racial backlash against the election and inauguration of a black president. Within this political climate, exacerbated by an economic crisis, a new conservative political party emerged—the Tea Party, which, curiously enough, borrows its historical moniker from colonial rebels fighting against British taxation and evokes a tradition of antigovernment resistance during the American Revolutionary War. Embedded in this historical "take back America" rhetoric is the unspoken belief that "America" belongs to "whites only."

Far more direct in their racist message were the "Birthers," a group of dissenters who had sought to depict President Obama as "illegally" occupying the White House—despite his legitimate election by the American people—because he is supposedly not a U.S. citizen. Similar to those who believe Obama to be "secretly Muslim," this group threw into question his birthplace in the state of Hawaii—a state that not only exists as an outlier set of islands but is often identified by its colonial annexation history and by its indigenous and Asian population (and, hence, its "nonwhite" and "un-American" status). Unlike other presidents before him, President Obama became the first to publicly release his birth certificate, which he did in April 2011, in order to "prove" his citizenship status.

In the political rhetoric surrounding Obama's questioned citizenship, religion, and ethnicity, the president's mixed-race blackness destabilizes the

body politic, thereby suggesting that the nation still favors whiteness as its primary identity—despite celebratory notions of multiracial and ethnic diversity. On the other hand, the same white supremacist conservatives who resent a black president also resent white citizens who do not follow gendered scripts that maintain white supremacy through "family values" and will even cater to black and other nonwhite groups to support antifeminist and homophobic campaigns. In cynical fashion, nonwhite communities are utilized as a political means to an end in the quest to regain a white heteronormative "America."

However, these political machinations are far more complex when we intersect race with gender and sexuality. One prime example of this is the interracial antiabortion campaign, *That's Abortion*, which mounted controversial billboards in African American and Latin@ neighborhoods that declared women of color's "wombs" as "the most dangerous place" for children of color. The same antiabortion group also used President Obama's image in a billboard that proclaimed, "Every 21 minutes, our next possible leader is aborted."[14]

There are two important variables to consider in this construction. The first is that Obama's racial identity is so entrenched in blackness that the subject of his birth could be used in an ad that highlights abortion rates in black communities—whether or not those rates are fabricated or taken out of context. The second is the obvious erasure of his white mother, Stanley Ann Dunham, since the women who represent her race, class, and gender status are not the targets in the ad. At the same time, Dunham becomes an unspoken marker of race, class, sexual, and national transgressions since it is her choices that impact on the questioning of Obama's birthplace, religion, and American patriotism. Such "debates" also invariably question her whiteness—by virtue of her marrying nonwhite and non-U.S citizens, living abroad, and giving birth to a mixed-race child.

Cynthia Enloe reminds us that, due to global white imperialism, white women have historically found mobility and access to travel the globe, provided they did so through "respectable means," either through chaperones while on tours, through religious missions, or in clearly defined segregated colonial spaces in which "part of . . . empire-building masculinity was protection of the respectable lady" (Enloe 1990, 48). Similar to U.S. domestic policies, which we could date as far back as the seventeenth century—when Virginia laws outlawed miscegenation and ensured that all offspring born of enslaved women would themselves be slaves—these cultural, political, and social conventions rely on women's bodies to safeguard and restrict the raced, classed, and geographic lines existing between the powerful and the powerless. The

interracial marriages and global travels of Obama's mother have confounded our race, class, and gender boundaries, which antiabortion ads such as the ones mounted by *That's Abortion* desperately seek to uphold in their efforts to restrict women's reproductive rights.

If white women's transgressions can confound such boundaries, then we can only imagine how much more disruptive empowered women of color would be to such narratives. This is why black women in particular quickly mobilized efforts to counter such antiabortion groups and advocated for their reproductive rights. As Loretta Ross of Sister Song Women of Color Reproductive Justice Collective declared in opposition to *That's Abortion*: "Whether black women were pro-choice or pro-life, we were united in believing that black women could reasonably decide for ourselves whether to become parents" (Ross 2011). This declaration of black women's rights to our own bodies will have wider implications beyond the reproductive justice movement.

CONCLUSION: MOBILIZING THE BLACK BODY

As black women on the ground work to ensure their bodily integrity, it is worth noting how such black feminist sensibilities are reiterated in more high-profile settings. For instance, while President Obama represents a new "Global Black," his wife, First Lady Michelle Obama, perhaps in the tradition of women's confinement to the domestic realm, remains connected to a "local blackness" that she has mobilized toward a national body. In her "Let's Move" campaign—which continues a tradition of fairly safe political "First Lady" projects—Michelle Obama chose to highlight the problem of childhood obesity. In so doing, she selected an issue that affects black children at high rates, and young black girls in particular. Although she received public criticism for this project—most notably from those who chose to see in this project an insidious negative campaign to undermine the self-esteem of young girls struggling with weight issues,[15] especially after the First Lady referred to her younger daughter Sasha as "getting a little chubby"—Obama nonetheless politicized the body as a site for self-determination and wellness.

Considering that various pundits have commented on Michelle Obama's regular associations with the local African American community in the D.C. area—an association that had not been nurtured by previous First Ladies— her campaign subtly shifted black women and girls "from margin to center" in national conversations. Moreover, she recruited Beyoncé in this campaign, in which the pop star altered her dance track "Get Me Bodied" for a music video, "Move Your Body." Although the video, which depicts Beyoncé dancing

in stiletto heels among school-aged children in a cafeteria, might send a problematic message to young girls about the stylish and restrictive ways that women are expected to "move your body," both Beyoncé and Michelle Obama must be commended for joining forces in encouraging the nation's youth to be comfortable with and attentive to their bodies and the ways their bodies move.

This is in stark contrast to Beyoncé's earlier performance of "Get Me Bodied" on the 2007 BET Awards Show, in which she recreated a scene from Fritz Lang's 1927 silent film *Metropolis* and performed as a curvaceous, seductive robot—thus illustrating how black women's bodies become objects for technological manipulation, as was fleetingly suggested in "Single Ladies (Put a Ring On it)." By reframing the body through the "Let's Move" campaign, black women are invited to reshape the body politic on their own terms. Interestingly, in the song remix and video of "Move Your Body," a multicultural and transnational blend of hip-hop, salsa, and dancehall reggae music and choreography highlight those particular urban ethnic and immigrant communities most at risk for childhood obesity. To encourage such women and children to "let's move" is to encourage national and transnational communities to take back the health and wellness of their bodies and the environments in which they dwell.

Despite the political realities that systematically oppress entire groups of people, the individual triumphs of the Obamas and Beyoncé say to the same groups: "I overcame, and you can too!" For some, such messages can inspire; for others, this is yet another mass distraction, an illusion, another cynical misrepresentation—especially when one considers that the black middle class in the United States had shrunk in size during the Obama administration, due in part to the economic crisis in which black unemployment and foreclosure rates were higher than for other groups. And yet, these black public figures have received enough media criticism—whether in the disapproval of Beyoncé's provocative dance moves, which call attention to her voluptuous body, or in the constant racialized scrutiny of the Obamas—to suggest that, even with the few visible black bodies in the public sphere, their display of cultural, social, and political power is subversive enough to alter dominant ideologies. Nonetheless, their bodies still function through what Collins calls the "new politics of containment," which relies on "the *visibility* of African-American[s] . . . to generate the *invisibility* of exclusionary practices" (Collins 1998b, 14; emphasis in original).

Overall, these varied narratives of the early twenty-first century nuance the contradictions of oppression and opportunity. After all, there is something to be said for a decade that began with the demonization of a

man called Osama and that ended with the rise to the U.S. presidency of a man called Obama, especially when the latter would become instrumental in the demise of the former. Meanwhile, at a historic moment when we rejoiced at political change, many of us tried to dance like Beyoncé, and First Lady Michelle Obama would later mobilize that desire to "dance like Beyoncé" into a political strategy for self and communal empowerment. While such representations demonstrate how "The New Black" can be recuperated from what Fanon calls "the shackles of history," we are still left to ponder its undetermined future of liberation.

Chapter 3

Body as Evidence

The Facts of Blackness, the Fictions of Whiteness

On February 20, 2006, I guest lectured for a graduate seminar on Black Popular Culture, at Duke University. There I was to engage students in conversation about my first book, *Venus in the Dark*, which examines the visual legacies of black women's sexual representations—beginning with the "Hottentot Venus," as embodied by South African Sara Baartman.[1] Our conversation, remarkably, reflected a great deal of distress and dis-ease with Baartman's story, as many found it disconcerting that I emphasized her "victimization," rather than consider her "sexual agency" in performing as a sexualized ethnic curiosity in Europe. When I reminded everyone that, whether or not we wished to view Baartman as a "victim" or "agent," we cannot overlook the simple fact that, in death, her private parts were carved out, dissected, and preserved in a jar of formaldehyde fluid, which was also placed on full display at a scientific museum in Paris, the class fell silent.

Less than a month later, on March 13, 2006, a young black college student, who was eventually named to the world as Crystal Gail Mangum, performed as an exotic dancer at a private party hosted by members of the Duke Lacrosse team before bringing forth a charge that she had been raped, sodomized, and bound in a bathroom by three men at that party. A year later, we would witness a nation divided, once again, over racial and sexual issues, where media attention would distort the facts of what occurred that night. Finally, on April 11, 2007, all charges would be dropped against three of the players—David Evans, Reade Seligmann, and Colin Finnerty—who would also be declared, as big screaming letters emblazoned across CNN's screen: "THEY'RE INNOCENT!"

And black leaders, such as Jesse Jackson, who had offered through his Rainbow Coalition a scholarship to Mangum so that she could attend college without entering sex work, would be brought on various CNN news programs to be coerced into admitting "guilt" in assuming the white men to be guilty of rape, when Jackson's point was that "I just wanted to offer the young woman an opportunity to support her children and attend college without having to dance naked in a room full of white boys." Such a comment underlies the anxiety of interracial sexual violence and the failure of black patriarchal protection, which grates against the dominant narrative invested in black guilt and white innocence. It also recalls a visual history—"dance naked in a room full of white boys"—of white subjugation of the disrobed black body, whether through slave ships, auction blocks, scientific scrutiny in cases such as Baartman's, or unequal entertainment stages and screens.

Incidentally, charges against the Duke athletes were dropped the same day that NBC decided to fire radio personality Don Imus for his use of racial and sexual epithets against the Rutgers University women's basketball team during his radio program. And, no sooner were the charges dropped than ABC and a few other news networks started showing pictures of and identifying the Duke Lacrosse accuser, subsequently inspiring some of the most racist and misogynistic blogs and commentaries all over the Internet. One commentary by John Lillpop, featured on a blog called "The Conservative Voice," invoked Imus's controversial words with the title: "Crystal Gail Mangum: Nappyheaded Ho?"

I offer this preamble because I am interested in examining the national distress over black female bodies, the cultural investment in white innocence, and also what I see as a cultural legacy of responding to black women's sexual representations through the specter of racialized sexual violence. Using the example of the Duke Lacrosse rape scandal in 2006 and drawing on racial scientific history and contemporary popular culture, I argue that mass media reports and other modes of popular culture, combined with science and technology through DNA discourse, conspire to create recognizable tropes and readings of the black female body through historical associations of deviance, illicit sexuality, and criminality. I further explore how, at other moments, the black female body serves as a conduit for the reshaping and redrawing of racial, sexual, and class divisions. Above all, I interrogate how these representations, these "facts of blackness"—to recall Fanon's description of the black body evoking convenient racial stereotypes—seem to be supported by what I term the "fictions of whiteness," in which exists a racial polarity between black guilt and white innocence. I recognize this construction of whiteness—and its associations with innocence, purity, and

morality—as "fiction" insofar as the prevalence of a "white guilt" sensibility renders the falsity of white innocence, a subject explored later in this chapter.

SCIENTIFIC SUPREMACY: THE STORY DNA TELLS

Science has often presented a complex and fabricated tale about race: from Thomas Jefferson's calling on science to prove the racial inferiority of Africans to actual attempts at proof by nineteenth-century European scientists, who pickled the body parts and internal organs of their colonial subjects in Africa and Australia, beginning with Sara Baartman, whose body was offered as "scientific evidence," from her pickled brain to her pickled genitalia. This scientific objectification was made all the more possible by the hyper-sexualization of Baartman in popular culture, as well as her accessible body, which was turned over to scientists by her "animal trainer" in Paris in 1815. What is important to remember is that her pickled organs represented the beginnings of the scientific shift from exterior investigation of the body to interior investigation, a legacy that impacted eugenics and affects our current scientific interest in DNA research and other genotype projects.

In addition to Baartman, medical experiments were performed on such enslaved women as Anarcha and Lucy, whose bodies fueled the early work of J. Marion Sims in Alabama from 1840 to 1849. Sims is credited with being the "founder" of gynecology and with inventing the speculum. His women patients not only bore the marks of sexual violence—they were treated for vesico-vaginal fistulas, a condition that is presently associated with rape victims in the Democratic Republic of Congo[2]—but were also subjected to further violence when Sims performed surgeries on them without anesthesia (Anarcha would be operated on thirty times). What these actions suggest is the legacy of scientific objectification and dehumanization of black bodies. Such acts would later reverberate in the horrific example of the Tuskegee experiments, which subjected black men in Alabama, who went untreated for syphilis, to medical experimentation for scientific study between 1932 and 1972.

Related to this is the story of Henrietta Lacks, recently documented in Rebecca Skloot's bestseller *The Immortal Life of Henrietta Lacks*, which narrates the history of the famous immortal cancer cells, HeLa, harvested from Lacks's body after her death from cervical cancer in 1951. Henrietta Lacks, like so many other low-income African American Baltimore residents during the Jim Crow era, received subpar medical treatment in the segregated ward of John Hopkins that provided a readily accessible supply of bodies on which scientists carried out medical and scientific experiments. Indeed,

Skloot recounts the ways that the medical staff at Hopkins remained more interested in Lacks's cancer cells than they were in her well-being, as Lacks repeatedly told her doctors the cancer was "spreading all inside me," even though they insisted nothing was wrong (Skloot 2010, 48). In extracting the cells from Lacks's body—unbeknownst to her or her family—scientists once again exploited the black female body, as earlier science and medicine had with Baartman, Anarcha, and Lucy, using the HeLa cells to lay a foundation on which advances in fields from cell culture to polio vaccine to DNA and genetics to the Human Genome Project would develop.

In light of this troubling racial and sexual history of science, what does it mean to African Americans to have to rely on science to affirm their African heritage and identity, as represented by the trend in using DNA to trace genetic history? Here, I refer to the intriguing interdisciplinary public scholarship embarked on by Henry Louis Gates Jr. in *African American Lives*, a series that premiered on PBS the same year the Duke Lacrosse controversy erupted. What especially does it mean for African Americans to construct an African identity while downplaying the European genes also coursing through our DNA, which tell a different story about our "heritage," and specifically a story about black women's bodies and the history of racialized sexual violence as linked to slavery and racial segregation? While such attempts to discover our African tribal affiliations may be revelatory and can instill a sense of black pride, they also risk the exposure of European genes, which speak to a different kind of heritage. As Adrian Piper reflects: "For some of course, acknowledgement of this fact [of a mixed-race heritage] evokes only bitter reminders of rape, disinheritance, and exploitation" (Piper 1998, 95).

This particular aspect of history raises troubling contemporary conversations, as witnessed in 1998 when DNA was used to prove that at least one of Sally Hemings's children was fathered by President Thomas Jefferson—though writer Ann DuCille questions why scientific proof was even needed in view of a long-standing oral history passed down the lineage of Hemings-Jefferson descendants and, she reminds us, written about by William Wells Brown in *Clotel, or the President's Daughter*, the first African American novel, published in 1852. When she taught this novel at the time the Thomas Jefferson DNA findings were reported, DuCille notes: "Despite everything I had said about history, story, fictive invention, and narrative and literary devices, the scientifically validated fact of Jefferson's paternity not only made the novel more immediately relevant to [my students] but also made it more culturally and intellectually valuable" (DuCille 2000, 450). Such validation is especially disconcerting in view of of the fact that whiteness and patriarchy are constantly accorded the acceptance of "historical accuracy," as opposed to the "inaccuracy" represented by black heritage and black testimony.

What I also find disturbing about these trends is the reliance on the scientific gaze on the body. Surely, the stories of Baartman, Anarcha, Lucy, the Tuskegee men, and Henrietta Lacks should caution us against pinning our beliefs on scientific "evidence." Consider that, once DNA tests in the Duke Lacrosse case—conducted to link the accused to the scene of the crime as well as to Crystal Gail Mangum's body—reportedly failed to confirm the accuser's narrative, the tide in the media quickly changed, leading to the beginning of the end of her "credibility." Of course, it was not until Mangum expressed doubt about the occurrence of rape, we were told—nine months after the incident—that charges were dropped.

Is it fair to compare the Duke Lacrosse rape scandal with the Thomas Jefferson/Sally Hemings DNA controversy? We may recognize the dual construction in national discourse—DNA as scientific "evidence," which we accept as irrefutable fact, versus a black woman's testimony, which U.S. courts of law have historically failed to accept or rely on—as questionable, especially when we examine this silencing in the historical context of slavery and legal segregation. In other words, we have a long-standing history in which black women, having been targeted for rape and sexual exploitation, have given birth to mixed-race children—often the "evidence" of sexual violation—whose racial provenance both legal and scientific racial constructions in this country were specifically designed to erase by reinscribing them as "black," even with as little as "one-eighth Negro blood." Indeed, the different categorizations of "mulattos, quadroons, and octoroons" encapsulate white denial and color distinctions formulated to preserve white purity through these particular detailed measurements of the presence of blackness.

This is evident in representations of Sally Hemings, who not only bore children by Thomas Jefferson but was also the half-sister of his wife, Martha Jefferson, thus revealing the incestuous relationship between slave and slaveholding families, as well as the matrilineal heritage that trapped enslaved black women, including Hemings and her mother, in a system of concubinage. Yet, historical descriptions of the "nearly white" Hemings as an "African Venus" reinscribe mixed-race women in North America through social and cultural "blackness"—unlike the "casta" systems that recognize different racial categories in Latin America. Indeed, our own present-day conversations about Thomas Jefferson and Sally Hemings—in movies such as *Jefferson in Paris* and experimental operas such as Garrett Fisher's *Sally Hemings Wakes*—reflect anxieties about their "interracial relationship," although Hemings's "quadroon" characteristics should already disrupt such narratives of "miscegenation."

In sum, these racial categories that collapse mixed-race bodies into blackness operate in the ongoing erasure of "evidence" of rape and interracial

sexual liaisons involving black women, so that before our testimonies are accepted our very bodies will be discredited, all in the interest of maintaining the "fictions of whiteness." When reflecting on this history, we may determine that present-day DNA discourse, designed to disprove the existence of biological race, is the twenty-first-century rearticulation of nineteenth-century "blood" discourse, in which the "one-drop rule" preserved the purity of whiteness. As Dorothy Roberts notes in *Fatal Invention*, twenty-first-century scientists, in the wake of the Human Genome Project, have simply reinterpreted genetic data through a racial lens: "An increasingly prominent trend is to redefine race *as* genetic ancestry" (Roberts 2011, 63; emphasis in original). We may question how these new articulations, in camouflaging "race," sidestep the social, political, and cultural realities of racism—particularly when the facts of blackness and the fictions of whiteness continue to wield enormous power and influence while recasting these exploitative histories in the interests of white supremacy and black subjugation.

CRIMINALIZING THE BLACK BODY

In the wake of the Duke Lacrosse scandal, Mangum authored a memoir, *Last Dance for Grace*, in which she maintains that she was raped. As she testifies in the following:

> For all the women who have been beaten by their partners and labeled battered women, for those like me who will be forever despised and dismissed as just someone who made up things, I am writing this book. I am also writing for those women who have been labeled accusers like me, women who may have not been able to move forward with their lives because of the double violation that they had to suffer—once at the hands of their attacker and then at the hands of the institutions that have the power to ruin lives and enrich others at the stroke of a pen. (Mangum 2008, 229)

Despite her public disclosure, which includes not only her account of what transpired on March 13, 2006, but also her hardscrabble experience with economic struggles, colorism, intraracial gang rape, bouts with depression, brushes with the law, and the exploitative nature of sex work in the strip club world, Mangum's story continues to be dismissed by legal and scientific discourse. Moreover, she has found herself "entrapped"[3] once again in the legal system, this time arrested for murder in what sounds like a tragic case of domestic violence, perhaps exacerbated by her untreated trauma and/or

mental illness. If DNA tells a certain kind of embodied interior story, then the exterior traits of the black female body narrate her "criminalization."

The black female body's link to criminality has a long history in the "criminalization of women who resist."[4] This has been captured, for example, in stories of mutiny aboard slave ships during the Middle Passage, in which female captives, who were deliberately unchained so that the ship's crew could have sexual access to their bodies, would use the opportunity to incite other captives in slave uprisings. Their only alternative choice led to the penalty enforced if they dared to resist sexual violence, as illustrated in the tragic story of a teenaged captive aboard the slave ship *Recovery*, who, as historian Saidaya Hartman recounts, chose severe flogging and eventual death rather than submit to rape.[5] Such stories have reverberated throughout the Americas as well, from the "flagellation of a female Samboe slave," as recounted by John Gabriel Stedman concerning an enslaved woman's resistance to sexual relations with her enslaver on the penal colony of Suriname, to Brazilian slave icon Anastacia, who was forced to wear a torturous iron mask because she too refused her enslaver. In North America, apart from the criminalization of fugitive slaves such as Harriet Tubman, whose radical work to liberate the enslaved from the plantation system was defined by the dominant legal discourse as "theft" of property, there is the example of Sukie, whose violent assault on her enslaver in attempts to resist his sexual advances resulted in her sale on the auction block. In other words, she faced such punishment because "she tole him no" (Perdue et al. 1976, 48–49).

Because of the moral and legal paradox established by slavery—black resistance to white oppression becomes a criminal offense—the "facts of blackness" constantly grate against the "fictions of whiteness." After all, the white body, by virtue of representing the law and moral authority, *legitimates* the immoral acts of physical and sexual violence. If the white body perpetrates violence, there is a presumed cause and rationale. The black body is presumed guilty in relation to the presumed innocence of the white body.

This racialized moral dilemma, of course, would form the gist of antislavery debates, in which white abolitionists constantly challenged other whites to renounce white debauchery, which flourished precisely because white misbehavior toward black bodies was legally permissible. Not only would such debates echo during anti-lynching movements and the civil rights movement in the twentieth century—think of the prevailing moral outrage against the jailing and penalizing of black protestors—but they would also form the subtext for media and public discussions surrounding the Duke Lacrosse case that sought to assuage white guilt over the specter of interracial violence. As Wahneema Lubiano, an African American Duke University professor,

observed, representations of the Duke Lacrosse players, who were formally charged with rape and assault, had to be normalized because of their race, class, and gender privileges: "mitigations [are needed to downplay white guilt] such as 'they aren't any different from other young men' who drink and party in boisterous manner and, occasionally, slip over the line of acceptable behavior. . . . Their offense has to decrease in size and severity" (Lubiano 2006). If we contrast this normalizing depiction of the Duke Lacrosse players to, say, the media depictions of Sean Bell, a black man in Brooklyn who was gunned down by undercover cops during his bachelor party at a strip club the night before his wedding on November 25, 2006, we more easily recognize how whiteness renders certain bodies "innocent," a judgment denied other bodies in similar situations. If Sean Bell is deemed a "not so innocent" victim of police brutality—due to his presence at a strip club—how curious it is that Duke Lacrosse players are excused of blame for hiring exotic dancers under false pretenses in their own residence and subjecting them to racist and misogynistic epithets—as attested by the dancers involved and next-door neighbors. And if Sean Bell's "innocence" may be questioned—even in death—it goes without saying that Mangum, a low-income black woman engaged in sex work, is denied any claims to innocence since her "illicit" black body already precludes her from such status. As Lubiano argues, "For those critical of the alleged victim, her 'perfectness' as victim is severely decreased by her position as an outlier in terms of norms of acceptable female gender behavior" (Lubiano 2006).

In light of this racial and sexual history, black women are not easily recognized as "victims." If, for instance, Clarence Thomas—when accused, during the 1991 Senate hearings confirming him as a U.S. Supreme Court Justice, of sexual harassment against Anita Hill—could invoke black male victimization through the discourse of a "high-tech lynching," Anita Hill was denied resort to similar "victim" iconography. The nearest thing black women have to comparable iconography—institutional rape—not only has been historically denied but the imagery itself invokes voyeuristic titillation rather than public shame. (We need only recall the prurient curiosity with which (white) senators grilled Hill on the details of the sexual harassment she had experienced.) However, in the context of the lynched bodies of black males, which was connected to their criminality and "proclivity towards rape," historian Paula Giddings argues that "[b]lack men raped, it was widely believed, because black men's mothers, wives, sisters, and daughters were seen as 'morally obtuse' [and] 'openly licentious'" (Giddings 1992, 443–44). As a result, criminalized black male sexuality is inextricably linked to black female sexuality, insofar as one body poses sexual threat while the other is deemed incapable of being sexually threatened.

Needless to say, such racist discourse pertaining to U.S. sexual politics has encouraged a culture of silence within black communities and a reluctance to expose sexual violence to the outside world. Moreover, in challenging racial oppression, the community often turned to "respectable citizens" to move the race forward, as in the example of Rosa Parks, who was deemed more socially acceptable for black protestors to fully support in their successfully organized bus boycott in Montgomery, Alabama, in 1955, compared to fifteen-year-old Claudette Colvin, who preceded Parks's actions months earlier when she too refused to give up her seat on a segregated bus. However, unlike Parks, Colvin was an unwed pregnant teen. Considering the ruthless nature of Jim Crow racism, black protestors needed to be morally above reproach if they were to challenge the immorality of state-sanctioned racism.

Although we could argue that such actions took place during a sexually conservative era, we need only point to our own time, which recreated the disapproving discourse surrounding the kind of work Mangum was engaged in when she encountered the Duke Lacrosse players. Whereas the Rutgers women's basketball team, for example, could rely on the politics of respectability as high-achieving college athletes to defend themselves against Don Imus's "nappyheaded ho" comment, Mangum had no such recourse. In these interstices between respectability and hypersexuality, Hortense Spillers reminds us that black women are the "beached whales in the sexual universe—unvoiced, misseen" (Spillers 1989, 74).

At the same time that black women needed to be "respectable citizens" in order to counter the guilt associated with the black body, they also had to rigorously refute the image of "white innocence" that marked the white body, especially when we look to the history of the Jim Crow South, where so many black women were constantly threatened with interracial rape. In her revisionist history *At the Dark End of the Street*, historian Danielle L. McGuire recounts the collective resistance by black women against institutional rape, including rewriting Rosa Parks as a militant anti-rape activist. While such histories highlight the ways that black women have provided the foundation for today's feminist anti-rape movements, the silencing of this history also points to systemic oppressions that continue to rely on constructions of black guilt and white innocence. Ignoring for the moment that McGuire does not address black-on-black rape in her study, her focus on white-on-black rape and the resistance to it as the foundation for the civil rights movement invites us to counter the "facts of blackness," based on stereotypes that suggest that black men are inclined to rape and black women inclined to sexual promiscuity, and question the "fictions of whiteness," which suggest that white bodies are incapable of black-white sexual encounters and are thus "racially pure."

Significantly, it is worth noting that, despite the criminalization of black women who resist, they still insist on speaking out in protest. As Baldwin asserts, "[The] victim who is able to articulate the situation of the victim has ceased to be a victim: he, or she, has become a threat" (Baldwin [1975] 1998, 562). It is this "threat" that must be suppressed, which is why certain feminist discourse that attempts to move us away from "victim" narratives in exchange for ones that assert "agency" misses the point entirely. In speaking, the victim is *already* an agent, and her narrative is especially threatening because it dares to expose violations and violence when others declare that such oppressions do not exist.

THE PROBLEM OF WHITE GUILT,
THE REFUGE IN WHITE INNOCENCE

From their investment in the innocence of the Duke Lacrosse players to the reinstatement of Don Imus, who maintained that he was a "good person"—despite his use of racist and misogynistic language—Big Media narratives that assert, almost aggressively, the prevailing belief in white innocence suggest an anxiety that threatens to expose such constructions as false premise, as "fiction." Indeed, such assertions seem riddled by the opposite: white guilt. However, the rhetoric of white innocence is a dishonest approach to the problem of "white guilt."

Even before the Duke Lacrosse scandal and the Don Imus incident, the September 11 attacks mobilized the rhetoric of American innocence, coming, as they did, at a time when we could conveniently ignore the UN World Conference against Racism, held only a few weeks earlier, where African Americans gathered in a global context to call for slavery reparations. The metanarrative of "white guilt," which reinforces individual whites' feelings of guilt over racism and white privilege, found a space within the national tragedy of September 11 for both political and historical erasures and a return to "innocence." As white antiracist feminist Ann Russo argued in her speech at the National Women's Studies Association conference in 2002:

> We're . . . encouraged to defend ourselves [as white middle-class Americans] against any demand for accountability through *amnesia and denial* about this country's history of conquest, slavery, racial segregation and terrorism, imperialism here and around the world. Embedded in the "why do they hate us" binary of good and evil [in post-September 11 rhetoric]—criminals and innocent victims— terrorists and innocent civilians—are nationalist assumptions of (white) innocence and (white) superiority, presented as defenses against

accountability—accountability for global instabilities, terrorism, fundamentalism, racism, crime, and violence. Deconstructing this "innocence" and creating a sense of accountability are integral to a struggle for social justice in this country and around the world. (Russo 2002; emphasis added)

Interestingly, the "amnesia and denial" that Russo describes and which our nation adopted as a political response surfaced metaphorically in films that debuted around the time of September 11. Both Christopher Nolan's *Memento* and David Lynch's *Mulholland Drive* disrupt the fictive narratives around white innocence. Through the portrayals of "guilty" white characters, who maintain their "innocence" by projecting their guilt onto other bodies, these films illustrate the disintegration and destabilization of the category of whiteness in an era of multiethnic, multiracial, and transnational identities that have redrawn the lines around race, class, gender, and nationality.

In *Memento*, the protagonist Leonard Shelby, or Lenny (played by Guy Pearce), suffers from short-term memory loss while holding onto his long-term memories. The results of this—Lenny can hardly remember events as they occur—are sometimes comical but ultimately tragic, as the film presents Lenny's murderous quest for his wife's killer in a reverse linear narrative, thus aligning audiences with the point of view of someone who has no sense of history. However, the horror that unfolds, in which we learn that it is Lenny himself, and not some mysterious "John G.," who is responsible for his wife's death reinforces the problem of historic erasures and the weight of a guilty conscience, which, as Lenny laments, "cannot heal because [it] cannot feel the passing of time." That Lenny carves a master narrative onto his body—"John G. raped and murdered my wife" (which he can only read while staring into a mirror)—confuses the narrative of identity and memory. This "killer's" identity is inscribed onto Lenny's body (i.e., the label "white male" is tattooed as a "fact" along his arm), while other bits and pieces of information create a puzzle of misinformation.

Curiously, Lenny ignores other markings on his body and on the bodies of others. For instance, he never questions the scratch marks on his face (which he acquired while murdering yet another presumed "John G." character) nor does he inquire about the bruised eye he had given another character. And beyond the fiction of "John G." is another fabricated memory and tattooed "fact": "Remember Sammy Jenkins." Both of these white males turn out to be different aspects of Leonard Shelby: the ruthless murderer (John G.) versus the accidental killer (Sammy Jenkins), who overmedicates his diabetic wife because he fails to remember injecting her with insulin as part of his daily routine. We are thus presented with the problem of white guilt, which

never resolves to be accountable since such white identity is predicated on a fabricated innocence while the crimes committed are conveniently projected onto someone else.

Similarly, *Mulholland Drive* presents a disruptive narrative in which our protagonist Diane Selwyn (played by Naomi Watts), a struggling actress who moves from Deep River, Ontario, to Hollywood, dreams an elaborate fantasy—reminiscent of Hollywood film noir clichés—that protects her innocence in the guise of Betty Elms, a wide-eyed optimist who discovers and seeks to aid the mysterious, beautiful amnesiac Rita (played by Laura Elena Harding). It is only in the "waking hour," the second act of the film narrative, that we discover that Betty and Rita are merely dream characters, that their "real" counterparts—Diane Selwyn and Camilla Rhodes—are much more hardened and less innocuous. More than that, we come to realize that Diane Selwyn, who had an affair with Camilla, conspired in her murder.

Peculiar to this narrative and to constructions of whiteness is the way that "white innocence" falls apart in the presence of nonwhiteness. Hence, the "dream" narrative begins to disintegrate, with the subsequent disappearance of Betty and Rita, after they attend Club Silencio, a Chicana/o space in which they encounter La Llorona de Los Angeles, Rebecca del Rio (portraying herself), whose Spanish version of Roy Orbison's "Crying" discombobulates Betty/Diane and literally begins the process of her violent awakening. We may question how the tensions between guilt and innocence play out when it is, in actuality, the white "cowboy" in his good white hat who issues the wake-up call. Nevertheless, the encounter with the Other, which also relates to Rita/Camilla's identity since she too engages in ethnic erasure (borrowing her name from a Rita Hayworth poster, which recalls a familiar history in which the Hispanic actress chose a more anglicized Hollywood name to achieve fame)[6] suggests that white identity erases, or "whitewashes," the dirt and grime of a gritty reality. Lynch definitely plays with these racialized conventions when he depicts a literal "black" man during the dream narrative in the back of the Winkies diner—the place where Diane plans her hit on Camilla—who then makes a reappearance as an androgynous-looking homeless person, thus representing Diane's dark side. This frightening and blackened face represents the reality of "white guilt" versus the fiction of "white innocence," which is elusively recalled when the whitened faces of Betty and Rita are overlaid on the blackened face toward the end of the film before returning to the stage of Club Silencio.

If, as the motif of Club Silencio suggests, "no hay banda [there is no band] . . . it is all an illusion," then such narratives explicitly reveal the illusion of white innocence, or at least the struggle for an articulation of it to offset white guilt. We may further recognize that, as Toni Morrison

argues, "the thematic of innocence coupled with an obsession with figurations of death and hell . . . [are] responses to a dark, abiding, signing Africanist presence" (Morrison 1992, 5). We see this beyond the examples of film noir. When a horror movie such as *The Exorcist*, for example, a film about demonic possession set in Washington, D.C., opens with the sounds of an Islamic chant and images of Middle Eastern men and women in Iraq, we immediately recognize that the narrative is invested in maintaining white innocence by projecting the dark, demonic "Africanist presence" not just outside the white middle-class family impacted by this possession but also beyond the national border. Indeed, as Ella Shohat describes of early cinema during the Hays Code era, nonwhite and non-Western space gets mobilized to project white "misbehavior" onto the "undisciplined" body of the Other. As such:

> The gender and colonial discursive intersections in Hollywood . . . exploit the Orient, Africa, and Latin America as a pretext for eroticized images, especially from 1934 through the mid-1950s when the restrictive code forbade "scenes of passion" in all but the most puerile terms. . . . Exoticizing and eroticizing the Third World allowed for the imperial imaginary to play out its own fantasies of sexual domination. (Shohat 1991, 68–69)

In these ways, black, brown, and yellow bodies signify the sexuality and criminality of white bodies—we serve as stand-ins while white bodies maintain their "innocence." Perhaps this explains why, during white women's early burlesque performances and "exotic dancing," they drew on black and nonwhite women's sexual expressions to construct their own erotic repertoire: begun most notably with the exhibit of belly dancing known as the "cooch dance," at the 1893 World Columbian Exposition in Chicago, which introduced new forms of sensual dancing to an American public (Brooks 2010, 15). This begs the question: If white sexuality derives from appropriating and colonizing black and nonwhite sexuality, is it any wonder that black women, as Giddings has pointed out, have not had a sexual revolution of our own (Giddings 1992, 462)? If our sexuality has been stolen and colonized, how can we testify to our own sexual liberation and sexual oppression? If our sexuality is constantly denied by dominant culture, or exaggerated into a hypersexual persona, how can our testimony be believed?

BLACK STRIPPER CHIC

If white women's sexuality derives from appropriating the black and nonwhite body, then such representations necessarily reduce blackness to the space of

the illicit, whereas whiteness functions as legitimate space. While the term "exotic dancer" derives from "exotic" dancing copied from a non-European context, the most forbidden spectacle originally relied on fantasies of black nude dancing bodies, as captured in early European accounts of travel in Africa as well as National Geographic–style documentaries of the type interrogated in postcolonial films such as Trinh T. Minh-ha's *Reassemblage*, which exposes the erotic titillation intended by the depiction of African women's nudity in ethnographic films, even while such displays suppress the pornographic gaze through the pretense of presenting anthropological education. We may also recognize the "black stripper" in the sensational performances of Josephine Baker in 1920s Paris.

This iconographic trope was highlighted in a *Newsweek* article entitled "Sex, Lies, and DNA," which reproduced many cellphone images of Crystal Gail Mangum captured by the party attendees in which her body was on full display, although her face was blotted out to "protect" her identity. These digitized images circulated throughout media without anyone's questioning whether such so-called "evidence" compromised the rape case or reproduced the pornographic male gaze. Similarly, a *60 Minutes* report included pictures of some sexually provocative dancing between the two strippers hired that night—Mangum and Kim Roberts—that reframed the two women as "lesbian," therefore as sexually "deviant," apart from their position as sex workers. The same *60 Minutes* coverage constructed the three lacrosse players as easygoing, hardworking college boys while it simultaneously reminded viewers that Mangum was just another illicit black stripper, as suggested by the video surveillance camera image depicting her pole dance at a strip club. The underlying premise of these images can be summed up in the question: Does this really look like a rape victim? It is hardly by coincidence that we have become accustomed to seeing the criminalized black body "caught on tape" through video surveillance.

These depictions are particularly troubling since they were so obviously designed to frame Mangum through recognizable and demonized tropes of the "black whore," "girl-on-girl action," or simply the "ho," to use radio personality Rush Limbaugh's words describing Mangum, or the "video ho," to use the derogatory labeling applied to the many black women who appear in rap videos. These particular media images, both the high-tech ones captured by the party attendees and those recast in news reports, connect to the prevalent imagery offered by Big Media, in hip-hop music videos, not just of the "video ho" but specifically of the "video stripper." The accuser's body became the "evidence" we needed to construct her as the "guilty party" while the Duke Lacrosse players remained "innocent" in mainstream

media discourse. Curiously, Mangum describes in her memoir how these same hip-hop music videos inspired the choreographed moves she utilized for her own exotic dance routines. However, as she concludes, these videos glamorizing exotic dancers are mere fantasy: "This kind of work is not about dancing gracefully and effortlessly. . . . The men and women [at strip clubs] do not think much of you. You will not become rich or even be able to be self-supporting" (Mangum 2008, 182).

The ubiquitous imagery of the "black stripper" is found not just in the music video realm (most notoriously depicted in rapper Nelly's infamous "Tip Drill" video). She also makes a brief appearance in the specter of Janet Jackson at the Super Bowl and in movies such as Jane Campion's *In the Cut*, starring Meg Ryan and featuring faceless black strippers whose presence frames the female protagonist's foray into illicit sexual experiences, and Craig Brewer's *Hustle and Flow*, in which the pimp protagonist (played by Oscar-nominated Terence Howard) is framed by the faceless women and disembodied buttocks that predominate in the film. Both movies illustrate how the black stripper continues to function as fetish object, existing only to further the agendas of white female and black male sexualities. By the time *Hustle and Flow*'s movie anthem, "It's Hard Out Here for a Pimp" by Three-6-Mafia, was performed on the 2006 telecast of the Academy Awards (where it was awarded an Oscar for Best Original Song), the image of "pimps and hos" was solidified and accepted in mainstream popular culture.

Specifically, hip-hop culture has contributed to this hyper-visibility of the "black stripper" in contemporary popular culture. As T. Denean Sharpley-Whiting argues, "Strip clubs are to hip hop what Zogby (polling) is to politics—an indicator of what moves the crowd. . . . Power moves and bottom lines have become decisively wedded to a booty clap [in the hip-hop market place]" (Sharpley-Whiting 2007, 119). In short, black women's hypersexuality marks hip-hop culture as both a lucrative business and an enticing culture of difference, signaling "urban dangers" and "exotic adventures" that contain sexuality in the realm of black deviance while whiteness remains "innocent" in these encounters with difference.

As a result, the "black stripper" image was already cemented in the popular imaginary and public discourse before Mangum (whose other roles included single mother, college student, and Navy veteran) could even make her case in the court of public opinion, let alone a court of law. Attention to these cultural atmospheres is sometimes elided in the sex work debates in feminist circles, which often reduce the subject to dichotomous constructions that oppose, for instance, violence against women to the need for a legitimate space for labor and sexual expression. Whether Crystal Gail Mangum in the

Duke case entered stripping as a means of paying her rent and her college tuition and supporting her children, or as a legal way to explore her sexuality while earning money, are women like her not entitled to a safe working environment? Moreover, if such work takes her to a paying customer's home, should she not be able to file a grievance if she is harassed or raped? Would we not support a nanny or housecleaner who filed similar grievances if s/he were assaulted in the workplace (often in someone else's home)?

Because our sex-negative, anti-poor, antiblack, woman-hating society does not readily acknowledge the basic rights of a sex worker, I find it imperative to call for a feminist discourse that bridges the two positions on sex work—violence against women versus sexual empowerment—and includes intersectional analysis to dismantle the complex narratives of race, gender, class, and sexuality. Some strippers and other sex workers may derive pleasure and a sense of sexual agency in the work that they perform, but we cannot overlook the fact that this work operates in a white imperialist and heterosexist system that is inherently oppressive and designed to contain and limit sexual expressions and acts through capitalist means. Moreover, we especially cannot overlook how this power dynamic that plays out on women at "point zero"[7] also frames women's work relations in other professions. However, just as black women are not easily recognized as "victims," neither are they recognized as "sexual agents." Part of sexual agency not only entails an ability to "say yes" to sexual expression but to also "say no" to sexual coercion and violence. If one cannot say "no," how can there be true sexual freedom?

DISCLOSURES: BLACK WOMEN'S RESISTANCE TO SEXUAL VIOLENCE

Despite a volatile history of racialized sexual violence, black women have found the courage to say no, to speak up and resist silence and to protest the outrages against our bodies, as I have already referenced with McGuire's recent history of the civil rights movement. Even before this era, Harriet Jacobs's *Incidents in the Life of a Slave Girl* began an important black feminist literary tradition of public disclosure. This 1861 slave narrative dared to expose sexual violence as it impacted on "house slaves" such as Jacobs. She further revealed the state of domestic violence as it existed in an antebellum, slaveholding household, and argued for her own respectability, despite being targeted for sexual assault. Such narratives set the tone for later creative works by black women, who would find the necessary language to "testify" to their experiences of racialized gender violence. Blues women, such as Ma Rainey, Bessie Smith, and Billie Holiday, took public disclosure to the next

level in songs that articulated sexual joys and sorrows, as well as struggles with racial inequalities.

In addition, Zora Neale Hurston documented domestic violence in her celebrated 1937 novel *Their Eyes Were Watching God*, which also explored the untold history of the effects of a Hurricane Katrina–like disaster upon poor, segregated black communities following the 1928 Lake Okeechobee hurricane in Florida, which resulted in the loss of nearly three thousand lives. Through her complex narrative of Southern black rural life, Hurston brilliantly intersects how race, class, and gender contribute to the tragedy of one black couple. Her literary depictions of African American folk culture would have a major influence during the 1970s, when the black liberation and women's liberation movements empowered black women to talk about taboo subjects. Authors such as Toni Morrison, Maya Angelou, and Alice Walker, in their books *The Bluest Eye*, *I Know Why the Caged Bird Sings*, and *The Third Life of Grange Copeland*, all published in 1970, addressed such subjects as incest, child molestation, and domestic violence.

In 1976, Ntozake Shange debuted on Broadway her choreopoem *For colored girls who have considered suicide/ when the rainbow is enough*, which not only gave voice to the marginal "colored girl" but also dared to touch on subjects such as abortion, acquaintance rape, and domestic violence, notoriously represented in the poem "a nite with beau willie brown." Unfortunately, a number of black male literary critics cried foul at this poem's negative portrayal of black men without acknowledging the brilliance of a poem that discussed—besides the brutal domestic violence situation that resulted in beau willie brown killing his children—postwar PTSD in the wake of his return from Vietnam and the difficulties he experienced when he sought veteran's benefits to treat his mental illness. For broadcasting such volatile issues, Shange was vilified by many in the black community, and in 2010, nearly forty years later, Tyler Perry's film adaptation inspired the same criticisms.

Alice Walker faced a similar public outcry and the accusation that her 1982 Pulitzer Prize–winning novel *The Color Purple* was a "male-bashing" work of fiction. These charges of male bashing escalated when the book was turned into a Hollywood motion picture in 1985, directed by Steven Spielberg. One could argue that the stereotypical representation of the "black brute" in the film adaptation lent credence to the outcry from those who thought Walker's novel recycled black stereotypes, but the critics' preoccupation with black masculinity obscured the more radical projects of black feminist liberation, same-sexual awakenings, and liberation theology espoused in the novel.

Curiously, the claims that such narratives only lend credence to prevalent racial narratives of black male brutality suggest that black women, as "subalterns,"

cannot speak. If such narratives fail to provide black women with sexual agency—under the premise that the dominant discourse merely re-objectifies our narratives and confines us within the sphere of black sexual pathology and deviance—we must still contend with the "fictions of whiteness" that render the "facts of blackness" so essentialist that they divorce the problems caused by sexual violence within the black community from the same problems as they are experienced in other communities. Domestic and sexual violence impacts *all* communities across all races, ethnicities, nationalities, and socioeconomic brackets. What black women reveal in their narratives impacts on *all* women. Presenting them as a "black problem" reinforces racial stereotypes and prevents multiracial dialogue on these social issues.

I am reminded of Diane Sawyer's interview with pop star Rihanna on *20/20*, which aired on November 6, 2009. After months of silence concerning her assault at the hands of her partner, R&B singer Chris Brown, Rihanna finally spoke about the situation. However, rather than frame Rihanna's experiences as yet another instance of the prevalence of domestic violence in the United States and across the world, Sawyer chose instead to treat Rihanna and Chris Brown as an anomaly and accused Rihanna of projecting a "fake" image of the strong black woman. "I *am* strong," Rihanna insisted to an incredulous Diane Sawyer, and has since projected imagery of hardcore masculinity and dominatrix-type femininity in her music trajectory.

Indeed, Rihanna has invited controversy with her depiction of themes of violence, which have shaped a number of her songs and videos. Part of the uproar from the public, I imagine, is tied to the release of a photo of her battered face on the celebrity gossip site TMZ, which was then circulated throughout media without Rihanna's consent. Because of this, Rihanna has had to wrest back control of the "victim" image foisted on her, and she in turn has challenged us rhetorically and visually to question and examine the power, danger, and violence that shape our intimate relationships. We see this in the videos for her songs "Russian Roulette," "Hard," "Love the Way You Lie" with rapper Eminem (about domestic violence), "We Found Love in a Hopeless Place," and "S&M," which flirts with bondage sex fantasies while simultaneously critiquing the media for keeping her tied (literally) to her "victim" image.

However, in her reggae song "Man Down," which invited further uproar for its violent imagery, Rihanna rejects the victim stance; in the video, she plays a rape survivor who guns down her attacker. When Barbados-born Rihanna locates this video in Jamaica, the birthplace of reggae, she not only returns to her Caribbean roots but also appropriates symbols of violent masculinity—the gun became a major trope in 1990s Jamaican dancehall—to

express female rage. The video's prologue recreates a Hollywood version of a dark-hooded femme fatale, but the unfolding storyline seeks to explain her motives, and we are invited to sympathize with a young island woman who, because she may have dressed and danced provocatively with a man at a dancehall, is seen as somehow "deserving" of rape. By pointing both a literal and lyrical gun at the issue, Rihanna asks viewers to consider what justice means in the context of sexual violence.

Through these narratives, it is almost as if Rihanna, in the wake of her abuse and the release of the photo of her battered face, has had to engage in a different type of masking and "dissemblance" to protect her vulnerability and to counter the debilitating image of the "abused black woman," who does not make a sympathetic victim. Moreover, black public discourse has reduced the issue to gender stereotypes: either one supports Rihanna against the "black brute" that Chris Brown had become, or one supports Chris Brown against the "angry black woman" who must have provoked his battery, or the "traitorous" black woman who turned him into the authorities (although it was a bystander who made the 911 call reporting this abuse). Such discourse, which reproduces simplistic dichotomies, is already supported by a popular hip-hop culture rife with sexual violence—not just in the violent language and images of hip-hop music but also in the documented abuses by popular rappers of their partners. In her exposé on the nexus between rap music and domestic violence, writer Elizabeth Mendez Berry queries, "When you get paid big money to call every woman a ho, at what point do you start believing you're a pimp?" (Berry 2005, 164).

Beyond the specter of intraracial sexual violence, I am also reminded of a different case of "domestic violence." Here I refer to Megan Williams, who was raped and tortured in October 2007 by six white supremacists in West Virginia, one of whom she had been dating. Because Williams was romantically linked to one of the perpetrators, Bobby Brewster, the initial response of outrage and shock at the heinous torture and "hate crime" to which Williams had been subjected drastically shifted to a discourse in which the violence was somehow "normalized" because it was connected to "domestic violence" and, therefore, did not seem so "horrific" or tantamount to the hate crime we had earlier believed it represented.

These public narratives should cause alarm, whether they involve intra or interracial violence or high-profile celebrities and ordinary citizens, because of how the bodies involved shape our feelings of outrage or disinterest. It is these particular narratives and stereotypes that shaped Aishah Shahidah Simmons's 2006 documentary film *NO!*, which sought to focus on the prevalence of the "black-on-black" crime of rape, not only to challenge

black communities' fears of "airing dirty laundry" but to also showcase how sexual violence permeates the lives of women from different socioeconomic backgrounds, as a number of perpetrators identified were not the criminalized "thugs" we have come to associate with rapists but were instead respectable citizens, community leaders, and educators. Simmons's most radical project in this film includes a segment on "healing," which involves women's creative approaches to reclaiming their bodies—including the activist work of rape survivor Salamishah Tillet through her art series and grassroots organization *A Long Walk Home*—and men's own political approaches to overcoming sexism and the normative construction of masculinity and its link to violence. These explorations of alternative outcomes involve addressing racialized sexual violence beyond our criminal justice system, which tends to re-victimize victims and racialize perpetrators.

Native scholar and activist Andrea Smith warns feminists and other antiviolence activists about working with the state: "Reliance on the criminal justice system to address gender violence would make sense if the threat was a few crazed men whom we can lock up. But the prison system is not equipped to address a violent culture in which an overwhelming number of people batter their partners, unless we are prepared to imprison hundreds of millions of people" (Smith 2005, 154). In other words, our righteous anger and rage need to address the inadequacy of the state's response to violence within our communities and what we, as feminists, must do about it. Smith further suggests community accountability and "restorative justice" (communal attempts to redress these crimes beyond putting more people into prisons), which requires rethinking criminal justice, since the present system is too broken to resolve our social and cultural problems.

In the meantime, rape survivors are still being categorized according to whether they are "good" people or not, as if such criteria determine whether they were "deserving" of the crimes committed against them. Is this kind of language helpful, or does it serve to further silence or marginalize victims? Moreover, can we as a multiracial community talk frankly about domestic and sexual violence without falling back on fears that such public disclosure will "land another brother in jail," "make the black community look bad," or reinforce black women's victimization or vilification?

Finally, what are we doing to resist the silencing of survivors' voices? In response to the Duke Lacrosse case, Alexis Pauline Gumbs, founder of the UBUNTU women of color survivor-led coalition and co-creator of the innovative high-tech Mobile Homecoming Project—explored further in chapter 4—argues for the mobilization of new media to speak out against sexual violence. In her essay, "The Revolution Will Be Blogged," she writes:

The reason I learned to make a blog was to share the work of my community of women of color and survivors of sexual assault in Durham, North Carolina during the media attack on women of color, sex workers and all survivors of sexual assault that accompanied the Duke Lacrosse rape case. We needed a media outlet worthy of our love when everyone from ESPN to BET was stepping up their ongoing game of shaming our names. . . . Beyond the hate speak, we found out who our people were. People documented their own National Day of Truthtelling events and vigils on their blogs. They broke the silence about gendered violence that they had survived or witnessed. . . . Once I learned there were blogs by loud, trouble-making women all over the Internet, I rode the Radical Women of Color blog ring like a merry-go-round. (Gumbs 2009)

I can agree with Gumbs on the importance of speaking out, for it was this supportive ring of voices and collective action through protests, rallies, blogs, and spoken-word poetry (my own included in this book's interlude) that provided sanity and calm in the midst of a cacophonous media blitz.

CONCLUSION: EMBODIED RESISTANCE

Despite the outcome of the Duke Lacrosse rape scandal, I commend Crystal Gail Mangum at the least for being outraged enough to report abuse, even though the cards were stacked against her. Whether or not she told the truth about what had transpired the night of March 13, 2006, there was enough "evidence" to suggest that some of the Duke Lacrosse party attendees were not completely "innocent"—from 911 calls reporting racial harassment to eyewitness accounts in the neighborhood of verbal altercations, to the racialized purchase of black strippers' labor by white privileged college athletes, even to a party attendee, lacrosse player Ryan McFadyen, sending an e-mail the night of the party that stated, "tomorrow night, after tonight's show, I've decided to have some strippers over . . . however, there will be no nudity. I plan on killing the bitches as soon as they walk in and proceeding to cut their skin off while cumming in my duke issue spandex . . . all are welcome . . ." The e-mail was later ruled by Duke University officials to be *not* hate speech.

These actions suggest that power imbalances of race, class, and gender surfaced in an ugly manner. Moreover, this evidence should not require the occurrence of rape to warrant outrage from communities that value social justice. Until sex (and sexual labor) is treated with mutuality and respect—

rather than as an arena to enact power and domination—we will continue to witness such intolerable displays of violence (both actual and symbolic). Until feminists confront the arbitrary division between "respectable" and "disreputable" women, an issue that gained visibility during the global and viral "Slut Walk" movement that began in 2011—after women in Toronto objected to a police officer blaming rape victims for "dressing like sluts"—we will continue to be ineffectual in addressing sexual violence and the different ways that women of color, low-income women, and sex workers are impacted by the devaluation and criminalization of their bodies in comparison to "respectable" white, middle-class, and/or heterosexual women. Until our sex-obsessed society envisions sexuality beyond commodity, we will continue to perpetuate "facts" and "fictions" of bodily difference and racial and gender hierarchies. Perhaps the most salient message is this: Until a black sex worker can successfully defend her right to freedom from sexual assault, no woman is safe.

Interlude: Hip-Hop Hegemony

Dedicated to the woman who reported being raped on March 13, 2006, at a private party hosted by Duke University lacrosse team players, who hired her to dance for $400, probably because she resembled the hip-hop music video dancer that they had seen on Viacom-owned TV.

I said hip hop
hip
hippety hip hop
and you don't stop
 don't stop
 don't stop
the onward march of new millennium protestors
fighting WTO NATO
 Halliburton
and UN incompetence
in the face of femicide, genocides
 and the military industrial complex
Are we still perplexed
by this new hip-hop generation
rising, shouting, resisting
the degeneration of an entire nation
 and Generation X
 Y

Zzzzzzzzzzzzz

Wake up, sisters (and brothers)
 Take back the mic
 and take back the night
and take back the right
 to rhyme

unmolested and uncoopted
by corporate controlled media
fueling machines of politics, war, and music
ipod tunes booming out soundtracks
in the ears of American soldiers
 stationed in Afghanistan and Iraq
stultifying and horrifying
woman-hating lyrics
laced to dull bases and beats
that take off the heat
as they ready
 Aim
 Fire!
on innocent civilians that look like terrorists

I said hip hop
hip
hippety hip hop
and you don't stop
 don't stop
 don't stop
gun shots keeping rhythm
to the bang bang boogie
up jumped the boogie
to the boogie of the rhythm of the beat
 beat
 beat
sounds of a cold and villainous heart
targeting a sand nigger
 who's not quite the real nigger
but close enough to trigger
a familiar rage and fear in a wigger
placed overseas by the bigger
 powers that be
spreading hatred, intolerance
 and a new age empire
of torture
can somebody say Abu Ghraib
 Guantanomo Bay
even Durham, N.C.

somebody anybody
 Everybody Scream!
loud enough to drown out
 that mechanical noise
emanating from homes, cars, bars
 and BET
impersonating the people
while denigrating the people
 and building murderous legacies
 and gluttonous palaces
on the blood
 of dead thugs

Rest in peace Tupac and Biggie
for I once delighted in your rappers' delight
 Keep ya heads up (even in the afterlife)
but how can there be peace for you
 when there's no justice for you
even while your voices crank out from
 commercial radio
is this the new spiritual medium
 owned by the same powers that be
spilling blood all over this planet
 that they sell out to the highest bidder
as if Mother Earth was ever for sale
 like the video ho they manufactured
marketing desire
 over love

Profits before prophecy
 decency
 integrity
but I fear for us more than for Terra Madre
who will rise up like her sister Katrina
 displacing her disobedient
 and disenfranchised
 children
who forgot to vote
 except for the next American Idol
so convinced were we by corporate rhymes

that our present system was righteous and fine
And now we bide our time

I said hip hop
hip
hippety hip hop
and you don't stop
 don't stop
 don't stop
these wars are ceaseless
(2006)

An earlier version appears in the special issue, "Women, Hip-Hop, and Popular Music,"
Meridians: Feminism, Race, Transnationalism 8, no. 2 (2008).

Part II

Geo Trackings

Chapter 4

Digital Whiteness, Primitive Blackness

Racializing the "Digital Divide"

Black bodies occupy a peculiar space in futuristic cinema. Look no farther than the 1999 box office movie hit The Matrix, which positions its main black characters in opposition to "cyberspace."[1] Morpheus, the celebrated techie and leader of armed resistance against the titular technocracy, first emerges on our hero Neo's computer screen, in which cyber news reports reference his underground existence as a "terrorist" eluding a "global search" by police and narrowly escaping this vast international manhunt. Morpheus's presence in this futuristic sci-fi film thus signifies on tropes of the criminalized black body under state surveillance. While The Matrix remains one of the few science fiction films prominently featuring black characters—which became a source of controversy when the Wachowski Brothers, the filmmakers behind this film trilogy, were sued for plagiarism by black science fiction writer Sophia Stewart, self-identifying as the "Mother of the Matrix"[2]—it nonetheless reinforces black people's hostile engagements with digital technology.

Lately, however, with the rise of early-twenty-first-century digital culture, the black male subject has been refigured and realigned with white masculine technological power. One example of this is hip-hop producer Timbaland's 2007 music video "Ayo Technology," which features rapper 50 Cent and pop star Justin Timberlake interacting with various video technologies, thus demonstrating how the black male body, no longer surveilled, is now juxtaposed with the white male body to engage in a different kind of surveillance predicated on the power of the male gaze. In this video, numerous female dancers from varying racial groups (visually coded as "strippers") play to and confine themselves to video surveillance. Specifically, women's bodies

are captured and reframed by cell phone cameras, hidden camcorders, and the music video's camera itself.

In light of this new alignment for the black male subject, what becomes of his "oppositional" stance in earlier representations of his access to and engagement with technology? Does he now get to join in a racially desegregated space of "Little Brothers," who have replaced Big Brother in the control over the global, corporately produced and consumed information of a twenty-first-century "technoculture," as Jodi Dean argues?[3] Moreover, if his newfound digital power is predicated on gender and sexual divides, what then becomes of the female subject in this latest narrative?

The latter question is of utmost importance when we consider that the black female subject continues to be racially and sexually marginalized within these systems of video surveillance. This is evident in the media narratives of the Duke Lacrosse rape scandal, as previously discussed in chapter 3. The media's images framed the body of Crystal Gail Mangum through pictures taken on the cell phone cameras of the party attendees and a video surveillance camera at a local strip club where Mangum worked even while news reports purportedly "protected" her identity, due to rape shield laws, by blotting out her face through software graphic tools. Such practices highlight technological scripts' re-objectification of marginalized bodies. These scripts are especially troubling when they recycle racist and sexist paradigms that have the effect of literally erasing black women's subjectivity while such women are reduced to their "illicit" black bodies. Moreover, within the context of sexual violence, digital technologies have already prompted service providers who work with abuse survivor populations to raise awareness of the ways that batterers are now empowered with high-tech gadgets to track and surveille their every move and pinpoint their geographic locations.

These contemporary examples of raced and gendered subjects, constructed in the realm of digital media and technology, suggest that the power dynamics that exist offline get reproduced online and in Big Media in disturbing and retrogressive ways. What we witness, then, are new media perpetuating old practices, thus undermining previous narratives, which posit cyberspace and digital technologies as progressive sites that allow for our transcendence from race, class, gender, and other markers of difference. When the Internet made its debut in the public sphere, for instance, advertisers were quick to boldly cast cyberspace as an arena that erased identity politics, where, as Coco Fusco ironically comments, " 'we' don't need to be concerned with the violent exercise of power on bodies and territories anymore because 'we' don't have to carry all that meat and dirt along to the virtual promised land" (Fusco 2001, 188; emphasis added).

Added to this are the ways that digital narratives, as Lisa Nakamura argues, simultaneously rely upon imperialist fantasies of racial difference to shape much of the imagery and discourse of the World Wide Web. Cyberspace ads, Nakamura posits, thus create "images of the Other in order to depict its product: a technological utopia of difference. It is not, however, a utopia *for* the Other or one that includes it in any meaningful or progressive way" (Nakamura 2000, 25; emphasis in original). Although advertisements are designed to advance optimism for a product, such as cyberspace in this instance, we may want to question, as other scholars have done with regard to technology discourse and gendered and racial constructions of digital technology, why we continue to view digital media as the panacea for our social ills while imagining that issues of "access" to computer technology, as articulated through discourses of the "digital divide," are the predominant concerns for social justice in the information age. We may also want to examine how much of this discourse is racialized to project images and attitudes that associate technological advancements with certain culture-, gender-, and class-based identities even while assuming that such technologies can advance us toward a society in which race, class, gender, and nationality lose their meanings.

Virginia Eubanks, creator of the Cyberfeminist e-zine "Brillo" and author of *Digital Dead End*, suggests, "As more power (economic, freedom of expression, educational attainment, political participation) is being routed through the [digital] network, it becomes increasingly important to rethink how we design sociotechnical systems . . . [including] discourse [about these systems] . . . in ways that enable broader public access, more flexible systems, increased democratic participation, and egalitarian distribution" (Eubanks 2004a, 170). For the purposes of this chapter, I wish to explore the discourse of such sociotechnical systems as cyberspace and analyze how their representation has perpetuated an expectation for "digital divides" along race and gender. I specifically revisit an earlier mode of cultural narrative—the futuristic science fiction genre of mid to late-twentieth-century cinema—to consider how tropes of technological progress are racially constituted for both contemporary and projected future expectations. Contrary to the "cyborg manifesto" of Donna Haraway in which cyborgs "require regeneration, not rebirth, and the possibilities for our reconstitution . . . [of a] world without gender [or race]" (Haraway 1991, 180), we instead witness in these sci-fi films reinscriptions, *not* regenerations, of the same old meanings of race and gender in cyborg imagery.

In light of the complicated relationships that marginal groups have with technology, including women, people of color, and communities of the global

South, I argue that representations of technology recreate social and cultural hierarchies that encourage appropriation and colonization of knowledge and bodies from marginal communities, even while our technological scripts deny the existence of any such knowledge worth mining and downplay the exploitation of the labor produced by these bodies. Yet, this same technology holds massive potential as a tool for social justice.

I further argue that our cultural narratives, which posit a racial digital divide, are rooted in the historical experience of enslavement, colonial conquest, racial segregation, and scientific racism, which have discredited the knowledge base of women and communities of color while lauding Eurocentric constructions of "progress" and "civilization" as the domain of white masculinist power. Radhika Gajjala and Annapurna Mamidipuni suggest that this historical precedent is very much in line with contemporary discourses about the Internet. As they argue:

> In the presence of Enlightenment from the West, several non-western modes of thought and life were implicitly and explicitly constructed as "backward," "traditional" and "ignorant." The peoples of these regions were thus de-empowered. . . . Within this context, how can the Internet and other digital technologies be used to re-empower people in "third-world" de-empowered contexts whether they are located geographically in the West or the East? Even as the Internet and digital world construct many as "ignorant" yet again, can we possibly use these tools for re-empowerment? (Gajjala and Mamidipuni, 2002)

Expanding on Eubanks and Gajjala and Mamidipuni, I suggest that only by exposing the racial and colonialist roots in contemporary discourse and representation of cyberspace and other digital media can we begin to unmask these power structures that position marginal people as either "outside technology" or as "passive subject of the technological gaze" (Piper 1997). In revealing the power differentials, we may begin to reimagine marginal groups' existence within the technological narrative even as they reconstitute it for their own identity formations.

It has been argued that the "digital divide" is the twenty-first-century manifestation of the twentieth-century "colorline."[4] However, strides have been made to reduce this perceived technological divide, and increasingly more women and people of color participate in the digital revolution. Yet, our cultural scripts—such as popular films and visual culture, which are examined in this chapter—have constructed a racial ideology *about* technology

when such divisions are invoked. By associating whiteness with "progress," "technology," and "civilization," while situating blackness within a discourse of "nature," "primitivism," and premodernity, the digital divide amasses cultural and racial weight while highlighting among marginal groups hostile interactions with such technology. However, a growing corpus of work by black artists, who engage in digital technology and science fiction, and Web 2.0 participants, who merge digital narratives with activism, has exposed these mythic constructions by reimagining black bodies beyond technological exclusion and surveillance.

In what remains, I first delve into the history of the technological divide between whiteness and blackness, as reflected in nineteenth and twentieth-century world fairs and cinema, prior to assessing contemporary themes of race and technological surveillance in turn-of-the-twenty-first-century science fiction films. I then connect these cinematic representations to the work of black artists, who underscore the presence of marginal groups in the realm of digital technology. Finally, I conclude by questioning whether or not social "revolutions" for racial equality and inclusion can, in fact, be "digitized."

A QUESTION OF PROGRESS

It is imperative that we recognize the racialized narrative of the "digital divide" as one that pre-dates the digital revolution. In particular, the Industrial Revolution, financed by Europe's colonial expansion and the transatlantic slave trade, gave way to a period of scientific development, which sought to order a racial and global hierarchy of power: from Napoleon's Egyptian expedition in 1798, which, as Edward Said argues, gave rise to Orientalism through acquisition of non-Western indigenous knowledge and culture,[5] to the trafficking and exhibiting of dark foreign bodies from colonial outposts onto the European continent, which constructed narratives of "primitive" peoples, most notably in displays of Africans. These colonial examples set the precedent for subsequent voyages and human displays in the nineteenth and twentieth centuries, which further developed scientific discourse that asserted racist and eugenicist sentiments heralding the advancement of the "white race" and the subjugation of inherently "inferior" nonwhite people whose bodies were framed in visual documentations of this "difference."

Before cinema was invented, other realms of visual culture, including early photography, fairs, and world expositions, fused popular and scientific rhetoric that cemented this cultural and "natural" divide between whiteness and blackness.[6] The bodies of people of color, especially women of color, usually depicted in semi-nude and nude displays, received intense scrutiny

from fully dressed Europeans in attendance at such fairs, while their exhibits—
often signifying on narratives of an underdeveloped rural lifestyle—provided
contrasts with the urban architecture, science, and technology advanced by
white "minds." One of the most impressive world fairs in American history
followed in this trajectory with the 1893 World Columbian Exposition in
Chicago, set against U.S. southern lynchings and the "scramble for Africa"
that ensued between the European imperialist powers.

Not surprisingly, exhibits at this fair, which already gave us the
"cooch dance," as mentioned in chapter 3, also displayed "primitive"
African "savages"—including a Dahomey village, featuring bare-breasted
women described in "full dress"—in sharp contrast to the advancements
of technology and "progress" that defined the "White City" representing
American culture and duly nicknamed because of the impressive buildings on
the fairgrounds whose stone facades appeared a glistening white. Subsequently,
the irony of the fair's nickname was not lost on people of color, nor was the
obvious goal of promoting white supremacy. Moreover, the fair marked the
four hundredth anniversary of Columbus's "discovery" of America, a bitter
reminder of Native American defeat, made evident by the recent massacre
of the Lakota Sioux tribe at Wounded Knee in 1890. When we consider
that Sitting Bull, one of the fallen heroes associated with this battle, had
previously performed in such ethnographic exhibitions as Buffalo Bill's Wild
West show, we are reminded of the power of social representation to reinforce
social reality. The "White City" further dramatized the exclusion of most
people of color. In response, notable African Americans, including Frederick
Douglass and Ida B. Wells, prepared a pamphlet in protest, titled *The Reason
Why the Colored American is Not in the World's Columbian Exposition*, and staged a
boycott against an organized "Colored People's Day."

Then, as now, communities of color recognized the importance of
waging an ideological battle against their exclusion from participation in
technological narratives, especially when their invisibility from such discourse
corroborated other scripts that highlighted their "natural" positions in
primitive underdevelopment, as illustrated in the display of "savage" Africans
and even in the debut of Aunt Jemima on the fairgrounds of Chicago,
thus eliciting a parallel view of domestic black subjugation (in this case,
a vestige of the "old days of slavery"). Images of both Aunt Jemima
and the Dahomey Amazon supported contemporary efforts in U.S. racial
segregation and European imperialism on the African continent, actions that
both Douglass and Wells resisted through their pamphlet. However, while
Douglass lamented, "as if to shame the Negro, the Dahomians are also
here to exhibit the Negro as a repulsive savage" (Rydell 1999 [1893], 13),

Wells flipped the script of the world fair, suggesting, in her essays on white cruelty exemplified by lynching, black disenfranchisement, and the convict lease system that reintroduced slavery, that the real savagery lies not in the primitive displays but in the morally bankrupt white supremacist class system framing the exposition: the White City recast, to use Douglass's words, as a "whited sepulcher" (Rydell 1999 [1893], 9). Nonetheless, the trope of advanced whiteness and primitive blackness, stemming from Africa, shaped subsequent shows and exhibitions at various world fairs.

Africa, not just as a continent but as a site that Hegel claimed had no history, has long existed in the Western imagination as a netherworld and a counterpoint to Europe's self-image of advancement, science, and technology. From the vast savannas and dense jungles that were labeled by European explorers as "terra nullius" (vacant land)—ripe for conquest and development—to the diverse animals and peoples, whose dark skins created an "Africanist presence," as Morrison argues, or "the dramatic polarity of . . . otherness [and] alarm" (Morrison 1992, 38), the continent became a mythical concept, forming part of a racialized binary between the "blackness" of nature and primitivism and the "whiteness" of development and civilization. Far more intrinsic in this dichotomous construction of "race" is the way in which the bodies that emerged from the continent hyperbolized into fantastical creatures—slave-ship cargo, savages, "missing links" between apes and humans, sideshow curiosities, and, most recently, downtrodden victims of all manner of evil, including genocide, famine, and the AIDS pandemic.

Such is our understanding of a fabricated and remapped "Africa." It is this powerful iconography around which present-day developed nations could rally for global charity—as in the "Kony 2012" campaign that condemned Ugandan warlord Joseph Kony through graphic images of suffering children or in celebrity charity efforts spearheaded by the likes of U2's Bono, Madonna and Angelina Jolie's adoption of African "orphans," and Oprah Winfrey's private school for girls in South Africa—and to which Africanists and Afrocentrics alike have advocated for counternarratives that identify rich cultural legacies of indigenous progress and civilization. Yet, this oppositional discourse reinforces the cultural divides in place since it does not offer an alternative model nor redefine the parameters of "civilization."

The defensive claims of the existence of African progress, as demonstrated in Balufu Bakupa-Kanyinda's 2003 documentary video *Afro@ Digital*, which earnestly embraces the digital technologies made manifest on the continent, are the product of an anxiety wrought by centuries of derogatory images and sentiments that uphold white superiority and black inferiority.

That *Afro@Digital* chose to explore an ancient artifact that could substantiate Africa's position as the birthplace of science and mathematics, rather than examine the briefly referenced present-day impact of violence and genocide in the Congo, a result of the political struggles over the mining of coltan, a raw material used in computer chips and cell phones, speaks to such anxiety and proves that cultural arguments—rather than issues of political economy—still shape the agenda of black nationalism. On the other hand, comments from my students, who upon viewing this video marveled that Africa isn't such a "backward" place after all, lend support to the filmmaker's concern with redressing the "digital divide."

WHITE FLIGHT FROM THE PLANET OF THE APES

Such anxiety-laden films emerge in response to a weighty cinematic history, based in Eurocentric thinking, in which early films more than highlighted the iconography of African primitivism, most notably in the icon of the ape. A popular trope in sideshow attractions, zoos, and world fairs, the "African ape" was linked to the African body in ways that reverberated back to scientific racism, which circulated vitriolic concepts of black animalism and primitivism that borrowed loosely from Darwin's theories of evolution and Aristotle's ancient model of the "Great Chain of Being." As popular culture and science combined in their perpetuation of racist stereotypes, cinema provided a worldwide arena in which these images proliferated. Perhaps the most enduring of these images is the magnified spectacle of King Kong (both in the 1933 original and Peter Jackson's faithful 2005 remake) atop the Empire State Building, the epitome of white progress and civilization contrasting with this "primitive blackness," or in the 1968 film *Planet of the Apes*, which debuted at the height of the militant black and third world liberation movements and spawned various sequels and reboots, most recently in the 2011 film *Rise of the Planet of the Apes*.

While it was popularly understood among African Americans that *Planet of the Apes* was symbolically "about us" and the social threat of black advancement in civil rights struggles, few have considered whether or not the apes in another 1968 film, Stanley Kubrick's *2001: A Space Odyssey*, also represented us. Through one of the most famous jump cuts in film history, spanning millions of years in "evolution," Kubrick's *2001* constituted in a prophetic way the "digital divide" that we have identified as our twenty-first-century "colorline." If anything, the film is ultimately about "white flight," escape and transcendence from the "planet of the apes."

"White flight" specifically refers to the period of the fifties and sixties when white communities eagerly fled urban spaces, where communities of color congregated as a result of federal policies of "red-lining" that perpetuated racially segregated housing; the creation of suburbia, as TV scholar Lynn Spigel notes, thus paralleled the development of a different type of white flight during this cold war era: outer space travel. Spigel further comments:

> This colonialist fantasy . . . existed on two levels. On the one hand, the fantasy of white flight was exhibited by the federal government's Cold War strategies to "contain" communism abroad. On the other hand, this fantasy can be seen at the level of everyday life in white America with its attempts to preserve racial segregation and female subordination at home. (Spigel 1997, 49)

Placed in this context, Kubrick's outer space setting invites a reading of the colonialist fantasy in which our only glimpse of life on planet Earth is situated in the "Dawn of Man" when our ape ancestors, on the verge of famine in Africa—another "primitive" script concerning Africanist depictions—learned to use tools for hunting and conquest, thus transforming from "animal" to "man" in the evolutionary "Great Chain of Being" that imagines these apes enlisting the help of an alien life-force (represented by the black monolith that inspires the tribe's leader) in this major step in "progress." Even as the narrative questions such advancements (which still rely on outside intervention) by noting that this development leads to murder, the moment of transcendence occurs as a celebratory point when the movie's theme, Richard Strauss's *Thus Spake Zarathustra*, trumpets over slow-motion shots of our ape-man dramatically grasping a bone from the remains of a carcass as his stride steadily gains strength in positioning this early tool as a potential weapon.

As the action moves, in the jump cut, to outer space in the year 2001, Kubrick offers us a glorious vision of "white" progress: from the impressive white spaceships waltzing to the non-diegetic music of Johann Strauss's *The Blue Danube* to the all-white crew and passengers gracefully striding in a zero-gravity atmosphere, to the glistening white environment of futuristic art décor. The gender dynamics, devoid of any influence of the sixties' burgeoning women's liberation movement, are fully entrenched in the dichotomies of white masculine space flight and scientific prowess and white feminine decorous servitude. Far away from planet Earth—our last view of which depicted our ape ancestors—this technological divide is one of social

and cultural "evolution" in which the hierarchical order of white masculinist imperial power becomes naturalized.

White flight, then, results not just in the escape from the inner city or planet Earth, but also, it seems, from the body itself. As Dyer argues, unlike blackness, which is reduced to the corporeal and thus to race, whiteness is disembodied, or "the white spirit [that] could both master and transcend the white body, while the non-white body [is] prey to the promptings and fallibilities of the body" (Dyer 1997, 23). Not surprisingly, this disembodied whiteness manifests in the cool, scientific, and unemotional interactions of the astronauts, who appear less dynamic than the computer HAL—a character not only of artificial intelligence but the essence of disembodied whiteness: the white mind whose god-like control over the spacecraft's journey to Jupiter leads to a final showdown with our protagonist Dave Bowman. However, when Dave embarks on his deep-space journey "beyond the infinite," his final station—a simulated hotel room where he witnesses his own rapid aging and ultimate transcendence from his fragile body—enables his evolution to pure digitized whiteness in the form of a "star child" in the womb of the universe.

What remains invisible in this narrative is the way in which a primitive blackness defines the boundaries of this transcendence to ultimate white spirit and mind. From the apes of planet Earth to the blackness of deep space, and from the mysterious monolith to the unseeable "womb" of the Mother of the Universe (a black feminine figure), which carries our "star child," this "Africanist presence" frames and gives breadth to digital whiteness. Yet, considering the ambiguity of Dave Bowman's confrontation with HAL when he enters the computer mainframe to dismantle its powers, we might question whether or not Dave's flight into deep space was actually a fabricated dream conjured by HAL.[7] If this is the case, then Kubrick's predictions for 2001 were far more prophetic than we imagined: envisioning the "infinite" possibilities of inner (or cyber) versus outer space travel. Nonetheless, the main interpretation that this is Dave's journey, and not HAL's, offers an urgent lesson for the twenty-first-century wired generation: namely, if we are to envision an expansive universe and acquire immense knowledge, we must "unplug" our computers and assert our freedom from technological dependency.

TECHNICAL DIFFICULTIES

The Internet has manifested much like Borges's map of the Empire, as Baudrillard describes: superimposing visions of reality through signs and simulations of a "hyper real." However, as Spigel notes, "Like outer space

before it, cyberspace is also being populated by mostly elites who can afford the technology, and its parameters are mostly developed in the research labs of the global communications industry" (Spigel 1997, 67). Referencing the digital divide, Spigel reminds us that the virtual reality of cyberspace parallels other environments perpetuating racial and class segregation, especially in its links to other historical moments of technological development.

Interestingly, this construction of cyberspace as the site populated by an elite white class, while others fail in their access to it, has already entered into our popular culture. Perhaps the best example of this resides in the Wachowski Brothers' *The Matrix*.[8] Although the film is often viewed as celebratory in its inclusion of black characters, *The Matrix* manages to recreate the "digital divide," since its premise concerns armed resistance against the technocratic world of machines by humans led by a black character, Morpheus (played by Laurence Fishburne), whose motivation still resides in locating "The One," Neo (played by Keanu Reeves), the white savior of the human race, as well as the one who can master and manipulate computer technology.[9] Thus, Morpheus's primary role is that of the "guardian of reality" in which, as David Crane argues, "blackness functions to authenticate—and envision—oppositional identities and ideologies associated with cyberspace" (Crane 2000, 87).

Indeed, the visibly black residents of the multiracial Zion depicted in *Matrix: Reloaded*, the 2003 second installment in the film trilogy, dwell in caves and boogie down to premodern percussion, highlighting the primitivist impulse of those who are outside the machine's mainframe, which generates the Matrix—the cyberspace realm of the "dream world" for those (primarily white) who remain plugged into the system. By contrast, the Matrix—reigning supreme in its high-tech virtuality—resembles a grand, stylized metropolis in which Neo, humankind's "savior," is too busy enjoying the disembodied powers of his mind, taking flight and opening infinite doorways and paths that lead either to an Orientalist landscape (such as an Asian city where he encounters Seraph, the "Buddha" depicted in code) or to the Africanist space of the inner city (where he reunites with Oracle, the wise elderly black heroine of the first film of the trilogy). Incidentally, both these figures of color turn out to be software programs, thus suggesting that nonwhite bodies and sites in cyberspace can be commodified and appropriated to reinforce what Nakamura calls a "technological utopia of difference."

Morpheus, however, is one of the few black characters who moves in and out of the Matrix with great skill; yet we are reminded in the first film that his function is that of a "hacker," a trespasser in cyberspace, and a terrorist wanted by state agents (vilified in the trilogy as white male machine

gatekeepers of the technocracy) who also manages to elude police until he is betrayed by one of his crew. When Morpheus is finally caught, the film actually recreates the Rodney King video moment, as Morpheus loses his battle with Agent Smith and is eventually cornered, subdued, and beaten by a mob of police agents. Taking into account the importance of the 1991 Rodney King video—an amateur video recorded by eyewitness passerby George Holiday—as technological evidence of racial violence, which was later re-scripted and reframed to support racial suppression (this video was used in the Simi Valley trial to contest charges of police brutality, resulting in a not guilty verdict and subsequent rioting in Los Angeles and other U.S. cities in 1992), it contributes to what writer Elizabeth Alexander describes as the "national narrative [that] deliberately contradicts the histories our bodies know" (Alexander 1994, 94).

Significantly, in film narratives about cyberspace, black bodies that interact with technology are tracked for surveillance and severely punished. As Crane reminds us, the Rodney King moment that occurs in *The Matrix* is also featured in an earlier science fiction film, Kathryn Bigelow's 1995 *Strange Days*. Within the story of this film, virtual reality is also explored. Through the development of a fictional contraption, a superconducting quantum interference device, or SQUID, first used for police surveillance technology, the film narrative explores the artificiality of human experience as the technology descends into the illegal market of tech piracy where our antihero, the ex-cop Lenny (played by Ralph Fiennes) "peddles the pieces of other people's life," as one character describes it. Designed to record and play back an "experience"—often illustrating the transgressive boundaries of human criminal behavior—SQUID's development projects a dystopic view of the future (in this case, the end of 1999 and the beginning of 2000 in Los Angeles) in which reality becomes blurred as hyperreality.

Much like Morpheus, the main black character, Mace (played by Angela Bassett), resists the use of this technology, routinely admonishing Lenny to "get real" and resist the "toxic cesspool" that his new trade represents. Linguistically, Mace links technology to the downside of "progress," as demonstrated in her allusion to environmental pollution resulting from industrial development. It is only upon Lenny's insistence, however, that Mace succumbs to the use of SQUID to witness a moment of racial injustice, the playback images of which are shown to the audience in Mace's POV shots.

Mace's playback is specifically troubling since it replays for us the Rodney King moment, as a marginal character, the black rapper Jericho-One, is gunned down by the LAPD. While the POV shot is offered to us through Mace's witnessing of the "video"—through the recorded "eyes" of another

marginal character, Iris, a white sex worker whose body was offered to the audience earlier in a graphic rape and strangulation scene from the POV shot of her rapist-murderer—we experience the terror of the technological gaze on raced and gendered bodies as Mace undergoes victimization while observing a scene of racial oppression. As such, Mace's interactions with technology—both as technophobe and object of its gaze—further distances her from any possibilities of embracing the digital revolution in positive ways while the film contradicts the history (of the Rodney King video) that Mace's body already knows, to reiterate Alexander's point. We are reminded of this specifically through another reenactment of Rodney King's beating, with Mace's body as the target of both police and military personnel who surround her and proceed to club her mercilessly while she lies powerless on the ground in the midst of a crowded New Year's Eve celebration toward the end of the film.

The rewriting of the Rodney King riots in LA occurs when the multiracial crowd, guided by the protests of a young black boy, mobs the police in an effort to halt the brutality. This revisionist history—accomplished through the lens of futuristic cinema—erases the racial tensions and divides that stem from the rage and despair of communities of color in response to police surveillance and injustice, and refocuses the "mob violence" to an action that seeks to provide patriarchal protection to the helpless female victim. It recasts this "riot" as an anarchic and celebratory moment in which the multiracial LA crowd responds to Mace's beating by police with the euphoria of New Year's Eve and the "end-of-the-world" millennium. Bigelow's reframing of this infamous beating through the feminized body of Mace (albeit a muscular body that emphasizes Bassett's well-built physique and her physical prowess in the film's many violent spectacles) further encourages movie audiences to view the victimized black male body as a feminine subject, even though Mace's hypermasculine black female body—once again, interpreted as "less feminine" in comparison to white female bodies—complicates the interstitial relation between race and gender. Here, gender differences are erased as the film racializes the black body as the sign of the primitive and the marker of transgressive and oppositional forces subject to state and technological control.

DIGITIZING BLACKNESS

In response to narratives that negate black bodies' technological encounters, Afro-British artist Keith Piper complicates the discourse through his 1997 computerized game "Caught Like a Nigger in Cyberspace," designed by

macromedia software. As Piper remarks, "I was struggling to envisage a Rodney King computer game," in which "the black presence [in cyberspace] would always be a trespassive one" (Piper 1997), as evidenced at the beginning of the game in which the black male avatar is positioned as a "target," both in terms of the mouse's location, where we are invited to "click on" his profile to "interrogate," and in the surrounding images of a gun targeted at his head and a lynch rope not far behind. Through the guise of satire and racial stereotyping (e.g., gamers can choose as their avatar an "Al Gore lookalike," a hacker-type "Techie," or a silhouetted black Other), this "game" transports us to the realm of cyberspace, advertised on a billboard in the vast expanse of the modern city.

However, while the Al Gore lookalike receives full access to the grand and glitzy world of the "Information superhighway," the black Other encounters several virtual roadblocks while attempting to "apply within" to access the privileges designed, apparently, for the white nuclear family who desire further white flight onto the "new frontier." While the black avatar is presented with two choices—either to not worry as he "finds contentment in premodernity" or to wait for his application to go through (in a simulated waiting room resembling an airport terminal with the sounds of elevator music echoing during his eternal wait for approval)—a third choice is offered as a non-choice in which he is forbidden access; it is only in "trespassing" that he encounters the hostility to his "rogue virus" position in cyberspace as he is targeted for extermination through a "barrage of tech jargon." It is a reminder of digital culture's resistance to racial difference even as it revels in racial fantasy.

In the wake of Piper's interactive digital game, black artists, much like other participants in our high-tech information age, are now fully immersed in digital technologies—thanks in part to the proliferation of accessible software programs and social networking sites that have been developed to counter a "barrage of tech jargon." Granted, we may recognize how communities in the African Diaspora had already taken part in technological scripts, whether through innovative uses of mobile phones on the African continent or in African American music, as Ben Williams has argued, pointing to the musical developments of hip-hop and techno as digital innovations employed by black deejays who surf the Internet for their remix samples.[10] Moreover, the multimedia, grassroots activist work of Alexis Pauline Gumbs and her partner Julia Roxanne Wallace showcase the even more expansive ways that black digital artists engage with these technologies.

Gumbs and Wallace's "Mobile Homecoming" project, begun in 2009, radically interweaves the "mobile" spaces represented by their recreational

vehicle, wireless access from their vehicle, and digital social networks—including wordpress, ning, Google Maps, Facebook, Twitter, and Vimeo—in documenting their communally-funded road trip across the United States to bridge history with community art and generational gaps within queer black communities. As they offer in their mission statement:

> Our RV [revolutionary vehicle] will not only travel through space, it will travel through time, sitting in the untimely place where this anomaly, this miracle, queer black initiates, media makers, adventurers transmitting history and reframing the future in a mobile home, is possible. We see the RV itself as surrounded in two-way windows, as we take in the lessons that the land and the people have to offer and transmit the insights of our journey out to the world. What would it mean to have a vehicle that is both state of the art and ancient [?] Where wireless streams, and ancestor lessons echo at the same time, where the turning of the wheel is a historical function, fueled by futuristic faith? (Gumbs and Wallace 2009)

Their vision and actions, which include mobilizing the black female body in both geographic and digitized spaces, provide a queer and communal spin on the adventures of Oprah Winfrey and her best friend Gail's televised cross-country road trip featured on *The Oprah Winfrey Show*, and—in a black diasporic and digital context—resemble the work of Oumou Sy, a Senegalese fashion designer featured in *Afro@Digital*, who powered her own "cyberbus" to bring Internet access to remote villages in Senegal, advertise her business, and create jobs for hundreds of workers.

Such insights and innovations demonstrate that black women no longer need to be confined by their race and gender—either physically or psychically. They also showcase how everyday computer users can transcend corporate expectations for passive consumerism and instead mobilize the technology for community, enterprise, creativity, and activism. Not only that, but black participation in and artistic intervention within the digital revolution continue to subvert and redefine our digital narratives.

A provocative example of this is the work of artist and filmmaker Ayoka Chenzira, who has created what she calls "tangible cinema." Her interactive cinema installation *CrazyQuilt Sightings* (Fig. 4.1) specifically incorporates three-dimensional art through different fabrics, representing the quilting element alluded to in the title, and the computer interface, which includes varied oral testimonials and images relating to the Hurricane Katrina aftermath in New Orleans. Using an interactive haptic cinema multi-touch

tabletop, Chenzira allows users to "build their own crazy quilt as they move items into a position and trigger a connecting video clip" (Chenzira 2007). Through her multimedia work, Chenzira demonstrates how digital technologies can be utilized, not only to shape art and cultural traditions—in this case, the tradition of African American women's crazy quilts to elaborate on black experiences of natural and political disasters—but to also encourage communal physical interactions (not just virtual ones) and shared memories. Such "tangible" approaches to cinema and art gesture toward future possibilities that expand black women's participation and representation in new territory and a new digital imaginary.

These engagements with digital media productions have led to Chenzira's development of an ambitious, interactive transmedia science fiction film, *Her*, which grapples with the subject of violence against women and imagines a superhero black goddess-like alien, who journeys to Earth to avenge against

Figure 4.1. Ayoka Chenzira, "CrazyQuilt Sightings," 2007. Interactive Haptic Cinema Production on the Digital Tabletop. Permission of the Artist.

the forces of patriarchy. Chenzira portrays our pink-haired heroine sporting a Zulu-locks hairstyle, with her well-toned, translucent CGI body depicting diverse women's faces—appearing rather like digitized tattoos of moving images. In rendering futuristic cyborgs through a black feminist aesthetic, as well as by illuminating how the body is a site of memory, history, and hybridity, Chenzira conveys a feminist "Afrofuturism."

A term coined by technoculture scholar Mark Dery, Afrofuturism refers to the complex black cultural signifying of technological practices developed by dominant culture. As Dery queries, "Can a community whose past has been deliberately rubbed out, and whose energies have subsequently been consumed by the search for legible traces of its history, imagine possible futures? Furthermore, don't the technocrats, [science fiction] writers, futurologists, set designers, and streamliners—white to a man—who have engineered our collective fantasies already have a lock on that unreal estate?" (Dery 1994, 180).

Visionary artists such as Chenzira have unlocked the gates to this "unreal estate," as have countless other black digital artists who have articulated an Afrofuturism to be found, as Dery further argues, "in unlikely places, constellated from far-flung points" (Dery 1994, 182), as seen not just in the street cultures of hip-hop music, graffiti, and breakdancing—genres that have remixed the sounds and detritus of a technoculture—but also expressed in metaphors connecting the slave past of abduction and captivity to the alien and robot future based in similar oppressions and struggles for liberation. Another manifestation of Afrofuturistic feminism is the music of Janelle Monae, who indulges a science fiction fantasy for her 2010 concept album *The Arch Android*. Inspired by *The Matrix* and its earliest predecessor *Metropolis*, Monae performs as "Cindi Mayweather," the messianic cyborg who emerges in the year 3005 to save the masses, who have few choices—"dance or die"—in a dark, machine-driven civilization that suppresses love, musical artistry, and individuality. Articulating Cindi Mayweather through her black female body and creatively remixing the genres of hip-hop, disco, soul, funk, jazz, and film scores, Monae effectively disrupts expectations for "primitive blackness" since her imagined revolution is not based in liberating the masses from technology but, rather, in mediating between the two impulses of digitization and "nature," thus leading to a transcendent, trans-human creation that blends humanity with virtual fantasy and history with the future.

As these artistic models suggest, the "digital divide" is less about "access" and more about how we may begin to challenge and subvert the technological dominance of a privileged few with global repercussions that impact all of us, especially now that we have become so closely connected

in the information superhighway. Marginalized groups, in particular, feel the impact of the high-tech age in profoundly personal and political ways. However, they are not just acted upon by technology; they have a creative and dynamic role in shaping our digital culture.

This is worth noting *and* worth repeating since dominant popular narratives continue to construct ideologies of "digital whiteness" and "primitive blackness." James Cameron's 2009 futuristic 3-D film *Avatar,* debuting ten years after *The Matrix,* is a case in point. Despite its visually intense, groundbreaking digital imagery of a fantasy tribe on a faraway planet called Pandora, *Avatar* recycles a rather clichéd colonialist tale akin to Pocahontas and the white man's "burden" in aiding "natives" against white imperialism.

The inhabitants of Pandora, called Navi, who appear to be long braid-haired blue-skinned amalgamations of Native Americans and Africans, are lauded for their harmonious relationship with their natural environment. However, their tails and their animalistic movements as they climb and dwell in trees, harken back rather dangerously to nineteenth-century scientific constructions of nonwhite primitivism and the "noble savage." Moreover, the white hero (played by Sam Worthington), a disabled soldier who gains access to the world of the Navi through an avatar-driven computer program, still relies on "white flight" fantasies in which his disembodied presence enables him to appropriate the body of the Other.

Once again, whiteness is allowed diverse adaptability and escape in the virtual world—not unlike the escapist fantasies of avatar-driven sites such as Second Life—while blackness (yes, even under the guise of a "blue body," which alludes to "color-blind" racialized discourse that pretends to dismiss the importance of race with statements such as, "I don't care if you're black, white, or blue!") is constantly under technological surveillance—as occurs with the Navi in this film.[11] Certainly, these imaginative virtual landscapes offer us exciting and innovative cinematic visions. The racial ideology, however, needs an upgrade.

Other sci-fi imaginations are possible beyond Hollywood cinema, not just in the examples of Chenzira and Monae, but also in the realm of African cinema. Kenyan filmmaker Wanuri Kahiu offers us such a vision with her film short *Pumzi* ("breath" in Swahili), debuting the same year as *Avatar.* Imagining a dystopic future, set on the African continent after World War III—known as "the water war"—Kahiu delivers a prophetic warning of the dwindling supply of planetary resources and the dominance of a totalitarian state aided by digital technologies, scenes that countries such as Kenya have already experienced with famines and dictatorial regimes.

Within the film narrative, an Afrofuturistic feminist vision gets articulated via our slender, clean-shaven-headed heroine Asha (played by Kudzani Moswela), who literally relies on the sweat of her body to sustain plant life. In a postapocalyptic barren world that forces the last surviving humans underground in a technocratic regime, Asha, who works as a curator for a virtual natural history museum, receives a mysterious gift of soil. Because the soil bears no trace of radioactivity, Asha experiments with it by planting an old seed, which is finally able to sprout leaves—thus convincing her that the aboveground world is ready to be reborn and rejuvenated.

Unfortunately, Asha lives in a machine state, in which bodily wastes such as urine and perspiration must be recycled and purified for their water supply, and in which computer technology can detect everyone's thoughts and dreams, thus inspiring the delivery of dictatorial lines to workers: "Dream detected: take your dream suppressants." When Asha tries to alert her superiors of her growing plant, her work is dismissed, thus leading to her demotion from her position and transfer to assembly line work, depicted as a mandatory workout gym, where she is expected to power this underground machine world through her burned energy. However, with the help of a white cleaning lady (played by Chantelle Burger), Asha escapes to the outside world and begins her journey across rocky terrain and sweeping deserts to plant her "tree of life" (Fig. 4.2). Inspired by the tree-planting ethic of fellow Kenyan and Nobel Peace Prize laureate Wangari Maathai, Kahiu depicts stunning landscape imagery and a cinematic vision of hope in which our messianic savior is embodied in an African woman, who dares to dream, to defy authority, to rely on female solidarity, and to engage in the revolutionary practice of nurturing planet Earth. Even as the film concludes with our heroine dying in the desert in her self-sacrificial act of sprouting new life, it presents us with a more complex view of the black body fueling technology while retaining cultural and spiritual memories of nature and sustainability.

CONCLUSION: WELCOME TO THE DESERT OF THE REAL

Our digital revolution has yielded contradictory narratives of racial progress: from guerrilla warfare and mass rapes in the Congo region, fueling the high-tech economy, to the increasing presence of a transnational and upwardly mobile class of communities of color engaging in computer technology. It is with this "reality" in mind that Morpheus "welcomes" Neo to "the desert of the real" in *The Matrix*. He thus calls on all of us, especially those who are "wired" and living in the "dream world" of American middle-class privilege, to witness the high-tech wastelands that are fast dominating the planet and

Figure 4.2. Film Still from *Pumzi* (directed by Wanuri Kahiu, 2009). Courtesy of
Inspired Minority Pictures/ONE Pictures.

to "wake up" from the capitalistic and inhumane slumber induced by our
passive consumption of the digital lifestyle. Indeed, as our black digital artists
have done, he advises us to constantly rewrite the hard- and software scripts
that we engage in, to "change them as we see fit."

Such politics of engagement become paramount when cyberspace is
viewed not just as a space for civic society and community building but also
as the space controlled by corporate interests and the "Little Brothers" of
global capitalism who dictate our technological scripts (Dean 2003; Dean
2001). However, we reflect on Morpheus's warning so that we may transcend
the controlling corporate system as we shift our roles from consumers to
producers of information. As Eubanks has argued, the public sphere of the
Internet may be corporately controlled, but like graffiti tagged on the property
of business owners, individuals can also "tag" cyberspace and carve out
individual spaces (Eubanks 2004a, 155), which has occurred in the current
blogosphere and other communal spaces, such as Facebook, Myspace, Twitter,
Tumblr, YouTube, Vimeo, and podcasting, where communities of color not
only participate in digital narratives—much like their artist counterparts—
but have used blogs and other social networking sites to rally around and
organize social movements.

This momentum was first illustrated in Alex Chan's machinima *The French Democracy*, which dramatized how in 2005 alienated youth of color in the suburbs of Paris mobilized street uprisings against police brutality via the Internet. Similarly, the Jena 6 protests here in the United States began with blogs circulating the news of an incident of racial discrimination and hate speech in Jena, Louisiana, and then mushroomed into an organized national march in that small town on September 21, 2007. On a much larger scale was the success of the presidential campaign of Barack Obama in 2008, which relied on digital media tools in mobilizing the American youth vote, and generating international good will. And in 2011, various media discourses have pointed to the role of social media—including Facebook, Twitter, and YouTube—in sparking the "Arab Spring" uprisings, which saw social and political revolutions unfold in Middle Eastern countries such as Tunisia, Egypt, Syria, Yemen, and Libya.

As Gina McCauley, of *What About Our Daughters*, once proudly proclaimed on her blog: "The revolution will not be televised, it will be blogged!" Referencing Gil Scott-Heron's 1974 musical recording "The Revolution Will Not Be Televised," in which Heron warned of telecommunication distractions that would seduce a generation of people of color into remaining passively in front of their TV sets rather than take to the streets, the digital age generation blurs the boundaries between digital media and street activism, which have direct lines from the living rooms, studies, bedrooms, and coffee shops, where Web 2.0 participants of color type in front of their computer screens and text on their mobile phones, to grassroots organizing, where "the revolution will be live." Contradicting the myopic visions of twentieth-century science fiction's racial futurism—which, unfortunately, continue to reverberate in millennial films such as *Avatar*—and manipulating tools both low- and high-tech, these participants have now brought race and gender into the realm of cyberspace, which has necessarily created online conflicts, cyber harassment, confrontations with sexualized images of women in various porn sites, and ubiquitous hate speech.

However, they are not backing down from white supremacists, who resent the infiltration of their once "race-free," or "whites-only," cyberspace by unseen but detected virtual bodies of color. Black and other nonwhite bodies have definitely subverted the "technological utopia of difference" of the Internet, bringing all their racial and sexual baggage to the "virtual promised land," to invoke Fusco, and more or less have rendered Haraway's dream of the cyborg's boundary disruptions in concrete ways, while also making manifest Chela Sandoval's oppositional consciousness in which "colonized peoples . . . have already developed the cyborg skills required for survival under techno-human conditions" (Sandoval 1995, 408). A new

wave of Cyberfeminists and Cyber-antiracist activists continues to redefine the digital revolution. They have "tagged" technology by disrupting the "digital divide," by complicating the "ownership" of technoculture, and by showcasing computer technology, not as the HAL-like "master" of the information age, but as just another tool in the service of cultural agitation and social justice.

Chapter 5

Digital Divas Strike Back

Digital Cultures and Feminist Futures

At the dawn of our information age, circa 2000, filmmaker Julie Dash embarked on The Digital Diva, an interactive CD-Rom and film project.[1] In this work, the titular Digital Diva, Anna Achebe, immerses herself in a digital lifestyle but is eventually targeted for police surveillance—and for death—when she hacks into a corporate scheme to change our privacy laws. While highlighting the technological hostility against black minds that engage with the digital revolution, Dash offers a heroine who outsmarts the guardians of technology as she bridges the divides between "reality" and the virtual. Anna, who inherits her decryption gift from her Nigerian grandfather, who had cracked the Enigma code used by Hitler during World War II, is situated within an African diasporic legacy of black intelligence, scientific engagement, and political resistance: unafraid of technology but "real enough" to utilize it for social justice.

While Dash's imaginative engagement with and critique of digital technology has not reached a wide audience, she nonetheless showcases how technology can shift its focus toward black women's concerns and aesthetics. In the wake of her creative efforts, other female artists have expanded digital technology in radical and provocative ways. How might we imagine new roles and interactions for women who engage technology? Moreover, how might these engagements reflect a politics of feminism, a politics of liberation?

These questions become urgent in this age of the computer revolution, especially when we realize that "Digital Divas" are still marginalized in Big Media narratives. Consider David Fincher's critically acclaimed 2010 film The Social Network, which debuted ten years after The Digital Diva and is based on the

life of Mark Zuckerberg, creator of the massive social network site Facebook, and the youngest billionaire in the world. The film imagines a world of Ivy League computer geeks that excludes women, except as the "muse" for inventive computer programs. Indeed, *The Social Network* depicts Zuckerberg (played by Jesse Eisenberg) coming up with Facebook by first lashing out at an ex-girlfriend on his live journal blog. In a fit of chauvinistic rage and embitterment, Zuckerberg creates in the spur of the moment an objectifying Web site called "Facemash," which allows men to rate the attractiveness of Harvard's female undergraduate students based on their online photos, which he has accessed by using his computer hacking skills. While Zuckerberg himself said he created Facebook because he just liked "building stuff," the film narrative relied instead on an old Internet archived blog feed, in which the young billionaire refers to a co-ed as a "bitch," and the infamous short-lived existence of Facemash, to constitute the "origin narrative" of one of the most populous social network sites on the Internet.[2] It is not surprising that *The Social Network* mobilized routine techno-cultural practices of linguistic and visual subjugation of women's bodies to frame men's innovative engagements with technology.

In this chapter, I examine the extent to which our digital revolution has relied on women's bodies to fuel and shape its technologies. This is evident in the assemblage of computers by various third world women assembly line workers here and abroad and in mass rapes in the Congo region, where the war over raw materials used in computer chips continues. This is also evident in the proliferation of Internet porn sites that simulate the violence underlying the femicide on the U.S./Mexico border, where some of our digital technologies are assembled, and in the increasing numbers of women who now have unlimited access to computer technology.

In response to these contradictions and possibilities, I further explore women's creative appropriations of digital technology to assess the complex interplay of gender with race, class, nationality, and other markers of difference. As I have already asked in chapter 4, Can a social revolution be digitized? And can we finally make meaning of "more and more information"? How, indeed, can information be transformed into knowledge and action?

RETOOLING RESISTANCE

The struggle to gain access to and proficiency with the latest tools of technology is not a new one for women, particularly for women of color. If the written word represents one of our earliest tools of technology, then we need only reflect on Virginia Woolf's thesis and the responses by Audre Lorde and Alice Walker, who assert that only a certain class of women could

have "a room of one's own" and access to "reams of paper, a typewriter, and plenty of time" in developing their artistic craft, while other women could only explore their creativity in gardens, blues songs, or poems written "between shifts, in the hospital pantry, on the subway, or on scraps of surplus paper" (Lorde 1984, 116; Walker 1984). However, such recognized economic differences are multiplied by social, political, and cultural differences, which have led to women's exclusion.

Think of the legacy of slave times, when an enslaved woman might face punishment for learning to read and write. Or, as in the case of Phillis Wheatley, her creative body of poetry might be subject to intense scrutiny and examination simply because she dared to assert that her poems were "written by herself." In the realm of art, a nineteenth-century black sculptor such as Edmonia Lewis might face hostility, persecution, and eventual expulsion from art school because she dared to improve her craft.

Added to this historic struggle for access is the cultural dismissal of our knowledge base. As Trinh T. Minh-ha reminds us: "The world's earliest archives or libraries were the memories of women," which therefore had to be discredited and "corrupted out of ignorance" (Trinh 1990, 121). As a result, our histories and our arts, which once served the foundations of culture, have become coded in oral expression or corporeal performance. We can only imagine how expansive the libraries obtained in our minds, hearts, speeches, and movements might appear if they took physical form; perhaps they would resemble Borges's never-ending "Library of Babel" with its intricate stairways and infinite galleries and shelves.

In visualizing this "Library of Babel," I am reminded of Christine Hill and Shelley Jackson's "Interstitial Library of Circulating Collection." Parodying the online library catalog, Hill and Jackson present an impossibly catalogued and "disordered" virtual collection:

The Interstitial Library's Circulated Collection is located at no fixed site. Its vast holdings are dispersed throughout private collections, used bookstores, other libraries, thrift stores, garbage dumps, attics, garages, hollow trees, sunken ships, the bottom desk-drawers of writers, the imaginations of non-writers, the pages of other books, the possible future, and the inaccessible past. In a sense, this library has always existed. However, until now it has had no librarians, no catalog, and no name. The Interstitial Library does not aspire to completeness. Indeed, we champion the incomplete, temporary, provisional, circulating and, of course, interstitial. (Hill and Jackson 2004)

By crafting an unfixed and unfinished "catalog" for a library that is at once nowhere and everywhere, especially when it can be fixed within the space of the Internet, Hill and Jackson playfully hint at the impossibilities of stabilizing sites of information while also contributing to a gendered discourse of information technology.

Their vocation as "head librarians" and the arduous tasks they describe themselves performing as information producers and collectors harken back, somewhat, to feminist articulations of the computer as "gender-female"— specifically in views of the machine as a replacement for the work of "computing" female operators, receptionists, and secretaries in the military industrial complex of the mid-twentieth century.[3] Indeed, in *Zeroes and Ones* Sadie Plant guides us farther back in time, by arguing that computing logic is based on nineteenth-century women's weaving.[4] In light of this, the image of woman-as-cyborg becomes more than just a figment of science fiction fantasies, as represented, for example, in *Metropolis* or *The Stepford Wives.* As Donna Haraway argues, "The machine is not an *it* to be animated, worshipped, and dominated. The machine is us, our processes, an aspect of our embodiment" (Haraway 1991, 180; emphasis in original).

Although there is a great deal of validity to Haraway's claim, there is still the question of naturalizing these processes via embodiment—especially relating to gender. Such articulations prove especially problematic for our digital future by metaphorically reducing the female body to that of a machine, as if this were merely abstract thinking and not based in reality. Beyond this reduction, female labor also gets invisibilized, as is the case with countless U.S. immigrant and third world women laborers—such as the maquiladora workers on the U.S./Mexico border—whose hands have assembled our computers and other machines in the digital age. As Fusco argues:

> It seems to me that the emancipatory script of the digital revolution is simply inadequate to interpret the situation of those on the "have not" side of the access divide, and . . . the *maquiladora* workers [are] a case in point. Calling these women "cyborgs" naturalizes the economic order to which they are subjected and mythifies the political nature of their interface with technology, which is precisely what needs at this point to be clarified. (Fusco 2001, 200; emphasis in original)

Ruminating on the digital divide, as well as on the feminization of this gap— as represented by these workers in technological industries—Fusco reminds us that these political and economic scenarios must enter our academic and artistic discourses on the "revolution" of technology. As she suggests,

"What their lack of access represents for me . . . is a challenge to expand the imaginative and metaphorical dimensions of telepresence, collapsing cultural and geographical distance so as to broaden and strengthen a sense of connection to them" (Fusco 2001, 201).

As Fusco further notes, these concerns take on an especially gendered urgency in view of the massacres currently occurring on the border, citing the murdered victims of sexual predators, kidnappers, xenophobic U.S. vigilantes, and drug and human traffickers. The mothers and other relatives of disappeared young women, as well as transnational feminist activists, have rallied against the concentrated femicide in such Mexican border cities as Juarez, where hundreds, if not thousands, of bodies of young women raped, strangled, and mutilated have been found in the desert, while many more remain missing. These murders began in 1993 in the wake of the North American Free Trade Agreement (NAFTA), and investigations over the nearly twenty years since have yet to yield clues identifying their perpetrators. Several of the victims had been employed by U.S.-owned maquiladora plants, which have attracted countless women throughout Mexico to the border cities in search of jobs and which employ feminized low-wage labor to generate the hardware for our digital technology. Our high-tech connections to these low-tech subalterns entangle us in a (worldwide) web of (mis)information.

DIGITAL SUBALTERNS

Our information age is premised on global and transnational circuits in which "goods can cross but people can't cross the border," to loosely quote Berta Jotar, one of the local Mexican feminist activists interviewed in Ursula Biemann's 1999 video, *Performing the Border.* Utilizing the video camera to frame these global processes and reproduce the video surveillance image, Biemann, as a feminist video artist, focuses on what she terms "geobodies" and the ways in which globalization has shaped the various movements of different gendered and raced bodies across the planet. In *Performing the Border,* which examines how "gender matters to capital," and is concentrated along the U.S./ Mexico border, Biemann employs the grainy, murky image of the amateur video, while also framing shots of television screens and interior circuits of computer parts, to explore how women's bodies merge with this technology.

Whether the surveillance gaze is represented by border patrol personnel, maquiladora employers, or the serial killers ravaging the bodies of young women, Biemannn reveals how these women's bodies are "fragmented, dehumanized, and turned into a disposable, exchangeable, and marketable component." The stark black and white footage of dumped bodies found in

the desert, combined with an ominous scrolling on the screen of digitized files detailing the brutal murders—often in cold, scientific language—illustrates with chilling effect the dehumanized and interlocking processes of data collecting, assembly line work, and mass murder. All three dimensions become "robotic and repetitive."

In a far more dramatic portrayal, Gregory Nava's 2006 *Bordertown* explores the Juarez femicide by intersecting these gruesome rapes and murders to our high-tech global economy. Despite the histrionics of Jennifer Lopez, who stars in this thriller as Loren Adrian, an ambitious and Anglicized, dyed-blonde Chicana newspaper reporter, there are moments when her melodrama is necessary to urge a political agenda. After putting her life in danger to track down the rapists and would-be killers of an indigenous Mexican survivor named Eva (played by Maya Zapata), Loren learns the significance of her role to advocate on behalf of the female maquiladora workers of Juarez.

When piecing together an intimate portrait of Eva, Loren's American editor (played by Martin Sheen) tells her he cannot publish her article since her report implicates NAFTA and the U.S.-owned multinational corporations that have established these plants while refusing to ensure the safety of their women workers, who are clearly disposable *and* replaceable. Upon learning that her article will be suppressed, Loren stages a temper tantrum, toppling many of the computers in the newspaper office while reminding everyone present that these gadgets of ours are "covered in blood." The point of this scene, though didactically heavyhanded, is one that bears repeating.

Interestingly, the opening credit sequence of *Bordertown* begins with a statement concerning NAFTA and what it has done to exacerbate poverty in Mexico. It also declares that "every three seconds a TV set is produced, every seven seconds, a computer." To drive home this point, we are then given the gendered statistics: maquiladoras specifically target women because women "work for lower wages, and complain less about the long hours and harsh working conditions." Perhaps one of the few films about the Juarez femicide that dares to implicate the northern side of the border, *Bordertown* is far more subversive than we acknowledge and less deserving of its negative reception. Nava's film also relates for us the many economic, cultural, social, and political issues facing women, and their resistance to these processes, on both sides of the border.

The power imbalance portrayed in this film, which undergirds the digital revolution, reverberates in other locations, from Silicon Valley to iPhone factories in Shenzen, China. Using the example of immigrant women workers in the tech industries in Silicon Valley, Karen J. Hossfeld asserts that

"for every young, white boy-wonder who made his first million tinkering in the garage (as folklore says the founders of Apple Computer . . . did), there are scores of low-paid immigrant women workers . . . [who] prop up the computer revolution, in what amounts to a very *un*revolutionary industrial division of labor" (Hossfeld 2001, 37; emphasis in original). Hossfeld's report on gender, race, and class inequalities becomes the subject matter for artist Prema Murthy's Web site, "Mythic Hybrid," which signifies on the information architecture of Internet search engines, most prominently Google.

"Mythic Hybrid," whose title appears in the space of a "search box," has already yielded a series of terms and topics—including "ASIAN WOMEN," "Labour experiences," and "Power, Identity, and Exchange in Cyberspace"— thus defining for the Internet surfer what these women's bodies and labor mean in the realm of digital technology. Replete with audio, video, and written testimonials, Murthy effectively "informs" her readers about the intrinsic role women of color play in shaping our technologies. They are both "mythic" (the invisible producers of the digital revolution) and "hybrid" (fusing their subaltern realities into the global network).

Amid all the wonders and excitement of new media, including powerbooks, laptops, and the latest cell and smart phone models, somewhere in this high-tech industry is an underbelly where the subaltern is silenced and erased from participation. This is not just replicated in the bloodsoaked border cities and sweat-drenched urban centers in the global North and South that rely on preyed-upon migrant labor. This is also represented in places such as the Democratic Republic of Congo, where the lust for raw materials such as coltan, used in laptops and cell phones, has fueled brutal and horrific scenes of war and genocide in the region, not the least of which has been a rape epidemic, which will be explored further in chapter 6.

Because women's bodies interface violently with the forces of our information age, an intersectional global feminist analysis is crucial in connecting the dots that link femicide in Ciudad Juarez, the Congo rape epidemic, and the symbolic violence perpetrated by the proliferation of porn culture—all aided and abetted by digital technologies. With every new development in visual technology—photography, cinema, video, camcorder, cable, satellite, and the Internet—pornography has never been far behind (Miller-Young 2008, 267). In actuality, some would argue that it is not the porn industry that has benefited from new technologies, but rather tech industries that benefit from pornography (LeVande 2008, 295). As the increasing pornification of our culture creates a demand for female sexuality to be broadcast in every media space, tech industries must keep up with the demand by generating porn images in ever more accessible and provocative ways.

Given that the Internet, and digital culture in general, have made accessible more pornography than in any other era of humanity, what does it mean that our global economy has relied on female bodies (onscreen or offscreen in maquiladoras or in war-ravaged countries) for its success? In light of real and imagined "digital divides," are there concrete ways that the tools of the digital revolution can be recuperated for women's liberation? In what follows, I will analyze the digital narratives that have emerged, which perpetuate spectacles of difference and hegemonic paradigms, and consider the possibilities for women to advance new modes of storytelling and art via new media.

RACED/ERASED SUBJECTS

Digital interventions in art have had a revolutionary impact. Our postmodern focus on fluid identities and our rapid global exchanges in information and goods are replicated in our manipulative control over digital images. All identities are accessible—we are told—and the cyborg body reflects this by depicting hybridity and changeable appendage. As art historian Jennifer González notes, "[Future] bodies [are] exemplified in a nonunitary, hybrid form" in much of our digital art (González 2000, 33). To illustrate this, González offers the example of the video morphing of racially diverse faces in the 1991 music video of Michael Jackson's single "Black and White," which calls for an end to racism, presumably leading to the creation of a mixed-race woman, the "raceless" face that the video morphing ends with. What we witness, then, are digital narratives "erasing" race through hybridity.

This particular form of race mixing, produced with Morph 2.0 software, was also applied to the "new face of America," as González further notes, depicted in the hybridized image of several races collapsing into the comely face of a woman of color, on a 1993 cover of *Time*. This cyborg— labeled "SimEve" by Haraway—represents what the average American will look like by the mid-twenty-first century, thus constituting the "future" racial identity of a body politic that is no longer predominately white. However, positioning this fantasy figure as a futuristic entity ignores the complex and multiracial history that has already shaped America's society, and the ways in which such race mixing was imposed mostly through white men's exploitation of the bodies of women of color—as discussed in chapter 3.

As Evelynn M. Hammonds comments, "[SimEve] is the representation of the desire to deny kinship and retain masculine power based on the maintenance of racial difference" (Hammonds 1997a, 120). With such categorical denials resounding throughout America's history of racial

mixing, of "mulattos" and "mestizos," it is no wonder that the hybrid body would seem a "future face" rather than the quintessential face of our collective pluralistic heritage already in existence. Moreover, as Hammonds reminds us, this turn-of-the-twenty-first-century strategy echoes the turn-of-the-twentieth-century utilization of the "mulatto" body in African American discourse to represent so-called progress while also reducing the mixed-race subject to the scientific and eugenic category of "hybrid vigor."

These erasures of history by technology necessarily render visual works such as Adrian Piper's 1988 video installation *Cornered*, a piece that confronts white viewers with the "facts" of their African ancestry, disruptive to our projected future racial narratives. Piper has described the often violent outbursts from white viewers that accompany the exhibition of this work when the realization takes hold that their whiteness cannot be secure when confronted with a multiracial American history (Piper 1998, 95). Despite our multiracial idealization of the hybridized—and, by extension, raceless (or de-Africanized)—body of the future, such actualities threaten white supremacy in a concrete way and, hence, highlight celebratory depictions of mixed-race morphing as insincere.

The celebrations of multiraciality and hybridity through the cyborg body remind me of Nancy Burson's provocative digital artwork of 2000, *The Human Race Machine*. In this installation, Burson incorporated computer technology to photograph and freeze-frame the face of a viewer and, using digital morphing, transform that face through different racial characteristics. Commissioned for the 2000 opening of London's Millennium Dome, it was mined for its provocative images to create an antiracist billboard in New York City's Times Square (Fig. 5.1), and has since been updated as an iPhone app called the "Racializer,"[5] representing the culmination of our multiracial desire for a democratic and futuristic society in which "race" no longer matters. As Burson herself comments, "The more we can recognize ourselves within each other, the more we can connect the human race. . . . There is no gene for race. . . . The Human Race Machine allows us to move beyond difference and arrive at sameness. We are all one" (Burson 2000).

By presenting this democratically conceived notion of race, supported by science (preoccupied with its own supposedly race-free Human Genome Diversity Project), Burson invites viewers of this installation to engage in a digitized game of "passing," as they witness the images of their faces morphing from white to black or vice versa (and including shifts through other racial categories). Through this computerized performance, they are allowed to appropriate the body of the Other via the digitized self-image, although without regard for the fact that this digital construction of race

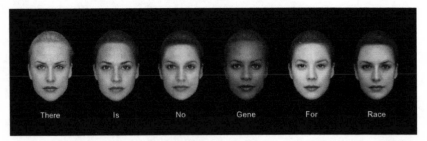

Figure 5.1. Nancy Burson, "The Human Race Machine," 2000. Billboard advertisement. Permission of the Artist.

reduces the subject to one of "bodily appendages or genotype, with little or no consideration of other cultural factors such as language, economic class, or political practice" (González 2000, 34).

In other words, it constructs an image of race that is literally "skin deep," since the digital face shifts both skin color and the external shapes of such facial features as nose, eyes, and lips. As provocative and fascinating as its vision may be in illustrating the socially constructed nature of race through photographic transformations of our faces, this artwork nonetheless digitizes the legacy of "blackface" or "racial passing" for the new millennium. *The Human Race Machine* offers us a twenty-first-century glimpse of the same racialized performances that have long been in circulation, despite Burson's advocacy for a color-blind future society. Using science and technology to proclaim the nonexistence of race merely allows the social and cultural aspects of racism to retreat underground and mutate into myriad new forms.

In ironic contrast to Burson's work, Kara Walker's self-described "low tech" installation *Insurrection! (Our Tools Were Rudimentary Yet We Pressed On)* (Fig. 5.2) opened the same year as *The Human Race Machine.* As the age of digital culture was dawning, Walker positioned an overhead projector—an outdated piece of late-twentieth-century classroom equipment—as a counterpoint to "high-tech" tools of art, even as it enhanced in bold and vivid colors her trademark Victorian-style black paper cut-outs of antebellum stereotypes. Specifically, Walker depicts in this work black silhouettes, pasted on white walls, of slaves engaging in a historic nineteenth-century rebellion, using the most "rudimentary tools" such as the service kitchen utensils associated with the labor of house slaves. The overhead-projected images radiate caricatures of the Southern landscape, such as cartoonishly rendered mossy trees, and the interior of a big house, reminiscent of Tara and its occupants in the celebrated Technicolor vision of the 1939 film *Gone with the Wind.*

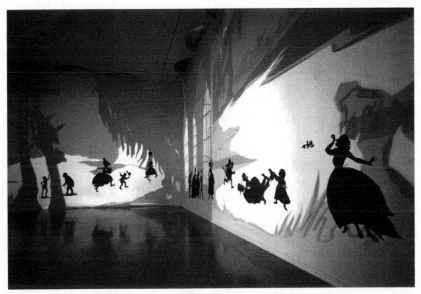

Figure 5.2. Kara Walker, "Insurrection! (Our Tools Were Rudimentary, Yet We Pressed On)," [detail], 2000 Cut paper and light projections on wall 12 × 74.5 feet (3.7 × 22.7 meters). Installation view: *Moving Pictures*, Solomon R. Guggenheim Museum, New York, 2002. Photo: Ellen Labenski. © Kara Walker, Courtesy of Sikkema Jenkins & Co., New York.

While the title of this work alludes to its content—the slave rebellion—we may also recognize it as a gesture toward the tools that our artist has utilized to depict this scene. Through her use of low-tech "rudimentary" artistic tools, including her paper cut-outs and her overhead projector (described by the artist as a "didactic" gesture toward the classroom experience),[6] Walker continues to "press on" with her racial discourse in the face of a high-tech culture that would sooner relegate problems of racism to another time than deal with its ramifications in the present day. However, this particular placement of her artwork beyond the boundaries of high-tech culture positions the "blackness" of the artist and the art form and content in an acceptable sphere of "primitivism"—devoid of or regressive in technological development.

Nonetheless, this installation provides onlookers with the peculiar opportunity to interact with these walled silhouettes and projected images, by observing that their own shadows, cast on the wall by the overhead lighting, are implicated in the melodrama of the scene depicted. Such interactivity suggests that we cannot so easily escape the racial dramas of the past, an

elusive lesson that undermines the assertions in *The Human Race Machine*, which creates the illusion of our racial selves transcending race. In these ways, we may recognize how "low-tech" tools are positioned to deliver both "history lesson" and caution against the high-tech visions that imagine race as an easily "erased"/de-raced subjectivity.

On the other hand, we need only surf the Internet or "Google" our own identity in a search box to determine how our race and gender are constituted via technology. Mimi Nguyen, author of the feminist e-zine, "Exoticize This!" verifies this in her description of her virtual embodiment, both linguistically and visually, as "Asian + Woman," in terms of "a digitized Frankenstein amalgamation of parts seen on All Asian Action or Hot Oriental Babes. The invocation of my body serves a purpose, then, something about keeping me in line; there are the threats of sexual violence, thinly veiled suggestions that they might enjoy the scene of my particular body in pain" (Nguyen 2001, 186). Returning to pornography, which, as I have already argued, is linked to the "desert of the Real" realities of border-city and Congolese sexual violence, we may recognize the extent to which all women's body parts become fetishized and racialized in virtual fantasies, and are thereby targeted for both symbolic and actual violence.

THE POLITICS OF DIGITAL ENGAGEMENT

Harking back to Laura Mulvey's "Visual Pleasure and Narrative Cinema," in which the male gaze—extending from cinema into cyberspace—"projects its fantasy onto the female figure . . . [which is] coded for strong visual and erotic impact" (Mulvey 1975, 11), it becomes evident that any virtual articulations from "woman" are subject to the pornographic gaze, which objectifies, dehumanizes, and verbally harasses—especially when said woman engages in discourse that is explicitly feminist. Some feminist and antiracist bloggers have had to shut down or moderate their blogs because of harassing comments from various readers, who feel empowered to attack from behind their computers in supposed anonymity and who have also learned to target particular symbols of Otherness. These linguistic forms of violence can only be symbolic, however, since we cannot always be sure that bloggers, commentators, and Web site authors are who they say they are.

A case in point is Tom MacMaster, a white American man posing as a "Gay Girl in Damascus" blogger. Apart from journaling his lesbian erotic fantasies in the first person, MacMaster caused online panic, which led to international calls for human rights investigations into the Syrian government, when he pretended to be kidnapped by state police targeting gay dissenters

during the Syrian uprisings in 2011. His fictional accounts had the insidious effect of not only endangering actual gay dissenters in Syria by casting doubt on their own blogs and independent media narratives, but also of trivializing and colonizing women's bodies, cultures, and identities in both Orientalist and heterosexist contexts.

Such virtual performances of difference undergird the critique Prema Murthy put forth in "Bindi Girl," another interactive art space that she created years before the MacMaster incident in her theorizing of gender, race, and technology. On this site, Murthy parodies both the Orientalist and pornographic gaze, as the Web site features a quote from the Kama Sutra—an ancient Indian text that has long captivated Western audiences with an appetite for "Indian" culture and erotica—and the mark of the "bindi," the red dot marked on the South Asian female body. An audio featuring celebrated Bollywood playback singer Lata Mangeshkar blares from the site in an attempt to overwhelm the user with these markers of Indian femininity.

Curiously, and, one should say, deliberately, Murthy employs the mark of the bindi to deny users sight of the revealed pornographic body by placing it in strategic locations that cover up the nude women. She also features a warning message about the content of pornography—thus inviting associations between its subversive critique of Internet porn and actual porn sites—and an absurdist chat room dialogue between a "woman" and "man" simulating a sex fantasy. Mobilizing cinematic bodies—through brief glimpses of famous Bollywood female stars and the sound of its playback singers—Murthy critiques the visual construct of both the Internet and the text of pornography.

These "information" sites—deceptive in the case of MacMaster or satirical in the case of Murthy—call attention to the fictive narratives that pass as "facts" and to the controlled space in which information is filtered. Mostly, they refute the claims that the Internet enables transcendence from race and gender when the various conversations, interactions, and both sexualized and racialized representations that abound in cyberspace suggest otherwise. As Nguyen reminds us: "In reality all kinds of bodies and their doubles—digitized, prosthetic, virtual, textualized—are circulated, exchanged, and performed in the electronic market because bodies do matter, at least when it comes to asserting social hierarchies and variously hegemonic cultural logics" (Nguyen 2001, 189). Because of these hierarchies and power dynamics, we are left to ponder just how *revolutionary* the digital revolution can be, especially when it has merely extended our social inequalities into virtual spaces. Do feminist and other social justice movements have a real "future" in this arena?

Various digital activists have engaged in aggressive criticisms of high-tech culture, including the "hacktivism" of Electronic Disturbance Theatre and the more playful Los Cybrids, a trio of west coast performance artists whose Web site once frightened Web surfers with the impression that their computers had become infected by a virus. One of the original members of Los Cybrids, artist Praba Pilar, further explores themes of digital technology through her multimedia one-woman show *Computers are a Girl's Best Friend,* starring the Digital Diva. Debuting in 2004, this performance art depicts a Latina showgirl uncritically embracing her high-tech lifestyle before finally questioning its ideology of domination when she explores issues of dehumanizing practices that range from technological sex toys to industrial wastes shipped to developing countries. Combining bawdy humor and satire, through her spoof rendition of Marilyn Monroe's "Diamonds are a Girl's Best Friend" (from Howard Hawks's 1953 movie musical *Gentlemen Prefer Blondes*), the Digital Diva—bedecked in a disc-covered plasticized gown (Fig. 5.3)—identifies with the wealth and glamour of the computer revolution, in much the same way that Monroe's character was hypnotized by DeBeers diamonds.

Sparkling in her absurdist high-tech gown, the Digital Diva invites us into her "backstage" room, in between her performances of the Monroesque anthem, to wax poetic about the excitement and dangers of women's interactions with computer technology. Through her integration of audio interviews, calls from her cell phone, and sharing of e-mail messages from her laptop, the Digital Diva learns, along with her audience, about the proliferation of technology as it intrudes upon our daily interactions, from sexual encounters to environmental pollution in the form of toxic tech super-sites stemming from old computer parts. In particular, as she listens to an online radio show while applying her makeup for her next performance, she receives critical information describing the relocation of super-sites to "third world" countries. "Third world?" she quips. "I'm from the third world," thus reminding us that even within her location in the developed world, she remains intimately connected with those sites that are linguistically distanced from our "reality." By the time the Digital Diva performs her anthem for the third and last time, her enthusiastic and orgasmic celebration of computers shifts to a questioning ambivalence about its overall positive impact.

This "critical ambivalence"[7] frames much of Pilar's art trajectory, which explores themes similar to those raised in *Computers are a Girl's Best Friend.* In particular, we find the Digital Diva transformed into a high priestess of the *Church of Nano Bio Info Cogno.* In this interactive, satirical performance—debuting in 2006—Pilar continues to question the optimistic

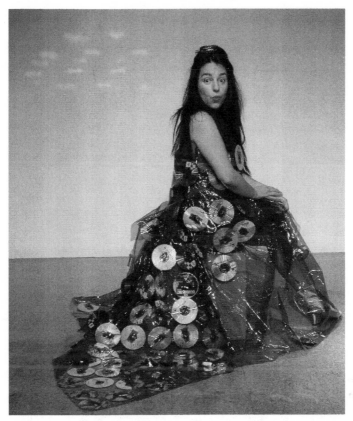

Figure 5.3. Praba Pilar, "Computers are a Girl's Best Friend," 2004. Permission of the Artist.

and even "messianic" discourse of the high-tech revolution stemming from the convergence of the major tech fields of nanotechnology, biotechnology, information technology, and cognitive neuroscience (NBIC).

Attending various NBIC convergence conferences, populated mostly by elite white men from scientific and business fields, and noting the positivist discourse around such futuristic projections as singularity and post-humanism (both of which advocate for the full integration of humans and machines), Pilar likens the enthusiastic reception of these ideologies to an apocalyptic Christian fundamentalist "church." By re-presenting this secular academic and industrialist zeal through the recognizable fervor of religion—including "praise" songs, altar calls inviting audiences to "confess" their sins against

technology, and sermons that condemn "Luddites and environmentalists" while praising a future filled with "nanobots, designer babies, and microchips in our bodies"—this performance art questions the "rational" linear progression of science and technology and recasts the logics of NBIC through the absurd (Pilar 2011). Indeed, she pinpoints the origins of this technological vision to the ninth-century theology of monks who imagined themselves as God's "co-workers" reconstructing the world through mechanical arts in order to access the divine and prepare for the second coming of Christ.[8]

Specifically, in a digitally fused photograph that signifies on Da Vinci's *The Last Supper* (Fig. 5.4) and hangs on a wall of this "church," Pilar positions her Latina body in lieu of the Christ figure to literally and figuratively disrupt white masculine authority, as she is surrounded by the various white male "disciples" of new technologies. Included in the image, placed above her head, is the four-pointed logo of her new church, representing each tech field and forming the shape of a cross, and a model of a DNA double helix placed before her on the "supper" table. Providing a new spin on "this is my body," Pilar dares to dismantle through embodied resistance the master narratives that promote uncritical embrace of the digital revolution while ignoring its unequal flow of information, labor, and consumerism. It is precisely the local and transnational position of our "Digital Diva" in the global network that needs to be interrogated at this contemporary moment.

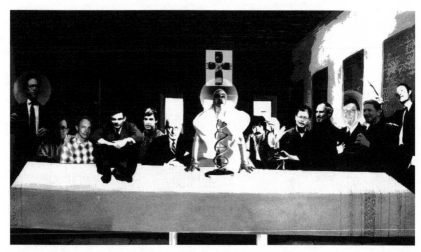

Figure 5.4. Praba Pilar, "The Last Supper" from The Church of Nano Bio Info Cogno, 2006. Permission of the Artist.

VIRTUAL "WORLD" TRAVELS AND SEXUAL (GEO) POLITICS

Just as the pornographic gaze was quickly put to use not long after each invention in visual technology, so too has the imperialist gaze shaped the trajectory of technological innovation. As Ella Shohat reminds us, it is no coincidence that photographic technologies emerged alongside Western imperialism during the mid-nineteenth century and flourished at the height of modernity in the twentieth century. Via the photographed body, global white imperialism combined with male dominance to display power and control over marginalized subjects. In some instances, these visual tropes combined in ethnographic nude portraits of women of color—think *National Geographic* or of any documentary filmed on the African continent.

In addition, the camera also serves as surveyor of both land and body, functioning as it does as a "travelogue," to cite Alison Griffiths in her research on turn-of-the-twentieth-century cinema. Anthropology and ethnography thus combine with popular culture to turn cinema into a "civic educator and tool of colonial propaganda" (Griffiths 2002, 173). Not surprisingly, the Internet borrows from this cinematic gaze, projecting itself as a "travelogue" via its "World Wide Web." As Nakamura argues, the Internet invokes a "technologically enabled transnationality . . . that directly addresses the first-world user, whose position on the network will allow him to metaphorically go wherever he likes" (Nakamura 2000, 17). In addition, it has mobilized technology for greater access to both women's bodies and foreign sites.

The cutting-edge work of artist Cao Fei examines these power dynamics. Navigating the avatar-driven social network site Second Life, which combines social networking with virtual gaming, Cao Fei mobilizes her artistic vision via machinima, an avatar-based video production, as she explores the fluid boundaries between the "real" and the "fantasy," between freedom of information and corporate limitations. The machinima *I.Mirror* (a three-part movie available on YouTube), based on Fei's interactions within the Second Life virtual world as China Tracy, further interrogates how identities, bodies, and nationalities are constituted via digital technologies.

In part one of *I.Mirror*, Fei as Tracy surveys the virtual landscape of Second Life, which is presented as "land for sale," thus reinforcing the precepts of consumerism and property while simultaneously promoting ideas of freedom from the "real world." She presents these contradictions, using her virtual body to literally fly beyond the national borders—represented by the numerous flags on display—while situating her identity nominally and geographically within China. Tracy may transcend the limitations of the physical and national body, but even within this virtual fantasy, she allows

"reality" to intrude by depicting an industrial cesspool that threatens the environment. The carefully drawn details of this toxic waste dump signify on crucial issues for the next era of our high-tech world, which has perpetuated these toxic super-sites with its avaricious demand for the latest technologies and global developments. If Second Life is a "mirror," then Tracy uses it to reflect not only what *is* but what *could be.*

Part two depicts her interactions and "chats" with a fellow Second Life user, Hug Yue, who accompanies China Tracy on her virtual "travels" across urbanscapes and rain forests. Hug Yue, who appears to be a young, dashing blond and tuxedoed avatar, reveals that he is a Californian in his sixties, thus reflecting his comments that Second Life is about "youth, beauty, and money . . . it's all an illusion." Hug Yue then presents a different avatar, closer to his real age, thus showcasing how these aspects of self can be altered at one's will. China Tracy herself, who keeps to a standard digitized body that most likely simulates her real self—long black hair and slender body—views the virtual space as an alternate reality, her avatar an alter ego of her split identity, even when she confuses "RL [real life] and SL [Second Life]." Constantly presenting her body afloat in space, Tracy suggests how easy it is to lose oneself and one's grasp on the Real.

This, of course, is the ultimate illusion in which our bodies seemingly transcend their sociopolitical realities. Tracy questions this conceit in part three by cataloguing the different raced, gendered, and nationalistic avatar bodies (even hybrid animal and alien bodies) one can access in Second Life, as well as the different sexual practices one can engage in through various interactions with others in this virtual world. The problem that Tracy showcases is how hegemonic these constructions tend to be, since women's bodies are rather pornographically designed, and the different "skins" one can try on for one's avatar are limited in melanin choices and body types (thus suggesting that no one would fantasize her or himself as dark-skinned or heavyset).

These normative constructions underlie the conclusion that, even within fantasy, not every *body* has a place. Or, more to the point, these bodies still adhere to a white supremacist, sexist, and ageist worldview. Through these critical interrogations, Tracy reveals the limits of our imaginations and the possibilities for unmasking what she concludes to be "human beings behind hollow digits, all those lonely souls." While Tracy ends her machinima with a wish for digital media that can provide a "new force which [transcends] this mortal coil," her documentation of "lonely souls" reaching out for shared experiences—even via virtual fantasies—speaks to the ways that the digital revolution continues to blur the boundaries between the private and the public.

When we move away from the online world and interrogate how the electronic and "real" worlds collide, we witness a different kind of "world travel," most notably in the music of artist and rapper M.I.A., née Maya Arulpragasam. Similar to Missy Elliott in her digital innovations and Lauryn Hill in her political musings, M.I.A. builds on the oppositional conscious-ness of her hip-hop predecessors by redefining and relocating hip-hop via the electronic drum beat synthesizer and her remix of "world music." As M.I.A. raps in the song "$20": "I put people on the map that never seen a map / I show them something they never seen / and hope they make it back." In essence, she remaps the terrain not just of the global North and South but of popular music.

Sampling and remixing alternative music, punk rock, hip-hop, bangra, reggae, and indigenous tunes from around the world, M.I.A. reimagines and politicizes a "world town," both on her debut album *Arular* (named for her father) and specifically on her sophomore album *Kala* (named for her mother), which was produced in response to the revocation of her U.S. visa when she was targeted by U.S. Homeland Security for lyrics on *Arular* that seemed to celebrate terrorist organizations.[9] So the story is told. The Sri Lanka–born and London-raised music artist traveled the globe to produce *Kala* and feature various local artists and youth from places such as India, Trinidad, Jamaica, Liberia, and Australia on different tracks.

The opening track on her second album, "Bamboo Banga," specifically calls attention to her "world runner" status, signifying on Modern Cars' "Road Runner," which is then remixed with her roll call of the global South—"Somalia / Angola / Ghana . . . India / Sri Lanka . . . I'm a road runner / I'm a world runner"—while the original narrative of the "freedom" of driving in a modern car on the outstretched road, "driving 100 miles per hour," is subverted with a scene of the hungry third world child "knocking on the doors" of the tourist's car. In blending and fusing a world sound, M.I.A. comments on the subaltern subjects that she herself had been linked to—including the poor in "Bird Flu," the undocumented immigrant in her popular "Paper Planes," and the militant protesting the military industrial complex in songs such as "$20" and "World Town." While M.I.A. has since received international acclaim, including Grammy and Oscar nominations, her narratives suggest that it is possible to map transnational resistance and close psychic and geographical distances when we syncretize and redefine our differences.

However, there are still power dynamics at play, in which artists posi-tioned in the first world sample and appropriate third world culture for cool or "street" credibility, and the politics of successful artists such as M.I.A.

have been questioned. Specifically, her romantic and professional links with Diplo (Wesley Pentz), a popular electronic remix DJ known for sampling world music, have raised the specter of white male patronage, power, and privilege in her musical trajectory. This of course is a source of contention for M.I.A, who considers such criticisms to be based in racist and sexist dismissals of her artistry.

Diplo, whose racial politics are often scrutinized, especially in conversations on popular culture blog sites such as *Racialicious,* was the subject of a "Twitter War" in March 2011, in which Venus Iceberg X of the Brooklyn-based hip-hop group Ghe20 Goth1k, accused him of being an "imperialist thief." While M.I.A. is seen as someone who bridges the global North and global South through her transnational fusions and "flexible citizenship," Diplo is instead labeled a "musical Columbus," traipsing around the globe and podcasting his various local musical "discoveries" online (Muse 2011). As Venus Iceberg X angrily tweeted when she learned that Diplo had been recording her live show on his Blackberry: "U can't hide behind postmodernism anymore. Its [*sic*] time to end your reign of terror whiteboy" (cited in Zeichner 2011).

Beyond this criticism of white hipster "postmodernism," which masks social inequalities as playful effacement and cultural exchange, is the equation of a white male DJ's Blackberry gadget with the hidden surveillance power of Big Brother (or "Little Brother," as the case may be)—designed to capture, steal, and repackage the "culture" of communities of color for a white audience. As Venus Iceberg X further suggests, artists like Diplo "keeps making $$$ and I can't pay rent." Incidentally, Diplo had already made a commercial for Blackberry, so there is a perception that, through cultural appropriation aided by the tools of digital technology, white artists can access commercial success while those artists of color who contribute to their success still struggle in the margins.

In addition to sampling world music, Diplo has been involved in the creation of the black cyborg Major Lazer, a fictional Jamaican dancehall DJ who was featured in an extremely sexualized dancehall remix song and Vimeo video, "Pon de Floor," which—when taken out of the cultural context of Jamaica—reduces the black body to fetishistic spectacle for white consumption. As *Racialicious* guest blogger Isaac Miller notes, Major Lazer "plays into racialized depictions of Black people as hyper-sexualized beings— stereotypes that go back to slavery and serve to reinforce characterizations of people of color as animalistic and inhuman" (Miller 2011). Of course, the sample of "Pon de Floor" takes on even newer meaning when it is

re-sampled for Beyoncé's "Run the World (Girls)." Whose music—and whose culture—is this?

Returning to M.I.A., these politics took on specific gendered concerns when she objected to music journalists routinely identifying Diplo as the source and "mastermind" behind the production of her music. As she expressed in an interview with the online magazine *Pitchfork*:

> I've had immigration problems and not been able to get in the country [the United States], what I am or what I do has got a life of its own, and is becoming less and less to do with me. And I just find it a bit upsetting and kind of insulting that I can't have any ideas on my own because I'm a female or that people from undeveloped countries can't have ideas of their own unless it's backed up by someone who's blond-haired and blue-eyed. After the first time [Diplo is mentioned] it's cool, the second time it's cool, but after like the third, fourth, fifth time, maybe it's an issue that we need to talk about, maybe that's something important, you know. (cited in Thompson 2007)

Here, M.I.A. identifies the problem of agency, which she is denied as a musical artist of color and as a woman, especially in the realm of electronic music, which is still dominated by men. Indeed, Björk, the most prominent female artist of electronica, came to M.I.A.'s defense, echoing her concerns that "people cannot imagine that women can write, arrange or produce electronic music" (cited in Nicholson 2008).

While Björk's musical concepts rely on collaborations with sound engineers and other high-tech artists, she maintains primary authorship—like M.I.A.—and is known for revolutionizing music through engagement with technology: think not only of her creative mixing of instrumental music with industrial beats but also of her innovative cyborg performances in the music videos for her songs "All Is Full of Love," in which she appears as twin robot lovers, and "Joga," which digitally merges her body with the volcanic landscape of her native Iceland. Björk has since embarked on the first iPad-produced multimedia app music album, *Biophilia*, which premiered in 2011. Fusing music and technology to meditate on her "love of nature," from the vast expanses of galaxies—digitally emulated on the app in the presentation of her songs as "stars" or "planets" in an alternate musical universe—to the molecular composition of such natural phenomena as crystals and viruses, Björk reconstructs the masculine spaces of music production and computer

technology for ecofeminist articulations. She also infuses her own mythical (world) view in the visualization and animation of her music, as well as in the contrasting sounds that she produces between her feminine, high-pitched vocals and the deeper tones created by the hybrid musical instruments controlled through her computer—including a pendulum harp that harnesses sounds from the earth's gravitational pull and a reconfigured pipe organ. Through these digital engagements, Björk reminds us that technology is intrinsically tied to the natural world, with music serving as our spiritual medium and the female artist as our sage.

The cyber-galactic musical journey of Björk expands the "SL and RL" travels of Cao Fei/China Tracy and M.I.A. toward infinite possibilities for the interconnectivity between art, technology, and social commentary. These electronic (world) views also reveal the increasingly shrinking dimensions of our world, made possible by the digital revolution. This narrowing distance— begun first with the global processes represented by discovery and conquest, colonization and imperialism, and now continued by neoliberal corporate globalization—may be shaped by economic, social, and political hierarchies, but these arguably feminist interventions carve out a divergent path in which such digital narratives can articulate a different reality and a different kind of community. The untapped potential for radical politics within digital culture remains.

CONCLUSION: DIGITAL (WORLD) VIEWS

The narratives cited, which have evolved in the public sphere, promise to expand media in more innovative and progressive ways. We need only look to the work of artist and architect Maya Lin, whose "last memorial," *What is Missing?*, through art installations, a Web site, a traveling exhibit, physical and digital books, and portable, downloadable media, documents the threat of mass extinction of rainforests and the reduction of the planet's biodiversity. Lin has been designing environmentally conscious art since her "first memorial," the Vietnam Veterans' Memorial Wall, which debuted in 1982. The minimalist design of the Wall—carved into the earth on the national mall in D.C. and reflecting on its black granite surface the names of more than 57,000 servicemen and women lost in that war—evokes the feminine principle, specifically in its V-shape, which contrasts with the phallic structures of other monuments in D.C. The Wall also reminds us of the ways that, through wars, death, and destruction, we scar the living organism that gives us our breath and our sustenance. As Lin describes her conceptualization of the monument: "I had a simple impulse to cut into the earth. . . . I

imagined taking a knife and . . . opening it up, an initial violence and pain that in time would heal" (Lin 2001, 4, 10).

In mounting her "last memorial" as a poignant bookend to the first one, Lin is moving away from a discourse of "national defense" to one promoting the "defense" of the planet.[10] Creatively incorporating sound media and video, Lin integrates sculpture, audio recordings of nature's sounds, and video imagery to heighten our awareness of environmental issues and the need for sustainability. Her *Listening Cone* installation, which premiered at the California Academy of Sciences in San Francisco in September 2009, includes shell-shaped sculptures that capture the "echoes" of the ocean, storms, and whales, and incorporates video footage of the threatened natural environment. The recorded natural "sounds" also shape the accompanying Web site, which launched on Earth Day 2010 and features an interactive satellite world map and extinction timeline. In addition to Lin's sculptures, perhaps her most visionary and awe-inspiring creation of digital art is an "Empty Room" traveling exhibit, first installed in Beijing, that utilizes concealed, floor-based video projections that enable onlookers to catch and hold projected images of different endangered animals in their hands.

What we witness through these revolutionary art hybrids are the harmonious blends of virtual and natural worlds. While technology is often constructed as antithetical to the natural environment, such artistic visions demonstrate how technology extends into the natural process precisely because it is representative of humanity, which is not divorced from nature, and becomes subversive in female hands. At the same time, these digital imaginaries cannot replace actual realities, especially considering that our high-tech industries have contributed to the natural disasters highlighted in Lin's work. We should especially not overlook how this environmental devastation parallels the global violence against women that stems from these same industries.

As is often the case, our digital narratives, and the images they inspire, lull us into believing these narratives are the only actions needed to gesture toward a radical politics. However, they are just that: a gesture, a call to conscience and consciousness raising. And when we fail to hear these "listening cones," the messages become muted—either through focusing only on aesthetic appreciation for these digital art works or by a cynical (world) view. By heeding the counternarratives in digital culture, however, we might be able to envision a different future for ourselves.

Our "Digital Diva," imagined as an Afro Geek Girl by Julie Dash, as the fabulously misinformed Latina showgirl-turned-high-priestess performed by Praba Pilar, or as any of the other digital artists mentioned, is revolutionizing

the way we engage our arts. She also lives her life fully immersed in the privileges afforded those who remain plugged into the digital lifestyle. Whether or not she is silenced by Big Media narratives that can only imagine her as a sex object or victim of our information age, she nonetheless exists to complicate these politics of engagement.

The Digital Diva also confronts the ways she is implicated in a larger global network woven by U.S.-dominated high-tech corporations, and works to envision a more inclusive and less toxic environment that transforms "information" into knowledge and empowerment. Widening the lens looking out on the world and on our bodies beyond a male, imperialist, and anthropomorphic gaze, she demonstrates subversive approaches in the retooling of technology. Other worlds and other futures are possible in the evolving Cyberfeminist imaginary.

Chapter 6

Exotic Sisterhood

The Limits and Possibilities of Global Feminism

not your
　　harem girl geisha doll banana picker
　　pom pom girl pum pum shorts coffee maker
　　town whore belly dancer private dancer
　　la malinche venus hottentot laundry girl
　　your immaculate vessel emasculating princess
don't wanna be
　　your erotic
not your exotic

—From Suheir Hammad's "Exotic," in *Born Palestinian, Born Black*

With a feminist sensibility and streetwise sass, Suheir Hammad, the celebrated Palestinian American spoken word poet, peppers her poem, "Exotic," with words of resistance to the objectifying, white, Western, and heterosexual male gaze that reduces her to a number of "exotic" stereotypes. Mapping these images across race, class, sexuality, and geography, Hammad recalls a collective history and experience for women of color and a common language in which we might resist both sexual and racial objectification. It is a linguistic strategy that rejects "exotic" constructions.

This particular phenomenon of exoticization, or Othering, is not just practiced within popular culture or within the sexual arena but also in U.S. feminist movements. Despite a longstanding tradition in which U.S. and

"third world" feminists of color have taken their white and/or Western
counterparts to task for either excluding or tokenizing their involvement
within feminism, an alarming number of otherwise well-meaning academic
and mainstream white feminists continue to stigmatize women of color as
spectacles of difference, failing to heed Audre Lorde's thirty-year-old call to
not only recognize this difference in more complex and meaningful ways,
but to also redefine it (Lorde 1984, 115). In short, women of color have
not only become the "exotic" collection represented in Hammad's catalogue
list—"harem girl geisha doll banana picker"—they have added "the spice"
needed at the feminist table.

Ella Shohat refers to this practice as a "malady within women's studies,"
in which there exists an academic disciplinary ordering of the "plight of
women: each outlandish geographical zone . . . matched with an abused
bodily part (bound feet [in China], veiled faces [in the Middle East], and
excised clitorises [in Africa])" (Shohat 2006, 1). Such geographical cataloguing
objectifies the "abject victim" who presumably suffers from extreme forms of
sexism, compared to the "more advanced" white or Western woman. The flip
side of this construction is the academic "Third World Diva Girl," whom bell
hooks castigates for disrupting "all possibility that feminist political solidarity
will be sustained between women of color cross-culturally" (hooks 1990, 94).

Even while acknowledging hooks's criticism of the postcolonial academic
feminist, whom she accuses of bringing to this country "the same kind of
contempt and disrespect for blackness that is most frequently associated with
white western imperialism," other black feminists, such as Michele Wallace, have
accused hooks of functioning similarly within academe, where women's studies
programs continue to marginalize feminist theorists of color, not just in pitting
U.S. and "third world" feminists of color against each other but also in selecting
tokens—such as bell hooks—who then stand in for an entire group or school
of thought. As Wallace laments, "In black feminism, two clearly divergent paths
are emerging: Either one travels the high road, the intellectual-creative route, out
of which such women as [Alice] Walker, [Toni] Morrison, and [Toni Cade]
Bambara have carved their path . . . or one travels the low road, the gospel
according to bell hooks firmly in hand, the path etched in the vertiginous stone
of rhetoric, hyperbole, generalizations, platitudes, bad faith, phony prophetism,
and blanket condemnation" (Wallace 2004, 159).

Such criticism exposes both cross-racial hostilities and infighting among
feminists. But mostly, it reveals a deep frustration that, within articulations of
a would-be global feminism, we have not yet achieved the goals set forth to
multiculturalize, transnationalize, and globalize women's studies and feminist
political movements. As Fawzia Afzal-Khan observes:

I think that the real issue here is the insufficiently articulated difference between the projects of postcolonial and minority interventions in the U.S. academy thus far, and, by extension, in the larger cultural and political scene. . . . Those who should be allied in their common struggles against racism, sexism, homophobia and class dominance, end up fighting each other. In other words, in the name of radical difference, we forget our shared oppressions, albeit different in degree though not entirely in kind. It is crucial, in my opinion, to close the gap created by this perception of difference. (Afzal-Khan 1996)

And yet, these differences continue to set us apart. As legal theorist Kimberlé Crenshaw has argued, an intersectional analysis is necessary "to account for multiple grounds of identity when considering how the world is constructed" (Crenshaw 1995, 358). Similarly, Chandra Mohanty (1991a) suggests that we map out our "cartographies of struggle" when locating feminists around the globe and the ways in which our movements intersect and collide, while Andrea Smith (2005) reminds us that the terrain itself has already been remapped by colonization. Specifically, Smith challenges feminists of color to interrelate what she calls the "three pillars of white supremacy"—slavery/capitalism as it impacts African Americans, genocide/colonialism as it impacts Native Americans, and Orientalism/war as it impacts non-U.S. citizens—in the fight against heteropatriarchy, since different communities experience intersectional oppressions differently and, therefore, must "re-envision a politics of solidarity that goes beyond multiculturalism, and develop more complicated strategies that can really transform the political and economic status quo" (Smith 2006, 73).

These political concerns invite us to decolonize our feminist view of the world, which is to say, to adopt a feminist (world) view that de-centers whiteness and the U.S./West in global discourse. We are specifically challenged to dismantle the hegemonic discourses of race, class, gender, and nation that frame our perceptions of feminism and seek to define what might constitute a feminist agenda that includes *all* women. While a "global sisterhood" cannot be taken for granted, there is still the certainty that coalition building across gender, race, class, nationality, and sexuality must occur if we wish to triumph over the various oppressions still impacting our world.

In this chapter, I will explore how a global feminism has been articulated and how we might begin to redefine it in more meaningful and effective ways that move us beyond "exotic sisterhood" and toward global power sharing as equals. I examine women's cultural productions and social protests from different world regions, and ruminate on the global flow

of culture, corporate globalization, warfare, sexual violence, and feminist protests in the wake of early-twenty-first-century struggles. I also elucidate the various trouble spots that might arise if feminists fail to incorporate a decolonized (world) view, as well as provide useful models to follow when decolonization has taken place.

Analyzing such cultural products as film, art, popular culture, and performative protest, I further argue that a decolonized feminist (world) view is crucial for U.S. feminist engagement with transnational coalition building and global feminist solidarity. These case studies suggest the continuous need for a complex understanding of our globalizing world and its impact on our lives, as well as for a planetary women's movement comprised of women (and their allies) willing to join together *as equals* in the fight against oppression. While this argument is not new, it bears repeating, especially at a time when imperialist dramas of the past seem to get replayed in an eternal loop.

A CURIOUS FEMINIST ODYSSEY

In order to achieve the goal of global feminism, it may be useful to map women's histories and experiences and place them, as Shohat argues, "in dialogical relation within, between, and among cultures, ethnicities, and nations" (Shohat 2006, 2). In the very act of transnational exchange, such discourse confronts the challenge for us to move beyond the exotic construction and uncover the potential for a "relational feminism," which "transcends an additive approach that simply has women of the globe neatly neighbored and stocked, paraded in a United Nations–style 'Family of Nations' pageant where each ethnically marked feminist speaks in her turn, dressed in national costume" (Shohat 2006, 2). In other words, what would it mean for global feminists to cross borders and boundaries in our critiques? Moreover, what would it mean to de-center U.S.-based feminism, which often becomes the normative means of resistance to gender and sexual oppression?

If bodies constantly migrate in transnational contexts to articulate meanings of race, gender, and nationality, then it behooves us to consider how feminisms also move either in concert with or against these narratives, often emerging from colonialist perspectives. Too often, U.S.-centered and Eurocentric feminists fail to articulate a global feminism that benefits women on different sides of national borders, let alone the different sides of war and occupation. For instance, the Revolutionary Association of Women in Afghanistan (RAWA) opposed the rule of the misogynistic Taliban—as did the U.S.-based Feminist Majority—but also—unlike the Feminist Majority—opposed the U.S. "war on terror" waged in retaliation for the attacks on

September 11 and through the United States' foreign policy and media discourse of the liberation of burqa-covered Afghan women.

The female body-as-battleground, to invoke Barbara Kruger's famous image, resurfaces in the global spheres of politics and militarism. However, some mainstream U.S. feminists have yet to fully incorporate the discourses of women of the global South most impacted by the policies enacted in these spheres; nor have they developed a "curious feminism," as Enloe advocates, to inquire about international politics in ways that can strengthen global feminism and "make the global workings of unequal power fully visible" (Enloe 2004, 305). Globalized war and terror necessitate that we become curious about each other's lives and the effects of global policies on our very bodies, not to better understand our "enemies" but to forge future alliances.

The "curious feminism" that Enloe advocates is exemplified in Afghan-born Canadian journalist Nelofer Pazira's *Kandahar*, a film made in collaboration with Iranian filmmaker Mohsen Makhmalbaf, which debuted in 2001 at the Cannes Film Festival shortly before the events of September 11 and the subsequent U.S.-led war in Afghanistan. Unfortunately, most commentators viewed and celebrated the film through a veneer of the savage, Orientalist East and not through an antiwar sensibility, which is its underlying premise. The film is based on Pazira's factual account of leaving Canada and returning to Afghanistan in a quest to locate her childhood friend—referred to in the narrative as her sister—who wrote her a suicide note in 1998, in despair after being injured by a landmine amid the solidification of the oppressive Taliban regime.

Kandahar blurs distinctions between "nonfiction" and "fiction" through its narrative, which interweaves storytelling with documentary-style reportage. Filmed along the Iran-Afghanistan border, *Kandahar* captures the despair of a war-torn country, witnessed through the journalistic eyes of Pazira, who revisits her homeland and undergoes culture shock. We experience with Pazira the devastating effects of war: the numerous landmines that litter the landscape and maim civilians; the denial of education to young girls and indoctrination of young boys, who are being trained to link Islam with militarism; the severe famine and lack of drinkable water that has developed during the course of continuous warfare; the lawlessness and border patrols; and the ubiquitous and enforced burqa that at first "suffocates" Pazira and the myriad faceless women in the film, then provides her "safety" and comfort from the many dangers she encounters.[1]

Even under full cover, the burqa-clad women defy this enforced invisibility by asserting their individuality and beauty throughout the film. They apply lipstick, paint their nails, wear noisy bangles, advocate for their

children's schooling, chant funeral dirges or sing wedding songs, and display colorful burqas, which Pazira herself calls breathtakingly beautiful in her film commentary. In these subtle depictions, we see Afghan women performing embodied resistance by insisting on their right to be seen *and* heard, even when we cannot view their faces.

Significantly, the film begins its journey into Afghanistan with a familiar image, reminiscent of *National Geographic*'s celebrated 1985 cover photo of the "Afghan girl," whose piercing eyes revealed to us the unspeakable horrors of war. At the point of Pazira's crossing the Afghan border on foot, the camera pans over numerous Afghan girls, who return the camera's gaze with their own defiant stares harsh enough to rival any *National Geographic* cover while receiving an important lesson on how to avoid landmines, one of which has already disfigured the eye of one of the young girls present. In this poignant shot, we recognize the colonizer/ethnographer's gaze and the ways in which the film subverts the colonial narrative, to "heal our imperialized eyes" (Bambara 1992). When we consider, however, that the "Afghan girl"—now known to the world by her name, Sharbat Gula— grew up to be pictured in the full covering of the burqa, as shown in the 2002 *National Geographic* update, and that these young girls will also don such invisibility when they become women, we appreciate the difficulties in creating third world female subjectivity in global narratives of war. In these ways, *Kandahar* plays to and counters the dominant representation of third world female victimization, but most importantly, it projects the (female) body politic onto the nation-state.

In another poignant scene, we observe men on crutches, who have been maimed by landmines, gathering at a Red Cross camp in search of spare prosthetics and desperately chasing after a plane flying over their heads, which has dropped by parachute various pairs of prosthetic legs—feminine in appearance. Having already been privy to an earlier scene depicting an Afghan man arguing with one of the white female medical volunteers at this camp for "suitable" legs for his maimed wife—because the available pair are too masculine—we might conclude, by way of globalizing Rosemarie Garland Thomson's feminist disability theory, that war renders the orderly spheres of gender, nation, and the able body meaningless. This lack of meaning, recognized in Western contexts as "the messiness of bodily variety," merely reflects the messiness of war (Thomson 1997, 24). Such disruptions extend farther into queer subtexts, as men desperately don feminine prosthetic legs to become able-bodied or, in another scene, as one attempts to escape the threat he perceives as a masculine subject by cross-dressing in a burqa when he encounters a border patrol.

In yet another subversive rendering of the body politic, the film dramatizes Pazira's encounter with an African American man posing as a local physician. Through this character, we are reminded of a specific history in the seventies that connected Black Power movements in the United States with third world and Marxist liberation movements, during which time our exiled American joined a Muslim sect in Afghanistan, fought in the local wars, and remained behind to provide humanitarian services. That this same man could then blend in as an Afghan, even while he was forced to don a fake beard—due to the Taliban's enforced codes of masculine presentation—further questions the fixed categories of race, ethnicity, and nationality. Again, war and border crossings destabilize such identities.

Unfortunately, Pazira fails to rescue her friend/sister from her suicide mission while embarking on this "curious feminist odyssey." However, we may be able to appreciate something of the pain and despair of this subaltern figure—whom we never meet—through the sobering images offered both in *Kandahar* and Pazira's follow-up 2003 documentary, *Return to Kandahar*, which examines how the U.S. war in Afghanistan has exacerbated decades of fighting, begun first with the Soviet Union, then with ethnic conflicts. The suicide of Pazira's friend—named Dyana in the documentary—could thus be interpreted as embodied resistance against the unlivable conditions produced by wars, not unlike the martyrdom enacted by female suicide bombers, minus the perpetuation of mass bloodshed. Such drastic measures serve as performative protest that counteracts state assertions of the necessity of war.

RE-FASHIONING THE BODY POLITIC

The subaltern figure may be silenced by the national, international, and patriarchal forces that surround her; however, she is also subsumed within a "universal" representation of gender that recognizes only white, Western-based heterosexual middle-class womanhood as normative. She is again silenced within a feminism that perpetuates the imperialist agendas of the state. This has prompted counternarratives from Middle Eastern, Muslim, and Islamic women who have reclaimed hijabs, chadors, and burqas as instruments of feminist liberation, especially in the wake of Islamophobia inspired by the global "war on terror" and anti-immigration policies in European countries such as Britain, France, and the Netherlands, which have adopted measures to restrict the wearing of the "veil." Muslim and Islamic feminists thus develop what Miriam Cooke terms a "multiple critique," which "allows them to engage with and criticize the various individuals, institutions, and systems

that limit and oppress them while making sure that they are not caught in their own rhetoric" (Cooke 2000, 100).

This challenge to avoid being "caught in their own rhetoric" is one that artist Shirin Neshat confronted a decade earlier in her visualizations of the veiled Muslim woman. An Iranian artist based in New York City, Neshat returned to her country of origin in 1990, after fifteen years in exile, and created a provocative series of photographs, *Women of Allah* (1993–97), in response to the postrevolutionary and postwar changes that she witnessed there. The photographs posit the female body as a conduit for cultural dramas and national struggles by creating a leitmotif of traditional dress (the chador, which references Islamic culture), the gun (symbolic of war and revolutions), and Farsi poetry written by Iranian women (symbolic of local feminist political consciousness). In "Rebellious Silence" (Fig. 6.1), Neshat

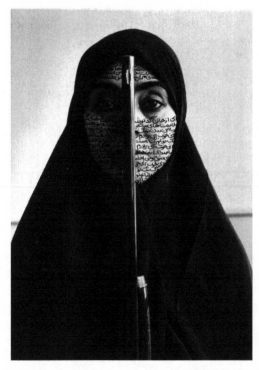

Figure 6.1. Shirin Neshat, "Rebellious Silence," 1994. B&W RC print & ink (photo taken by Cynthia Preston). 11 × 14 inches. © Shirin Neshat. Courtesy Gladstone Gallery, New York and Brussels.

inscribes on her face handwritten Farsi calligraphy in a style resembling henna decoration, juxtaposing words and images with her body serving as the canvas. The title of this piece also suggests that Neshat transcends the silences imposed on the body by culture, religion, and war and envisions agency for the female subject. The gun featured, ambiguously, could represent either a militant feminist subject or one who is threatened by militarized violence.

Because of the cultural specificities found in Neshat's work, especially in the non-translated text of Farsi poetry, which prevents easy access to the culture—and, by extension, to the body on view—Neshat's photograph challenges us to rethink embodied resistance within the arena of global feminism. Viewing these images also requires that we constantly decolonize our Eurocentric gaze, which encourages a paternalistic attitude toward women's struggles in the global South, or what Mohanty calls Western feminism's attribution of "Third World difference" to non-Western women's lives (Mohanty 1991b, 72). As Negar Mottahedeh cautions, Neshat's images would, "if unevaluated critically, feed into and proliferate stereotypical representations of Middle Eastern cultures not unlike earlier traditions of Orientalist art" (Mottahedeh 2003, 184). This potential Orientalism has already garnered criticism, as art critic Lindsey Moore accuses Neshat of reducing the Farsi text to mere "decoration" in the eyes of a non-Farsi-speaking public (Moore 2002, 3).

Neshat herself has commented that her art reflects the "naiveté of an artist living aboard, returning and very sincerely wanting to understand" (Horsburgh 2004). Nonetheless, we should not dismiss the "curious feminism" she brings to the photographic image in illustrating the gendered, raced, and national body as the site for cultural and social contestations over power and identity. In another photograph in the series, "Speechless" (Fig. 6.2), Neshat zooms in on half of a woman's face, "decorated" with poetic text overlaid on her image, while the barrel of a gun appears just below her ear, dangling like an elaborate jewelry piece and thus suggesting the normalization of war and the militarization of the female body, which is rendered silent by cultural and state intimidation. Through this visual, Neshat critically questions Iranian women's allegiance to the new politics of the nation, which represses women's rights, while also challenging the Western gaze by reframing and disrupting cultural signifiers of the "Orient."

In a different visualization, Cameroon-born photographer Angèle Etoundi Essamba recuperated the image of the veiled woman in response to prevalent anti-veiling and Islamophobic narratives, as envisioned in her 2002–08 series Unveiling the Veils, which reconfigured a "Femme du Monde" beyond whiteness and Western femininity. Significantly, Essamba shifts the

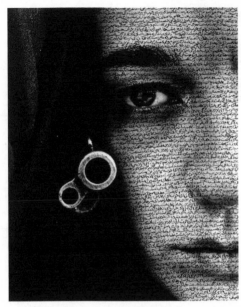

Figure 6.2. Shirin Neshat, "Speechless," 1996. RC print and ink. 46³/₄ × 33⁷/₈ inches. © Shirin Neshat. Courtesy Gladstone Gallery, New York and Brussels.

veiled female body into an African context, on the island of Zanzibar. Weaving a black feminist aesthetic into the fashion model mystique, Essamba reclaims the veil as both fashion statement and beauty symbol, reframing the black female body within this global discourse (Fig. 6.3). As she illuminates it in her online video: "Behind the veil I [seek] above all to capture the inner strength and the pride that these women radiate. They tell their own story through their own values and fashions, thus challenging all the stereotypes that serve to marginalize the veiled woman" (Essamba 2009). These images took on new meanings when they appeared in an open space exhibit on the streets of Sevilla, Spain, in 2009, where large photographs installed on sidewalks in billboard style disrupted the local cultural and environmental space, which is still in contestation as Spaniards struggle with anti-immigration sentiments, similar to those expressed throughout the European continent, toward the influx of both Muslim and African immigrants within their national borders.

Whatever new challenges this immigration will bring to the global North, certain European Muslim women have modeled strategies of

Figure 6.3 Angèle Etoundi Essamba, "Toute en dignité" 2, from the *Voiles et Dévoile-ments (Unveiling the Veils)* series, 2002–08. Permission of the Artist.

resistance. One example is Cennet Doganay, a young French Muslim woman who in 2004 shaved her head when French laws banned her from wearing her headscarf to school.[2] We may recognize the "multiple critique" that Doganay used to exert agency over her own body and sense of belonging. Similar protests against the ban occurred among street and performance artists, including Princess Hijab, who spray-painted black "hijabs" onto French models in billboard ads, and NiqaBitch, a duo who cloaked their faces with the banned "niqab" while exposing their legs as they walked the Parisian streets in miniskirts. Implicit in these actions is resistance to a Western male gaze that is known for sexualizing and policing the "exotic" Other, especially in light of France's colonial history, which afforded colonials sexual access to African and Antillean women's bodies—often displayed in the nude in the Western imaginary—and simultaneous lack of access to the veiled Muslim woman, hidden from public view within Islamic culture that relegates women to the private realm (Cooke 2000, 101).

Histories and contemporary scenarios such as these politicize the veiled female body and invite us to contest Western tropes of Islamic

womanhood, which reduce Muslim female subjects to stereotypes and often silence their revolutionary voices. This silencing was captured during the Egyptian revolution in early 2011, in which such important women activists as Asmaa Mahfouz, who used her Facebook video blog to urge millions of her citizens to take to the streets, were ignored in both Big Media and feminist narratives of the West. While U.S. media eagerly championed the importance of social media in the "Arab Spring" uprisings, they focused on male protestors, even though Mahfouz helped to ignite the spark in Egypt. As Nadine Naber argues, "[Egyptian women's] struggle[s] cannot be explained through Orientalist tropes that reduce Arab women to passive victims of culture or religion or Islam. They are active participants in a grassroots people-based struggle against poverty and state corruption, rigged elections, repression, torture, and police brutality" (Naber 2011).

Of course, when we consider that such revolutionary roles taken on by women in the Middle East refute the prevailing narratives in the West of the oppressed woman in her "veil," their silencing by mainstream media is not surprising. Their silence is even more pronounced when we also consider that the types of narratives that Big Media *does* promote about women of the Islamic world often reflect anti-veiling and/or anti-Islamic sentiments—including the reportage by Egyptian journalist Mona Eltahawy, the popular graphic novel *Persepolis* by Iranian author Marjane Satrapi, the memoirs of Somalia-born Dutch politician Aayan Hirsi Ali, and the nonfiction book and film adaption of *The Stoning of Soraya M.* by Freidoune Sahebjam, which concerns the stoning of an Iranian woman falsely accused of adultery. In the interests of maintaining global white Western imperialist heteropatriarchy, certain gendered and cultural stereotypes are kept in place and certain stories are told and circulated.

These "exotic" representations and political struggles thus reiterate the motif of "your body is a battleground." This time, the battle has expanded beyond reproductive choice, which was the focus of Kruger's pro-choice poster, to cultural dress codes, assumptions, assertions, and policies that have drawn nationalist battle lines onto women's bodies. What remains to be seen is how feminists will reclaim their right to their own bodies, to "choose" to veil or to not veil. The challenge persists in creating transnational conversations that benefit women on different sides of these battle lines and that complicate these spectacles of difference. For the remainder of this chapter, I examine some of the pitfalls of global feminist discourse that occur when we objectify non-Western women rather than treat them as equals. I also turn to the examples of other global feminists who provide us with important visions that can move us forward in a project of decolonization.

BODIES IN COMMON?

Feminist purveyors of global sisterhood—a sisterhood based on common genitalia—would do well to note that even apparently similar body parts have different histories and locations. (Oyewumi 2001)

A main challenge to recognizing and complicating "difference" involves U.S.-centered and Eurocentric feminists shifting from notions that all women have a common experience with sexism. Operating within a discourse of sameness, this assumption of commonality imagines, for instance, that all women can build solidarity around our wombs and our sexual politics—rather than recognize the "different histories and locations" of women's embodied experiences, as Oyeronke Oyewumi admonishes in the above citation. To believe that a global feminist movement could center on women's shared biological characteristics is to dismiss the ways in which our gendered experience shifts according to our race, class, nationality, sexuality, and dis/ability. As such, ideologies of domination, which elide our differences, also work to erase our geographic specificities and how these might impact our resistance strategies.

For example, the California-based antiwar feminist group Baring Witness, co-founded in 2002 by Donna Sheehan, developed a series of photographs featuring fifty nude white women protesting the U.S.-led "war on terror" by forming with their bodies the words "No War" and "Peace," the first photographs taken in November 2002. Inspired by the actions of six hundred women in a Nigerian village, who had staged a protest against Chevron-Texaco beginning in July that year, and who had threatened to strip off their clothes in a cultural act of shaming, Sheehan formed her group in response to this "glorious vision" of women's nudity as a way of "using the greatest weapon women have, the power of the feminine, the power of our beauty and nakedness to awaken our male leaders and stop them in their tracks" (Sheehan 2003). Unlike the Nigerian women, whose standoff against corporate globalization lasted for months and finally came to a victorious end, resulting in the fulfillment of the women's demands for local jobs and contributions to their community's healthcare, education, and environmental concerns, Baring Witness failed to prevent the war in Iraq, which they were protesting through their "vulnerable nakedness."

Part of the failure of Baring Witness had to do with mistranslation, imagining that what is effective in Nigeria—a culture that views female nakedness, especially in older women, as a sign of potency or a curse,

alongside ultimate shame upon witnessing this nudity, which has nothing to do with "beauty" or "vulnerability"—would work in a U.S. cultural context. Not only did this perspective miss the point of the Nigerian protest, in which women risked their bodies in their fight against impoverishment within the global economy, but Baring Witness reproduced the spectacle of nudity on their Internet Web site, thereby neutralizing whatever potency their photos might have had by circulating them within U.S. mass media alongside the most extreme pornographic images of women's nudity. In other words, this protest strategy could not possibly "shame" American men, nor "stop them in their tracks" because our nude bodies, unlike those in Nigeria, do not bare/bear the same level of shame.

Granted, I would have had a different view had U.S. feminists across races and ethnicities (versus the all-white spectacle of Baring Witness's participants) taken to the streets and collectively bared our breasts in the wake of, say, the Janet Jackson scandal back in 2004, when her exposed breast at the halftime show of the Super Bowl created far more moral outrage than our unjustified war in Iraq, if only to shame our nation in its lack of moral and ethical priorities and in its continued racist misogyny. In this context, a nude protest within the U.S. makes sense, if only because race perpetually underscores our gender politics, in which white female bodies seem aesthetically acceptable while black female bodies remain disruptive.

I would also have had a different view if Baring Witness had made more concrete connections between Big Oil's actions in fueling the Iraq War and the corporate takeover it had staged in Nigeria, which the local women were protesting. However, at the heart of Baring Witness's problematic approach is their appropriation of a non-Western tactic, thus perpetuating a colonial gaze. In critiquing cultural appropriation, Fusco notes, "While it is true that no culture is fixed and that exchange among cultures has taken place throughout history, not to recognize historical imbalances and their influences is *the* strategical evasion that enables the already empowered to naturalize their advantage" (Fusco 1992, 71; emphasis in original).

Moreover, these acts merely reduce women in the global South to what Uma Narayan calls the "Third World as Mirror . . . a reflecting pool that gives a Western Narcissus back his own pale reflection" (Narayan 1997, 141). In mirroring the actions of Nigerian women, Baring Witness eagerly appropriates their performative protest to make meaning of their own gender politics—reduced in their vision statement to an essentialist understanding of "war as a masculine invention," while peace exists within the feminine terrain of the body. They also reduce the African subject to a familiar trope of "naked savagery" and hypersexuality. Hence, as Narayan

suggests, "[While] 'Looking Up To' one's Others may *seem* a good strategy to counter a history of 'Looking Down Upon' . . . [we would] prefer that such encounters . . . occur Eye-to-Eye and Face-to-Face" (Narayan 1997; 156 emphasis in original).

Not only would we prefer equality to romanticization, but demonization—its flip side—is never far behind, as evidenced that same year by the international protests of Western-based contestants of Miss World, some of whom boycotted the 2002 beauty pageant because it took place in Nigeria at a time when Amina Lawal, a Nigerian Muslim woman, was under threat of being stoned to death under Sharia law for giving birth to an illegitimate child. The irony of these contestants taking a "feminist" stance, while failing to make connections between the pageant's objectification of their bodies and the Sharia court's objectification of Lawal, can only be understood when we recognize how Western women often contrast themselves to "downtrodden" third world female victims. This is especially evident in a post–September 11 context, in which Islam and the global South form an image of the "uncivilized" Orient or "darkest Africa."

Within Nigeria, national conflicts—such as economic struggles sacrificed for an opulent pageant and the display of contestants in revealing clothing, which clashed with Islamic fundamentalist values—eventually culminated in riots that killed hundreds and displaced thousands from their homes. Nigeria's bid to enter the international community by hosting Miss World ended in neocolonialist defeat, best symbolized when the pageant relocated to England. Unfortunately, struggles over ethnic conflicts and the global economy are continuously mapped onto the female body. Nonetheless, while we may reflect on this terrible moment and at least feel gratitude that Amina Lawal's life was eventually spared, thanks in part to the international protests surrounding her case, we should not overlook the part local feminism played, specifically the work of her female defense lawyer, Hauwa Ibrahim, who defeated the Sharia case against Lawal not by condemning Islam but by reinterpreting the Koran and Muslim doctrine to successfully defend Lawal's right to life.

THE VAGINA DIALOGUES

Both Baring Witness and the 2002 Miss World debacle serve as cautionary tales against women objectifying other women. Such misguided worldviews are continuously dramatized in the specter of the circumcised African female body, for example, which still holds currency—much like the veiled Islamic female body—in prevalent Western feminist discourse. Like her African American counterpart, who in U.S. popular culture is often fetishized and

reduced to her posterior, the African woman is similarly reduced to her "presumably missing parts" (Oyewumni 2001). Within a historical context, we might recognize these fragmented body parts as, once again, remnants of the iconic legacy of the "Hottentot Venus"—whose buttocks (the subject of her live exhibition) and genitalia (the subject of her posthumous display) shaped a common vocabulary and visual trope in referencing black female sexuality. Incidentally, Baartman's remains, once housed in the Musée de l'Homme in Paris, were finally returned to South Africa, where she was laid to rest on August 9, 2002—the same year that we witnessed other postcolonial and neocolonial struggles, as exemplified by Nigerian women's protests against Chevron-Texaco and the Miss World fiasco.

These symbolic configurations seep their way more deeply into the realities of international policies when familiar tropes and stereotypes frame our responses to the global scene. In her study of asylum laws in the United States and their effects on refugee women, Connie G. Oxford notes how the "Third World difference" reverberates in legal defenses. In particular, she describes how representations of the circumcised African female body trump all other concerns that these women face. Thus, in sharing the story of Sahara, an Eritrean national, Oxford writes:

> Like most of the women I interviewed who had been granted asylum because of female circumcision, Sahara did not leave Ethiopia because of this. In fact, Sahara did not consider circumcision harm at all as it was performed in infancy and she has no memory of it. Instead, Sahara left Ethiopia after she was jailed and tortured for being an Eritrean national. . . . She discussed her rapes while being imprisoned in the context of being Eritrean, not in the context of being female. . . . When the conversation turned to female circumcision, she told me that she didn't understand why "they" (her attorney and service providers) were talking about "that" (female circumcision). . . . She explained that they told her it would help her with the asylum case and that she only talked about it to gain asylum. (Oxford 2005, 27)

As Oyewumi (2001) queries, "How and why does female circumcision, which is not practiced by many African cultures, become the defining characteristic of Africanness?" While specifically referencing Alice Walker's magnification of African female circumcision in her creative and political work, Oyewumi's criticism can be leveled at any feminist who has fixated on this issue—most likely because we insist on genitalia as our universalizing

feature while simultaneously relying on the trope of racial difference (or ethnic difference, in the case of Walker's objectifying stance), which was at the heart of displaying Baartman's private parts, as Sander Gilman and others have argued.[3] Sadly, Sahara's attorney and service providers seem woefully ignorant about wars and ethnic conflicts—failing to incorporate intersectionality in these gendered cases.

We must address this global inadequacy in our theories and practices. After all, well before Oyewumi challenged Walker's misguided approaches to African female genital surgeries, Audre Lorde wrote an open letter to Mary Daly in response to her 1978 *Gyn/ecology*. Because Daly failed to include in this manifesto the stories and resistance strategies of women of color in any meaningful way, other than to reference African female circumcision, Indian women's sati, and Chinese women's footbinding—in other words, to highlight third world female victimization—Lorde warns, "When patriarchy dismisses us, it encourages our murderers. When [feminism] dismisses us, it encourages its own demise" (Lorde 1984, 69).

It would seem that mainstream popular feminism has not heeded Lorde's words. We need only take note of Eve Ensler's successful *Vagina Monologues*, debuting twenty years after Daly's influential book *and* perpetuating the same victimized representation of "female genital mutilation." However, Ensler's vision of embodied resistance through discourse on the vagina, which is annually celebrated in U.S. feminist circles and on college campuses around Valentine's Day (renamed V-Day), not only objectifies the "Third World victim," but also erases the existence of such practices here in the United States. As the Intersex Society of North America (ISNA) argues in an open letter to V-Day participants: "We felt invisible [in the monologues], it presented horror stories about genital mutilation occurring in other continents, as if we do not experience them here" (cited in Hall 2005, 105). Their response thus challenges both the work's colonial gaze and its heteronormative paradigm by disrupting the two-sex gender binary through intersex genitalia, which is routinely "mutilated" by the medical profession due to our cultural insistence on gender norm constructions.

In addition to this counternarrative to V-Day and *The Vagina Monologues* is another open letter, this time addressed to Eve Ensler and written by a Mexican-based organization, Nuestras Hijas de Regresso a Casa (Bring Our Daughters Home), who questioned the appropriateness of Ensler's mobilization in 2004 of an international protest against the murders and kidnappings of women in the U.S./Mexico border city of Juarez, which was linked to her V-Day focus on domestic and sexual violence. As they expressed in their letter:

We think that the emotional state of those affected by the loss of the lives of our daughters and sisters does not permit them to enjoy fundraiser celebrations . . . that target affluent and socially connected people. In reality, those people are protected and immune from the daily dangers and pain that do indeed imperil us. The destruction of the lives of nearly 400 women and an incalculable number of disappearances over the past eleven years in Juarez have nothing to do with domestic violence, nor do they have anything to do with the harassment and violence that all women are exposed to in general by men who are close to and known to them. (Nuestras 2004)

While the organization seems to dismiss the useful global connections made between V-Day's focus on domestic and sexual violence and their own experience with mass femicide, their resistance is one that rejects the gender-only analysis that comprises the philosophy behind Ensler's International V-Day, and with good reason. The murders taking place on the border—discussed in chapter 5—reveal the interlocking effects of global capitalism, transnational racism, and anti-immigration policies along the U.S./Mexico border, and the exploitation of women's bodies in both the labor force and sexual arena. The epicenter for this disastrous situation—the border city of Juarez—is a site of illicit activities and international violations of human rights and the environment precisely because of its precarious border location. To reduce the femicide in Juarez to patriarchal violence, thereby disconnecting it from the wider politics of border patrol, illicit trafficking, and the global economy, is to render global feminism incompetent in assessing our global situation.

Thus, Ensler unwittingly "mobilizes a colonialist discourse" (Hall 2005, 103) and constructs a myopic feminist worldview, exemplified in her International V-Day, which impacts on our popular views, not just of women of color but also of Eastern European women, such as those in Ensler's Bosnia project, which highlights the "mutilated" vagina when articulating Bosnian women's horrific experience of genocide in mass rape camps. My criticism of Ensler's response to global politics, however, is not intended as a solely negative reflection on U.S. feminism. Ensler's analysis and public performances are sorely needed in a world that continues to devalue women's bodies and subject them to the worst forms of violence. However, her cultural work can only be enriched by applying intersectionality *and* a decolonized (world) view.

A similar gaze is applied to Lisa F. Jackson's 2007 documentary film *The Greatest Silence: Rape in the Congo,* which connects the filmmaker's horrific experience of gang rape in the affluent neighborhood of Georgetown in Washington, D.C., with the mass rapes occurring in the Democratic Republic

of Congo. While Jackson's perspective again reduces global feminism to a "common" embodied experience, in this case rape, her film actually complicates patriarchal violence by introducing to the narrative issues of the political global economy and how corporate environmental rapists rely on actual rapists to create the necessary chaos in which they can steal raw materials from the Congo to fuel our high-tech economy. However, Jackson does not arrive at these conclusions herself; her female subjects theorize these connections *for* her, proving Enloe's point that our "curious feminism" must "listen" to other feminists and different feminist messages around the globe, especially those with the most ready knowledge on the ground. In these ways, despite some trouble spots, such as when she fails to interrogate the white and U.S. privilege she wields in order to gain access to perpetrators of violence or when she pointlessly offers nail polish to rape survivors who are healing from their wounds, Jackson's film serves as witness and gives voice to these women.

FROM EXOTIC SISTERHOOD TO GLOBAL MOTHERHOOD

The airing of Jackson's documentary on HBO prompted a lively conversation in the U.S. feminist blogosphere, producing a "blog swarm" on April 13, 2008, in which countless bloggers addressed the issue. Woman to Woman International featured a "Run for Congo" marathon on International Women's Day that year to raise awareness of the atrocities. While these conversations are useful in raising our global feminist consciousness, there still exists the problem of overrepresenting victimization and negative stereotypes in third world contexts, especially when referencing the African continent. As one African blogger, Grata from *The Village* blog, complained in response to the blog swarm:

> I am simply tired of the hypocrisy of the outside world that wants to make African war crimes like rape as unique only to Africans. This kind of stereotyping needs to be checked and we shouldn't let ignorance prevail. This is obviously not a justification of rape, but for all those in the struggle for justice it is important not to be persuaded that this is a problem that is unique to Africans. This kind of thinking would not help much with your cause since from the onset one may assume that they are dealing with a problem that is race specific yet its [*sic*] not. Who knew that in this day and age we would have Abu Ghraib courtesy of US forces including women as the perpetrators of the abuse? (Grata 2008)

In light of this overrepresentation, which not only fails to situate these local atrocities in global and transnational contexts but which reinforces racism, the international focus of global feminism, as represented by the narratives of Ensler and Jackson, appears to be concerned exclusively with the rape narrative, and to ignore any useful analysis of the ways sexual violence is informed by race, class, and national conflicts during war and genocide, thereby failing to direct attention to the fact that, in contexts of war and terror, rape is not simply a weapon of patriarchy but a tool of imperialism, corporate globalization, and white supremacy. However, Jackson's narrative is at least more successful than the mass media's in exploring these connections, in that she has privileged the voices of local women who understand how their bodies intersect with the state and the global economy. These connections routinely get downplayed in sensationalized media reports of the recently recognized international "war crime" of rape.

Along with neocolonial arguments that encourage the demise of feminism, as Lorde remarks, by their inability or refusal to intersect patriarchal oppression with white supremacy and imperialism, persistent gender essentialism dichotomizes militaristic violence by adopting familiar gender binary discourses of women as victims and men as perpetrators. Such accounts fall short by failing to address the war crimes and human rights violations committed by not only female suicide bombers and other "terrorists" but also such female perpetrators as Pauline Nyiramasuhuko, who served as the Director of Women's Affairs in the government of Rwanda before she became the first woman to be tried by the UN International Tribunal and, for her role in orchestrating mass rapes against Tutsi women during the country's genocide in April 1994, convicted of crimes against humanity. As Grata reminds us, there is also the example of U.S. Army Reserve Private Lynddie England, who was prominently featured in the photographs that surfaced in 2004 depicting U.S. soldiers torturing Iraqi prisoners at Abu Ghraib.

These women may not be the norm, but they are also not aberrations of their sex. Within our own U.S. cultural context, we hear stories of young women who set up other women to be date raped at parties or during spring break vacations, and on the U.S./Mexico border, we hear about women who contribute to the femicide in Juarez by helping kidnap young women and girls. Moreover, throughout the world women routinely entrap other women in sex work. We do not need to cite the brutalities associated solely with wars and genocide to illustrate that the lure of power and control knows no biological boundaries, regardless of our insistence that feminism revolves around "common genitalia." The personal is indeed global; unfortunately, sisterhood—contrary to what we have been taught—is not.

While some feminists have challenged the symbolic value of sisterhood in organizing women's movements—stating that it recreates the West-based nuclear family (Collins 1998a; Oyewumi 2000)—others find a more powerful image in motherhood and co-motherhood, the latter existing in polygamous and communal societies. This symbolism poses its own gender essentialism, although we would be remiss if we were to overlook how motherhood has mobilized social protest throughout time (Bejarano 2002)—from the Madres in Argentina at Plaza de Mayo, bringing to the world's attention the disappearance of their children under a repressive regime, to the mothers in Juarez, organizing on behalf of their missing daughters, to Cindy Sheehan in the United States, mobilizing protests against the war in Iraq after the death of her son. The politics of motherhood is also reflected in global environmental movements, especially in the articulation of Earth as our global mother, or Terra Madre, as ecofeminist Vandana Shiva champions.[4]

This global principle is captured in the writings of the late Nobel Peace Prize laureate and environmental activist Wangari Maathai, who meditates on her mother's teaching of the "tree of God," the source for her rural community's water supply in Kenya:

> I later learned that there was a connection between the fig tree's root system and the underground water reservoirs. . . . Indeed, wherever these trees stood, there were likely to be streams. The reverence the community had for the fig tree helped preserve the stream and the tadpoles that so captivated me. The trees also held the soil together, reducing erosion and landslides. In such ways, without conscious or deliberate effort, these cultural and spiritual practices contributed to the conservation of biodiversity. (Maathai 2006, 46)

Maathai's (world) view ignited a national Green Belt movement in Kenya—beginning with various mothers' collective efforts to counter the colonial legacy of deforestation by planting trees to sustain the life of their families and communities. Such actions refocus on what Shiva calls the "living commons" of Earth Democracy, based on a sustainable economy, which offers "a new way of seeing, one in which everything is not at war with everything else, but through which we can cooperate to create peace, sustainability, and justice in our violent and violable times" (Shiva 2005, 115). Both Maathai and Shiva reclaim the body of Earth as a living being and urge feminists and anticolonialists to realign our own bodies within this planetary system: affirming life through our collective embodied resistance.

Such visions of environmental and inclusive justice may steer global feminism onto the path away from "exotic sisterhood," provided we don't

reduce the radical construction of Terra Madre, and our interconnected relationship across the planet, into a romantic and clichéd image of Mother Earth, or what Eli Clare describes as a "reverence often stolen from Native spiritual traditions and changed from a demanding, reciprocal relationship with the world into something naïve and shallow" (Clare 1999, 25). There are material realities at stake in protecting environmental resources, which reach far beyond a romantic view of simply "hugging trees"—an act first started in 1974 by rural women in India, who protected the trees on their land from deforestation in what would later become the Chipko movement. More recently, indigenous women's groups, such as the National Federation of Peasant Women of Bolivia,[5] were instrumental in advancing Bolivia as the first nation in the world to recognize the rights and laws of Mother Earth in 2011. A global feminist movement will need to re-center our very planet as we forge global and transnational alliances and interconnect our struggles.

CONCLUSION: CLOSING THE DISTANCE

The examples of protests and cultural productions presented in this chapter illustrate that exoticism, war, sexual violence, global capitalism, xenophobic battles, and environmental struggles are ongoing sites of power and control and that feminist resistance remains a viable alternative to these ideologies of domination. However, as Lorde reminds us, "[Unless] one lives and loves in the trenches it is difficult to remember that the war against dehumanization is ceaseless" (Lorde 1984, 119). Our resistance must persist because these wars persist.

Many of us are still bleeding at the intersections of race, class, and gender, the way the third world bleeds when it grates against the first world at the borders, to loosely quote Gloria Anzaldua. Our privileged existence as U.S. feminists thus presents obstacles when attempting multiracial and international alliances without decolonizing our practices. How do we position ourselves in these millennial struggles?

One way I have attempted to address these concerns is through the tools of our present-day digital revolution, which have narrowed the distances between us and made our lives more transnationally and globally immediate. By creating a "digital classroom," my students and I have an opportunity to explore how the personal is global and how we might visualize relational feminisms. Despite the prevailing belief that the present millennial generation of students is vastly more knowledgeable about digital technology than their instructors, I have often found quite the contrary. They are vastly more *immersed* in digital communications than we tend to be, but that engagement does not necessarily translate into "knowledge." While it may be true that

our current students' everyday experiences are increasingly digitized—texting, e-mailing, gaming, tweeting, blogging, or updating their Facebook pages—they often lack basic critical assessment of the "information" they generate and receive, not to mention lacking knowledge of the processes by which this information is constructed via computer technology.

Having learned <html> code and keyboarding during the late twentieth century, I have found this early knowledge quite useful in teaching students information literacy, even though they can now access various software and hardware scripts without basic knowledge of computer language skills. At the same time, when I teach students <html> design, they almost invariably speak of this learned skill in terms of empowerment. Suddenly, the space of the Internet is less intimidating, and their production of genuine information enables their full participation in both digital and global processes, an important goal of present-day global feminist resistance.

In addition to Web design—with the <html> page serving as the basic site on which to build and construct radical information—I utilize a set of digital tools, specifically blogs and Google Maps, to teach global feminist consciousness. To offset the nefarious ways Google Earth enacts hegemony—literally employing surveillance across the globe, even in the sky and the oceans, in Big Brother style—one philosophy that I teach to students is the power of subversion and the reframing of certain tools for feminist articulations. As they Google Map "danger zones" of femicide, immigrant journeys from women's novels and films, the transnational flow of women's music, or links between the historical Underground Railroad and domestic violence "escape routes,"[6] students illuminate the processes of border crossings and mobile resistance.

By personalizing and globalizing feminisms in the virtual sphere, while also maintaining awareness of the power dynamics of digital tools—including the powers to exclude, silence, and surveille those who lack technological access—we make manifest the global reach of feminist praxis. However, can these digital spaces amplify the voices of the subalterns? After all, their problem is not that they cannot speak but that they "cannot be heard," to reiterate Spivak. What remains to be seen is how emerging media tools will generate emerging narratives that will move us forward toward decolonizing our (world) views. More importantly, in light of the environmental justice of Terra Madre, we will need to start exploring alternative technologies that rely less on toxic materials, which are polluting our planet, and focus more on community building rather than capitalist consumption.

If we are to actively engage in each other's struggles and recognize each other beyond "exotic" constructions, we may finally realize that it is not our "bodies in common" or even unbridgeable differences that link or

separate us. We are interconnected in a global web of economies, cultural flows, traveling rhetoric, and relational feminisms. Most importantly, we are connected by Terra Madre, which was never meant for sale or for conquest and which now demands a more rigorous and sustainable praxis. The contact has already occurred, and the distance is already closing.

Epilogue

Widening Our Lens on the World

In the midst of widespread destruction and suffering, misguided Eurocentric news coverage "explaining" Haitian poverty and its history of political upheavals, and various pleas for donations and relief, the women of Haiti took to the streets and summoned G*d.[1] Raising their voices in song to deliver the right notes that "broke the back of words" (Morrison 1987, 321), Haitian women quieted the Big Media conversation heard on various news outlets and refuted the racist words of televangelist Pat Robertson, who blamed the January 12, 2010, earthquake in Haiti on "the pact they made with the devil" (erroneously referencing Vodun and its mythic connection to the historic Haitian revolution that led to the island's independence and emancipation from slavery). Christocentric white supremacists may have interpreted the devastating 7.0 magnitude earthquake—which killed three hundred thousand people and leveled the capital city of Port-au-Prince to ash and rubble—as an apocalyptic sign punishing evildoers (in this case, impoverished black third world citizens), but when the CNN cameras panned the marching and jubilant singers and reporters ended their incessant babble to listen in awe to the voices of the subaltern I saw something profoundly different, reminiscent of the same Book of Revelations that was inspiring our apocalyptic visions:

> *These are they which have come out of great tribulation*
> *and have washed their robes and made them white in the blood of the Lamb.*[2]

After such a wondrous sight, if some of us could still look upon such a scene and see only black victimization, underdeveloped poverty, and the cruelty of nature, then some of us simply will never recognize the face of G*d. This face may be a mediated version, but what other vision of

the divine could we possibly have? Unfortunately, one of the setbacks for those whose worldview has been shaped by global white imperialist patriarchy includes an inability to witness and experience divinity in the image of the Other. And in this failure lies an incomplete picture of how we may strive toward social justice and what Dr. Martin Luther King Jr. once embraced as the "beloved community." We rely instead on the superficial trappings of monetary donations and televised spectacles of giving and caring—as exemplified by the multi-channeled broadcast of the celebrity-driven *Hope for Haiti* telethon, which aired on January 22, 2010, ten days after the earthquake. As a nation and as a worldwide community, we mean well, but who could find any of the carefully framed musical spectacles from the telethon more spiritually moving than the spontaneous praise song that we heard from the women in Haiti who seized the opportunity provided by international TV cameras to testify to their survival and undying hope?

Will such women forever remain the "subaltern" who cannot speak because they "cannot be heard?" After all, in the wake of the earthquake Haitian women became hyper-visible even as they keenly felt the invisibility caused by the silencing of their voices. As Gina Athena Ulysse notes, "The poorer women of Haiti are the ones most overtly visible to the West," even though their voices are often "obscured by middle- and upper-class women's groups that have more access to media and decision makers" (Ulysse 2011, 38). Moreover, only 27 percent of the billions of dollars that our telethons helped to raise for earthquake victims reached those who most needed aid (Ulysse 2011, 39). Again, I ask: What spiritual and moral lessons can we discern from such musical spectacles when the spontaneous praise song, sung in Creole, testifies to a different reality?

Not only that, but will such voices ever be respected, rather than appropriated, as occurred when Mac McClelland, a white, female American journalist reporting on the increase of post-earthquake rape among displaced Haitian women, exploited the horrific gang rape of a woman identified as K* by deliberately staging a (controlled) episode of rough sex in order to fashion her own sexual healing from post-traumatic stress disorder? In response to what many considered to be McClelland's insensitive and dehumanizing appropriation of a Haitian woman's experience, celebrated Haitian-American author Edwidge Danticat sought to give voice to K*, translating her words with permission: "You have no right to speak of my story" (Danticat 2011).

How can K* tell her story to a global audience? How can we hear her voice? How can we bear witness to her and others' praise songs, another form of the "protest song" discussed in chapter 1? In her performance piece *Because*

When God is Too Busy: Haiti, Me, and the World, Ulysse intersects anthropological praxis with the space of the sacred, by interweaving Vodun chants with poetry and theory, to give voice to Haitian women.

By dismantling the sacred/secular divide in her performance, Ulysse uses Vodun invocation to find voice, to disrupt "logic," and to invite us to reevaluate the multifaith dimensions of community. This is in keeping with the "pedagogies of the Sacred" that M. Jacqui Alexander, a scholarly practitioner of Santeria, advocates as she challenges the colonialist dimension of modernity that "secularizes women's labor" and thus renders "African-based cosmological systems [as] subordinated to the European cosmos." As Alexander further argues: "Taking the Sacred seriously would propel us to take the lives of primarily working-class women and men seriously, and it would move us away from theorizing primarily from the point of marginalization" (Alexander 2005, 328). Now that we are living in a millennial world in which different religious worldviews are competing against each other for dominance, and now that more communities are feeling the effects of political, economic, and natural disasters, how do we interconnect our lives within this grand cosmos that continues to reveal itself in both material and spiritual dimensions? How will we arrive at a different (world) view?

BEYOND THE SACRED/SECULAR SPLIT

As I have argued throughout this book, the story of the early twenty-first century is the story of media and mediated visions of race and gender in shaping how we view and respond to different bodies. This story also involves the mobilization of media in a call to action, although there are differences as to what that call might be and how the action it calls for should manifest. While I conclude this study with a scene of the sacred, I would like to move toward the secular and consider the space for G*d-talk—especially as it relates to morality, ethics, and spiritual awakenings—within this context and how media can enable such a space. More importantly, as in feminist narratives that call for disruption of easy dichotomies—male/female, black/white, East/West—I would like to consider disrupting the sacred/secular divide, as black feminist scholars such as Ulysse and Alexander have done.

Because religious discourse is often entrenched in dogma, there exist few genuine spaces, outside of the worship arena, in which to intellectually and emotionally engage in G*d-talk. Curiously, there also seems to be no genuine space to engage in *atheistic* discourse. Consider this reflection by atheist scholar Sharon P. Holland:

When you say that you are atheist, when you tell someone you don't believe in "God," there is often vacuous silence. . . . Questioning "God" is simply not a matter for public discussion, and when it does become "public," the silence is overwhelming. What is a radical politics that does not take into account a radical questioning from without, rather than from within? What might a world without the belief in "God" be? What would hold us together? What would tear us apart? (Holland 2007, 65)

Holland's questions are absolutely critical in moving us forward—theists and atheists alike—in discussing our future and our visions for a just and ethical world. However, if we assume that G*d-talk and all spiritual matters are to be kept private, then how can we even begin to challenge spiritual and religious oppression in the open, let alone articulate spiritual liberation, especially when it is embedded in the intersections of race, class, gender, sexuality, and nationality? Moreover, how can feminists, who claim to be committed to the liberation of all women, complicate their criticism of male-dominated religious institutions, which are fully supported by female devotees? The response is certainly not to keep quiet and find solace in secularism.

Silence is especially dangerous when those who attempt religious domination—whether they advocate Christian evangelical supremacy or identify as "Islamic extremists," violently and restrictively defining the boundaries of faith—squeeze out other voices promoting religious and spiritual inclusivity and manipulate political arenas to accomplish this. Such dominance rests on raced, gendered, sexualized, and nationalistic power dynamics based in historic struggles. As Shohat reminds us with regard to the imposition of Christian supremacy that constituted the 1492 "discovery" of America, which was financed by Spain amid the forced expulsion of Jews and Muslims from the nation:

The point is not that there is a complete equivalence between Europe's oppressive relations toward Jews and Muslims and toward indigenous peoples. The point is that European Christian demonology prefigured colonialist racism. Indeed, we can even discern a partial congruency between the phantasmatic imagery projected onto the Jewish and Muslim "enemy" and onto the indigenous American and Black African "savage," all imaged to various degrees as "blood drinkers," "cannibals," "sorcerers," and "devils." (Shohat 2006, 211)

Andrea Smith makes similar arguments, complicating this Christocentric imperialism through the lens of heteropatriarchy and elucidating how both systems rely on the "family" to legitimate power: "Just as the patriarchs rule the family, the nation-state rule their citizens. Any liberation struggle that does not challenge heteronormativity cannot substantially challenge colonialism or white supremacy" (Smith 2006, 72). Identifying twenty-first-century moral struggles over immigration, religious minorities, reproductive rights, and same-sex marriage, Smith points to the ways that gender and sexuality, as constituted by heteropatriarchy, serve as "building blocks of U.S. Empire" grounded in Christian principles (Smith 2006, 71). However, biblical scholars such as Ken Stone argue that religious arguments can be made to counter gender and sexuality hierarchies beyond political ideology. As he challenges:

> It is tempting to conclude, on the basis of the actions and visibility of such organizations as Focus on the Family, that the tight link now often made between Christianity and "family values" in the U.S. is primarily made within so-called "right-wing" or "fundamentalist" Christianities. Yet quite liberal mainline Christians often seem taken aback as well by any suggestion that "family" and "marriage" are not inherently Christian values. (Stone 2009, 27)

Indeed, Elaine Pagels reminds us that the earliest Christians flocked to their new religion precisely because it freed them from the confines of marriage, family, and gender roles. As she recounts in the story of Thecla, a rebellious female convert who defied an arranged marriage to follow a life of celibacy and who self-baptized when the apostle Paul refused to aid her in this ritual, such early Christians "disrupted the traditional order of family, village, and city, encouraging believers to reject ordinary family life for the sake of Christ" (Pagels 1988, 21). Considering that twenty-first-century Christians—at least those who identify as U.S. "conservatives"—adhere to a rigid structure of "family" and gender relations and greet any woman defying her traditional gender role with suspicion, these changes in spiritual "values" over time illuminate that our code of ethics, our spiritual definitions of what constitutes our sense of self and community, are constantly in flux and tied to larger social, cultural, historical, and political forces.

Outside the Christian context, gender roles and constructions remain sites of contestation. M. Jacqui Alexander notes how African-based religions such as Yoruba, Santeria, Vodun, and Candomblé invoke gender-fluid deities who "mount" their devotees through "cross-dressing and gender-bending"

modes of worship. Within Islam, Margot Badran argues that Islamic feminism maintains a much more radical edge than secular feminism in challenging gender roles: "Islamic feminism insists on full equality of women and men across the public/private spectrum (secular feminists historically accepted the idea of equality in the public sphere and the notion of complementarianism in the private sphere). Islamic feminism argues that women may be heads of state, leaders of congregational prayer, judges, and muftis" (Badran 2002).

In other words, by engaging religious discourse, feminists and other liberationist practitioners such as these transcend the neutral space of the secular to reframe moral arguments and, by extension, assert with moral authority the need for social change to usher in social justice and a new way of engaging the world and each other. Of course, such engagements still center the sacred with little space for atheistic or secular moral articulations. While such critiques and challenges within religious discourse and practices are necessary to dismantle the more dominant narratives, how might we bridge different cosmologies and multifaith practices that can open up new conversations, the way hybrid and syncretized faiths have often done in the creation and articulation of new religions and spiritual praxis?

POPULAR THE*LOGIES

Perhaps the lack of a public discourse that reflects a multifaith worldview in secular culture—whether based in belief or unbelief—has required that spiritual discourses take on a different guise, especially within the arena of popular culture. We need only consider certain sci-fi movies, such as Danny Boyle's *Sunshine*, which ends with the main character (played by Cillian Murphy) reaching out to touch the sun's surface as he is engulfed in its eternal light while on a deep-space mission to reignite this dying star. It is an image of spiritual catharsis, even though he had just engaged in battle with a religious fanatic, thereby suggesting that the problem is less an issue of faith than an issue of dogma.

Similarly, Darren Aronofsky's *The Fountain* depicts the main character (played by Hugh Jackman) journeying to the star Xibalba in deep space before he is swallowed up in its light, transformed as he is by death, which is "the road to awe." While Aronofsky appropriates Mayan mythology and Buddhist philosophy to articulate this spiritual journey—as if white Westerners are only permitted spiritual discourse in non-Western contexts, to avoid charges of being "religious"—he downplays the Judeo-Christian spirituality (or reduces it to premodernity) that informs the main quest for

the "Tree of Life" in the triangular storyline of the film. Both *Sunshine* and *The Fountain* draw from the ultimate spiritual sci-fi movie, Stanley Kubrick's *2001: A Space Odyssey*, except the Kubrick classic does not end with its hero engulfed in light but, rather, with him reborn in the blackness of deep space and presence of the mysterious black monolith that reappears throughout the film.

All three films rely on the visual allusion to Michelangelo's *The Creation of Adam*, which depicts Adam reaching out to touch the finger of G*d (an image popularized in the movie poster for Steven Spielberg's *E.T.*). Whether the point of any of these films is the exploration of alien intelligent life or the triumph (and failures) of science and technology, the goal always seems to be: G*d, I'm looking for you! Can you give me some kind of proof of your existence? No matter how atheistic or agnostic science is claimed to be, these sci-fi films suggest that this has been the point all along, and the fact that science and technology have to be used to explore this basic premise illuminates that, in Western secular culture, religious discourse must be sublimated.

Interestingly, when we move away from these messages in science fiction and futuristic films to contemplate the messages in explicitly feminist narratives, the focus is on a just world on Terra Madre, as Kahiu's *Pumzi* already demonstrated. Consider Octavia Butler's novels *Parable of the Sower* and *Parable of the Talents*, or Marleen Gorris's fable-like film *Antonia's Line*. These stories are primarily concerned with establishing "postapocalyptic" communities (although Gorris's idyllic film is set in post–World War II Holland—a different kind of postapocalyptic setting—while Butler's dystopic novels are set in the near-future) in a world not directed by the oftentimes oppressive and hypocritical Christian church or by an all-powerful deity.

What these popular the*logies reveal is that we, as a common humanity, still rely on myths, fantasies, and the ingenious power of storytelling to summon the divine, govern our ethics, and inform our relationships with each other and the world around us. The narratives may differ in what the divine looks like, or what our ethics ought to be, and how these relationships will function, but they all urge us to build on a common vision of love and higher consciousness with oneself and each other. Whether they are based in a dystopic nearby or faraway future or a fabled history, these prophetic stories call on us to determine our present to shape a yet to be determined future.

Nevertheless, a balance seems to be maintained in secular popular culture, in which the specter of religiosity is either repressed or rejected. When the story relies on biblical exegesis—as in the case of the Hughes

Brothers' futuristic film, *The Book of Eli*, which portrays the titular devout Christian (played by Denzel Washington) safeguarding the last existing copy of the Bible while on his perilous journey across a postapocalyptic landscape—audiences become divisive. Secular sci-fi fans object to a film that openly celebrates Christianity, while devout Christians reject the film's ending, which equates the Bible's importance alongside other religious texts and literary masterpieces in our world history. Such divides expose both our cynical worldview and our inability to complicate discourses. Whichever side one represents in these kinds of debates, what seems to be missing is useful conversation on *The Book of Eli's* portrayal of ethics meted out in survival, alienation, and community building. Is it possible to move beyond dogma—secular or sacred—and ascertain the deeper messages mediated in these narratives?

I have come to believe that one reason why Western, Judeo-Christianized secular culture often discounts spiritual worldviews—at least when they are not brilliantly disguised in the gnosis of science fiction and fantasy narratives—is that it is steeped in white supremacist thinking that characterizes "primitive" peoples and cultures as antithetical to a modern, secular worldview devoid of superstition and myths. As Trinh reminds us about colonialist interpretations of these "superstitions" and "myths": "The story becomes *just* a story. It becomes a good or bad lie" (Trinh 1990, 129).

However, the opposite also occurs, in which some Westerners turn to non-Western culture for romantic reaffirmation of the spiritual world that the modern one has since abandoned. Besides those traditionalists who cling to a "fundamentalist" or "Orthodox" version of Christianity or Judaism, other Westerners rely on a romantic construction of the "Orient," as represented by Asian spiritualities and the popular secularization of Yoga, or the "noble savagery" of indigenous American spiritualities that might give "meaning" to their lives. Interestingly, these same seekers of non-Western spirituality tend to avoid African spiritualities, which are still perceived as "too dark," a blackness entrenched in the colonialist missionary mischaracterizations of such religions—Vodun, Santeria, Candomblé—as "devil worship" (to reiterate Pat Robertson).

I have also not overlooked that, even though philosophical questioning of G*d's existence has most likely taken place since ancient times, it was not until the Enlightenment that a secular worldview began to emerge. Perhaps when Europeans were immersed in colonizing and contrasting themselves to the G*d-worshiping peoples of the world, such empire building—even as it relied on a belief in "divine right"—required that white people eventually

abandon G*d to "become gods" in Nietzschean fashion while establishing global white supremacy. After all, it did not take much for nineteenth-century scientists to elevate white people to a position just "below the angels," in a rather Luciferian development of superiority, while black people were reduced to a position just "above the apes."

Even when Christianity was being used to colonize the world, those of us who were colonized found ways to create hybrid forms of our worship and our spiritual beliefs. As womanist theologian Katie Geneva Cannon argues:

> Our reimaging of Christianity is necessary in order to redeem it from the desecrated imagery of white Christians who snatched black Africans from Africa in slave ships named *Jesus, Mary, Liberty, John the Baptist,* and *Justice* . . . we blacks (who became Christians with historical memory) reimaged Jesus, Mary, John the Baptist, justice, and liberty. From this centuries-long reimaging of Jesus emerged a beautiful, redemptive black liberation theology. (Cannon 2008, 133–34; emphasis in original)

Perhaps such reimaging was also possible because, in its origin, Christianity was a faith of the oppressed and the colonized, and at its core is the politics of decolonization. Consequently, feminist the*logians such as Elisabeth Schüssler Fiorenza encourage a rethinking of biblical text and doctrine through the perspective of anti-imperialism, since the Hebrew authors, early Christians in particular, constantly addressed the question of liberation from various empires, especially the Roman Empire. How might such ancient struggles mirror present-day struggles with globalization and neocolonialism? How, indeed, might we decolonize the future, a question that has formed the basis for much of our apocalyptic literature?

DECOLONIZING JUDEO-CHRISTIAN NARRATIVES

Smith, who bridges the worlds of both Native American feminism and Christian fundamentalism, suggests that we create "unlikely alliances" in the struggle toward social justice. Our identities are much more complicated, and we may have more in common than we have dividing us. More importantly, she suggests we envision what a future of justice and liberation would mean. As Smith observes about social justice movements: "While many groups on the Left organize *against* something . . . the Christian Right is actually fighting for something, a world based on biblical principles. . . . Certainly,

if a movement has a clear vision of the world it wants to create, it would also seem less likely that it can be co-opted by another movement" (Smith 2008, 253–54; emphasis in the original).

In the ancient anticolonial text that is the Book of Revelations, the exiled author gives us a vision of a theocratic "new world order," in which the everlasting justice of a Judeo-Christian G*d topples the earthly power of the Roman Empire and establishes in its place a "new heaven and new earth." However, for those who resist its patriarchal, celestial vision, there is still the issue of re-imaging a different "paradise." This is the vision Toni Morrison suggests at the close of her novel, *Paradise*, which specifically revises the apocalyptic image of "paradise" offered in Revelations for something that affirms blackness, femininity, and the divine space of planet Earth:

> In ocean hush a woman black as firewood is singing. Next to her is a younger woman whose head rests on the singing woman's lap. . . . Around them on the beach, sea trash gleams. Discarded bottle caps sparkle near a broken sandal. A small dead radio plays the quiet surf.
>
> There is nothing to beat this solace which is what Piedade's song is about, although the words evoke memories neither one has ever had: of reaching age in the company of the other; of speech shared and divided bread smoking from the fire; the unambivalent bliss of going home to be home—the ease of coming back to love begun . . . Now they will rest before shouldering the endless work they were created to do down here in paradise. (Morrison 1998, 318)

This scenario reiterates the message of the divine feminine, invoked in the novel's epigraph—taken from the Gnostic Gospel, *Thunder: Perfect Mind*. As such, Morrison signifies on biblical narratives through the counternarrative offered in the rediscovered ancient text of a gospel tradition suppressed by official histories. Reinserting a new narrative for a new millennial audience, Morrison deliberately crafts a counterpoint to Revelations' end: paradise located in the ocean's depths, versus the heavenly skies, "ocean hush" replacing celestial trumpets, worldly scattered trash on a beach contrasting with the otherworldly purity of pearly gates, and a loving, accepting black feminine deity—with the mysterious and indigenous-sounding name Piedade—versus the judgmental, warring male deity. In situating our collective destiny "down here in paradise," Morrison articulates a the*logy that places emphasis on the environment and on community in a timeless present where our work is needed to create sustainability and peace.

Such narratives become difficult to teach in the secular classroom, however, as I have experienced when teaching this novel to both undergraduate and graduate students in women's studies. Students have expressed their discomfort with the G*d-talk, even when the message is explicitly feminist. They also indicate their lack of knowledge of biblical and Christian symbolism, allusions that Morrison takes for granted as familiar to her readers.

While we have come a long way from biblical teachings dominating the U.S. classroom, this lack of knowledge is less a stance of resistance to a religious worldview and more of a prevailing cultural ignorance, since students also lack knowledge of Islamic, Buddhist, Hindi, and indigenous American and African texts. In an increasingly multiracial, multinational, and—by extension—multifaith world, we might expect an increase in knowledge of our various cultural narratives, not our decreased knowledge. Unfortunately, when religious discourse is suppressed, in its place remains a cultural void, or worse, the sublimated presence of a Judeo-Christian ideology that still shapes Western worldviews, even in secularism, because we refuse to name it for what it is so that we can offer, instead, a different decolonized (world) view that moves us in a new direction.

Because of this, the meaning of "resistance" to a certain religious discourse becomes lost to secular readers in the feminist narrative of Morrison's *Paradise*. Moreover, we ignore the Judeo-Christian paradigms that still predominate in Western-based discourse, whether they reverberate in movies or in political language that mobilizes our consent to war or our rejection of civil rights and human rights for marginalized groups. Our media might suggest that the modernist world has rejected the ancient one, filled with spirits, angels, demons, and gods. However, our popular culture continues to recycle these tales, demonizing certain groups while deifying others.

A curious recent case of demonization concerns a conspiracy theory existing on the Internet in which, as Ebony Utley observes, successful black men and female pop stars are linked with "devil-worshipping" secret societies, which "conflate masonry, Egyptian mythology, Satanism, and the Illuminati, as if they were all the same" (Utley 2010). These free-floating claims and associations constantly remind us of the ways that Christocentric "religious" discourse seeps seamlessly into secular space, hence requiring deeper sacred-secular analyses to contest racialized and sexualized Othering while advancing more complex G*d-talk. Those of us engaged in resistance narratives—narratives that dare to think of G*d differently (or not at all), define new ethics, and formulate new relationships—are now required to constantly recognize the signs and recreate our own visions of divinity.

Filmmaker Terrence Malick offers a magnificent view of the divine in his 2011 film, *The Tree of Life,* which includes a sequence featuring scenes of our universe, as captured by the Hubble telescope. Scored against sacred music and framed by an epigraph from the Hebrew text of the Book of Job, such imagery, usually framed in the context of secular science, took on a spiritual dimension and served as a metaphorical mirror of G*d in the Christocentric narrative. We are invited to interpret the material space of the universe as endorsing the traditional view of a Judeo-Christian male deity. However, the structure of deep space bears striking resemblance to ancient cosmologies articulated in indigenous cultures, from the Mayans in Mexico to the Dogon in Mali, thus suggesting that the spiritual universe may reflect a different face of G*d.

In a different context, artist Adrian Piper superimposes an image of the Hindu god Shiva onto similar telescopic imagery in her digital photograph, *Everything will be taken away #13.1 (Dancing Shiva Ardhanarishvara)* (Fig. E.I), reinterpreting the material heavens through a different spiritual tradition and manifestation. This work is part of her "Everything will be taken away" series, based on a quote by Russian novelist Alexander Solzhenitsyn: "Once you have taken everything away from a man, he is no longer in your power. He is free." Integrating secular philosophy with sacred imagery, Piper makes manifest the paradox of "everything" as nothingness, redefining liberation beyond materialism and toward the spiritual. Shiva, the androgynous creator and destroyer, plays on this paradox represented by destruction as creation and vice versa, as well as by her/his gender duality. Piper, who is now a Yoga specialist, has illuminated the links between Hinduism and black liberation theology—best exemplified by Gandhi's influence on King's praxis of nonviolence—and encourages a multi-faith dialogue that transcends race, gender, and nationality (Piper 2011).

CONCLUSION: TOWARD NEW COSMOLOGIES

Perhaps Holland's question—"What might a world without the belief in 'God' be?"—is a difficult one to answer or imagine, for some, but it needs to be anchored in the summation James Baldwin once made about our religious and spiritual traditions. As he put it: "If the concept of God has any validity or any use, it can only be to make us larger, freer, and more loving. If God cannot do this, then it is time we got rid of Him" (Baldwin [1963] 1998, 314). Indeed, we may well wonder if we are capable of becoming "larger, freer, and more loving" without attributing these qualities to a higher power. This is not to say, however, that such cosmology must evolve into an atheist

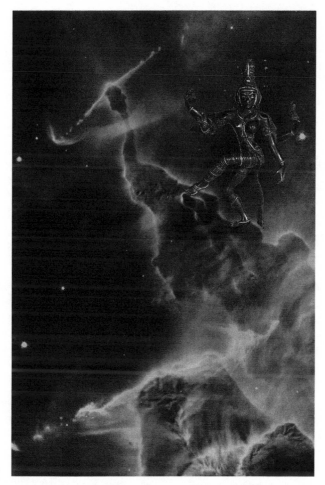

Figure E.1 Adrian Piper, "Everything will be taken away #13.1 (Dancing Shiva Ardhanarishvara)," 2006; limited edition of 20 photo prints, each 4 × 6 inches. © Adrian Piper Research Archive Berlin. Courtesy: various private collections. Permission of the Artist.

or theist perspective. If we truly want to complicate our cosmic worldview, we might recognize that neither position is contradictory of the other—the divine, after all, is much too incomprehensible to be contained in either belief or in an either/or dichotomy.

In this new millennial age, we have witnessed the destruction wrought by religious warfare, from September 11 to the "war on terror" to ethnic

conflicts and genocide. It would seem, then, since these battles are neither new nor peculiar to our era, that we view our temporal space less as a linear timeline—itself an offshoot of a Christocentric worldview—than as a time cycle or spiral. Beyond that, we need new symbols.

In the immediate aftermath of September 11, in New York City, I attended the millennium space planetarium at the American Museum of Natural History. I went with a friend who was visiting the city for the first time. On a surreal day, when there were no long lines, we easily accessed the planetarium and were treated to an awe-inspiring narration of satellite-captured images of our vast universe. Such a mediated view of this great mystery that is deep space and the worlds around us trivialized the heavy burden we felt, having witnessed secondhand the effects of the traumatic events that had taken place at the World Trade Center earlier that week. It was difficult for me to fathom G*d as I knew it, or as the terrorists knew it, or even as those of us summoning this supreme being in our prayers and vigils around the nation knew it. Earth is a mere dot in the grander scheme of things, and if we truly are the only living organisms in material existence, we have certainly wasted our time and potential. Attending church the next day, I found it difficult to conceptualize Heaven in the usual way, since our stained-glass windows paled in comparison to the heavens I had viewed captured by new technologies.

However, it would take another disaster ushering a new decade, this time the Haitian earthquake, to remind me again of what G*d looked like and what G*d sounded like. The divine may be a hard concept to grasp or comprehend, even as it is constantly iconized in art and media, but it is how we make it personal and global that matters. In the vast expanse of galaxies colliding and tectonic plates moving, we as living beings must move in rhythm with these forces and develop a wider consciousness of our interconnectedness, or we will be destroyed. As Gloria Anzaldua once urged, "Now let us shift" (Anzaldua 2002, 576). And let us craft a new vision in this shifting.

Postlude: Technologies of the Flesh

ever connected
ever distant

flesh meets flesh
mis/seen and detected

joined and disjointed
by the miles that separate us

and intimacy is grasped
across geography and time

now zeroes and ones
replace sinew and bones

and the mind substitutes
for the soul

now technology reflects
the face of G*d

through a glass darkly
via satellite

somewhere in the ether
across the universe

our loneliness screams
in silence

swallowed whole
by a death star

regurgitated
on a living planet

where reality begets fantasy
begets love

keeping rhythm
to a techno beat

Notes

INTRODUCTION

1. See Margot Magowan, "Disney's Male Execs to Stop Making Movies Starring Girls," *Ms. Magazine Blog* (November 23, 2010). Available: http://msmagazine.com/blog/blog/2010/11/23/disneys-male-execs-stop-movies-starring-girls.

2. Walker has since disavowed the feminist label.

3. The nonprofit industrial complex is a subject fully explored in the anthology *The Revolution Will Not Be Funded: Beyond the Non-Profit Industrial Complex*, ed. INCITE Women of Color against Violence (Cambridge: South End Press, 2007).

4. The debate between Steinem and Harris-Perry, then known as Melissa Harris Lacewell, which aired January 14, 2008, on NPR's *Democracy Now*, with Amy Goodman, is available: http://www.democracynow.org/2008/1/14/race_and_gender_in_presidential_politics. Steinem has since revised her position in Beverly Guy-Sheftall and Johnetta Cole's collection, *Who Should Be First? Feminists Speak Out on the 2008 Presidential Campaign* (Albany: State University of New York Press, 2010).

5. See hooks (1992); Neal (2003); and Brooks (2008).

6. Some examples include Clear Channel, which owns several radio stations, Viacom, which owns several cable TV stations, including youth-based channels such as MTV and BET, and News Corp., which owns several TV stations, newspapers, and the Twenty-First Century Fox movie studio. For more on this issue, see Meredith LeVande, "Women, Pop Music, and Pornography," in *Meridians* 8, no. 1 (2008): 293–324.

7. See Toby Miller et al., eds., *Global Hollywood 2* (London: British Film Institute, 2005).

8. Mario Epanya has since moved on to create *Winkler*, an African beauty and fashion magazine, which launched in 2011.

CHAPTER 1. POP GOES DEMOCRACY

1. See Jorge Luis Borges, "On Exactitude of Science," in *Collected Fictions* (New York: Penguin, 1999), 325.

2. See Bill Carter, "For Fox's Rivals, 'American Idol' Remains a 'Schoolyard Bully,'" *The New York Times*, February 20, 2007. Available: http://www.nytimes.com.

3. For more on Elizabeth Taylor Greenfield, see Story (1990) and Young (1855).

179

4. See my symposium article, "Everybody's Protest Song: Music as Social Protest in the Performances of Marian Anderson and Billie Holiday," *Signs: Journal of Women in Culture and Society* 33, no. 2 (Winter 2008): 443–48.

5. According to music critic blogger Lyndsey Parker, TV voters are primarily "moms and daughters" (or, more derisively and chauvinistically, "cougars" and "tweens"). See also Scott Collins, "American Idol's Christian Connection," *LA Times*, May 23, 2010. Available: http://articles.latimes.com/2010/may/23/entertainment/la-ca-0523-idol-religion-20100523.

CHAPTER 2. UNDERSTANDING "THE NEW BLACK"

1. An allusion to the popular 1979 song, "Video Killed the Radio Star," by the British New Wave group, The Buggles.

2. A viral video refers to online videos that have tracked millions of viewers.

3. See Mark Anthony Neal's "Tyler Perry and the Black Bible Belt," VIBE's *Critical Noire* (2007). Available: http://www.vibe.com/blog/man/2007/05/tyler_perry_and_the_black_bibl.html.

4. "Video vixen" is a term describing the overly sexualized representations of music video dancers, models, and actresses, usually those appearing in rap music videos.

5. See Nevergold and Brooks-Bertram, *Go Tell Michelle: African American Women Write to the New First Lady* (Albany: State University of New York Press, 2010).

6. This episode first aired on September 23, 2009.

7. For an astute analysis of such race, gender, and queer representations, see Brendan McHugh's paper, "'Just a Small Town Boy': Queering the Quarterback, Whitening the Queer, Re-Othering the Other," delivered at the University at Albany Women's Studies Student Conference on December 4, 2009.

8. This is a subject I explore in *Venus in the Dark: Blackness and Beauty in Popular Culture* (New York: Routledge, 2005); see also Nell Painter, *Sojourner Truth: A Life, A Symbol* (Princeton: Princeton University Press, 1997).

9. Hobson (2005).

10. See Sander Gilman, *Difference and Pathology: Stereotypes of Race, Sexuality, and Madness* (Ithaca: Cornell University Press, 1985).

11. This is best represented in Michael Joseph Gross's cover feature, "Gay is the New Black," *The Advocate*, November 16, 2008.

12. Etta James apparently spoke against Beyoncé during one of her concerts in Seattle, Washington, not long after the Inauguration event, although she would later admit that she did so in jest.

13. See Aiwah Ong, *Flexible Citizenship: The Cultural Logics of Transnationality* (Durham: Duke University Press, 1999).

14. I am grateful to Cathy J. Cohen, who alerted me to this billboard in her keynote address at the Collegium for African American Research Conference in Paris, France, on April 7, 2011.

15. For a chronicling of this controversy surrounding Michelle Obama's campaign, visit the Michelle Obama Watch blog. Available: http://www.michelleobamawatch.com.

CHAPTER 3. BODY AS EVIDENCE

1. I am indebted to Mark Anthony Neal for inviting me to guest lecture at his graduate seminar at Duke University.

2. I am grateful to Ime Kerlee for pointing this out to me in a discussion about these enslaved women experimented upon by Sims. For more on this history, see Terri Kapsalis, *Public Privates: Performing Gynecology from Both Ends of the Speculum* (Durham: Duke University Press, 1997).

3. This is an allusion to Beth E. Richie's theory of black women's "gender entrapment" in both domestic and state violence in her groundbreaking *Compelled to Crime: The Gender Entrapment of Battered, Black Women* (New York: Routledge, 1995).

4. This is an allusion to a chapter title by Lisa Neve and Kim Pate, in *Global Lockdown: Race, Gender, and the Prison-Industrial Complex*, ed. Julia Sudbury (New York: Routledge, 2005), 19–33.

5. Saidaya Hartman, *Lose Your Mother: A Journey Across the Atlantic Slave Route* (New York: Farrar, Straus, and Giroux, 2007).

6. See Domino Renee Perez, "Lost in the Cinematic Landscape: Chicanas as Lloronas in Contemporary Film," in *Velvet Barrios: Popular Culture & Chicana/o Sexualities*, ed. Alicia Gaspar de Alba (New York: Palgrave Macmillan, 2003), 229–47.

7. An allusion to Nawal el Saadawi's *Woman at Point Zero* (London: Zed Books, 1990), based on an interview with a criminalized sex worker in Egypt facing execution for the murder of her pimp.

CHAPTER 4. DIGITAL WHITENESS, PRIMITIVE BLACKNESS

This chapter is an expanded rewrite of the article, "Digital Whiteness, Primitive Blackness: Racializing the 'Digital Divide' in Film and New Media," *Feminist Media Studies* 8, no. 2 (2008): 111–26.

1. For the purposes of this chapter, I will be using the term *cyberspace*, an early description of the Internet, interchangeably with the term Internet. First coined in William Gibson's celebrated 1984 sci-fi novel *The Neuromancer*, cyberspace refers to a complex web of high-tech networks. While the term *cyberspace* has become somewhat dated by the end of the first decade of the twenty-first century, I invoke it here to maintain its historicity.

2. Presently, the Wachowski brothers are involved in a legal suit, instigated by science fiction writer Sophia Stewart, who claims authorship of *The Matrix*. She has also mounted a Web site to present her side of the story (2005) http://www.sophiaoracle.com.

3. See Jodi Dean, "From Technocracy to Technoculture," *Theory and Event* 5, no. 1 (2001).

4. This concept of the digital "colorline" is explored in *Technicolor: Race, Technology, and Everyday Life*, ed. Alondra Nelson et al. (New York: NYU Press, 2001).

5. Edward Said, *Orientalism* (New York: Random House, 1979).

6. See Alison Griffiths, *Wondrous Difference: Cinema, Anthropology, and Turn-of-the-Century Visual Culture* (New York: Columbia University Press, 2002).

7. I am grateful to my colleague Judith Johnson for offering this interpretation during a discussion following a film screening of *2001* in March 2005.

8. The film pays homage to Baudrillard's concept of the hyperreal in an early scene featuring a hollowed-out book version of his *Simulacra and Simulation.*

9. This interpretation is based on the casting of Keanu Reeves, a white actor with Asian ancestry, which does not necessarily capture the original intentions of the story since a black actor, Will Smith, was initially approached to play the role of Neo.

10. See Ben Williams, "Black Secret Technology: Detroit Techno and the Information Age," in *Technicolor: Race, Technology, and Everyday Life,* ed. Alondra Nelson et al. (New York: NYU Press, 2001), 154–75.

11. The Navi heroine in *Avatar* is actually voiced by Afro-Latina actress Zoë Saldana.

CHAPTER 5. DIGITAL DIVAS STRIKE BACK

1. Julie Dash features information about *The Digital Diva* on her Web site (2000) http://www.geechee.tv.

2. For more on the online history of Mark Zuckerberg, see Bonnie Goldstein's "The Diaries of Facebook's Founder" (November 30, 2007), Available: http://www.slate.com/id/2178939. See also Margaret Lyons, "Mark Zuckerberg says 'The Social Network' Got His Clothing Right," *Pop Watch,* October 18, 2010. Available: http://popwatch.ew.com/2010/10/18/mark-zuckerberg-social-network.

3. See *Processed Lives: Gender and Technology in Everyday Life,* ed. Melodie Calvert and Jennifer Terry (New York: Routledge, 1997); see also *Technicolor: Race, Technology, and Everyday Life,* ed. Thuy Linh N. Tu et al. (New York: NYU Press, 2001).

4. Sadie Plant, *Zeroes and Ones: Digital Women and the New Technoculture* (New York: Doubleday, 1997).

5. The iPhone app of *The Human Race Machine* is available at http://www.racializer.com.

6. In an interview published on PBS's artist biography site on Kara Walker (2003) http://www.pbs.org/art21/artists/walker.

7. Based on her research of information policy and community technology centers, Virginia Eubanks suggests that low-income women are neither technophobes nor resistant to computer technology. Instead, they maintain "critical ambivalence" toward it, which, as she argues, is "a symptom of the mismatch between the symbolism of computers as social and economic progress and these women's own experience of technology as exploitative, intrusive, and limiting" (Eubanks 2004b, 29).

8. Here, Pilar references the racialized and imperialist history converging religion and technology, which is also explored in Joel Dinerstein, "Technology and Its Discontents: On The Verge of the Posthuman," in *Rewiring the "Nation": The Place of Technology in American Studies,* ed. Carolyn De la Pena and Siva Vaidhyanathan (Baltimore: The Johns Hopkins University Press, 2007).

9. The debut album track "Sunshowers," for instance, includes the lyric, "Like PLO I don't surrendo."

10. This critique is offered in the documentary film *Maya Lin: A Strong Clear Vision* (Freida Lee Mock, 1995).

CHAPTER 6. EXOTIC SISTERHOOD

1. From Pazira's running commentary on the DVD version of the film.
2. See "Muslim Girl Shaves Head Over Ban," BBC News (October 1, 2004), Available: http://news.bbc.co.uk/2/hi/europe/3708444.stm. I am grateful to students in my "Global Perspectives on Women" course in the Spring 2011 semester, who brought this story to my attention during a group project on "The Veil Debates."
3. See Gilman (1985) and Oyewumi (2001).
4. Spanish term for "Mother Earth," which I am borrowing from Vandana Shiva's *Earth Democracy: Justice, Sustainability, and Peace* (Boston: South End Press, 2005).
5. I am grateful to Aurora Levins Morales, renowned poet and activist, who directed me to the radical environmental justice work of Bolivian and other Latin American women.
6. I am indebted to my colleague Vivien Ng, who alerted me to innovative Google Earth assignments, such as Google Lit Trips, available: http://www.geolit.org, and the U.S. Holocaust Museum's "World is a Witness," available: http://blogs.ushmm.org/WorldIsWitness. These sites provided me with teaching models.

EPILOGUE. WIDENING OUR LENS ON THE WORLD

1. I am borrowing from Jewish and Christian feminists who don't spell out the words G-d or the-logy, which is the study of G-d, since G*d is unknowable. I also avoid gendered terms to describe this entity.
2. From Revelations 7: 14. Curiously, many of the survivors televised *were* dressed in their cleanest clothes and bleached white tees, thus testifying to a people of the African Diaspora who value cleanliness even in the midst of chaos and lack of clean water.

References

Afro@Digital. 2003. Dir. Balufu Bakupa-Kanyinda. California Newsreel.

Afzal-Khan, F. 1996. Bridging the gap between so-called postcolonial and minority women of color: A comparative methodology for third world feminist literary criticism. *Womanist Theory and Research* 2, no. 1. Available: http://www.uga.edu/~womanist/ Khan2.1.htm. Accessed May 1, 2003.

Alexander, E. 1994. "Can you be BLACK and look at this?": Reading the Rodney King video(s). In *Black male: Representations of masculinity in contemporary American art*, ed. Thelma Golden, 91–110. New York: Whitney Museum of American Art.

Alexander, M. J. 2005. *Pedagogies of crossing: Meditations on feminism, sexual politics, memory, and the sacred*. Durham: Duke University Press.

American Idol (2002–11). Dir. Bruce Gowers. Exec. Prod. Nigel Lythgoe and Ken Warwick. Fox Television.

Angelou, M. (1970) 1973. *I know why the caged bird sings*. New York: Bantam.

Antonia's Line. 1996. Dir. Marleen Gorris. Bergen.

Anzaldua, G. 1987. *La frontera/ borderlands: The new Mestiza*. San Francisco: Aunt Lute Books.

———. 2002. Now let us shift . . . the path of conocimiento . . . inner work, public acts. In *This bridge we call home: Radical visions for transformation*, ed. Gloria E. Anzaldua and Analouise Keating, 540–76. New York: Routledge.

Avatar. 2009. Dir. James Cameron. Perf. Sam Worthington, Zoë Saldana. Twentieth Century Fox Film Corporation.

Ayo, D. 2010. *Obamistan! Land without racism: Your guide to the new America*. Chicago: Lawrence Hill Books.

Badran, M. 2002. Islamic feminism: What's in a name? *Al-Ahram Weekly Online* 569 (January 17–23). Available: http://weekly.ahram.org.eg/2002/569/cu1.htm. Accessed: August 23, 2011.

Bakhtin, M. M. 1981. *The dialogic imagination*. Ed. Michael Holquist. Trans. Caryl Emerson and Michael Holquist. Austin: Texas University Press.

Baldwin, J. (1955–1985) 1998. *James Baldwin: Collected essays*. Ed. Toni Morrison. New York: Library of America.

Bambara, T. C. 1992. Preface to Julie Dash's Daughters of the Dust: *The making of an African American woman's film*. New York: New Press.

Barthes, R. 1977. The grain of the voice. In *Image-music-text*, trans. Stephen Heath, 179–89. New York: Hill and Wang.

Baudrillard, J. (1981) 1994. *Simulacra and simulation*. Ann Arbor: University of Michigan Press.

Bejarano, C. L. 2002. Las super madres de Latino America: Transforming motherhood by challenging violence in Mexico, Argentina, and El Salvador. *Frontiers* 23, no. 1: 126–50.

Berry, E. M. 2005. Love hurts: Rap's black eye. *Vibe* (March): 162–68.

Björk. 2011. *Biophilia.* Apple iPad and iPhone.

The Book of Eli. 2009. Dir. The Hughes Brothers. Perf. Denzel Washington. Warner Brothers.

Bordertown. 2006. Dir. Gregory Nava. Perf. Jennifer Lopez, Antonio Banderas. Mobius Entertainment.

Bordo, S. 1993. *Unbearable weight: Feminism, Western culture, and the body.* Berkeley: University of California Press.

Borges, J. L. 1999. *Collected fictions.* New York: Penguin.

Brooks, D. 2008. "All that you can't leave behind": Black female soul singing and the politics of surrogation in the age of catastrophe. *Meridians* 8, no. 1: 180–204.

Brooks, S. 2010. *Unequal desires: Race and erotic capital in the stripping industry.* Albany: State University of New York Press.

Burson, N. 2005. "Homepage." Nancy Burson Pages. Available: http://www.nancyburson.com. Accessed January 23, 2005.

———. 2011. "Racializer." Available: http://www.racializer.com. Accessed September 24, 20011.

Butler, J. 1993. *Bodies That Matter: On the Discursive Limits of Sex.* New York: Routledge.

Butler, O. E. 1993. *Parable of the sower.* New York: Four Walls Eight Windows.

———. 1998. *Parable of the Talents.* New York: Seven Stories Press.

Calvert, M., and J. Terry, eds. 1996. *Processed lives: Gender and technology in everyday life.* New York: Routledge.

Cannon, K. G. 2008. Christian imperialism and the transatlantic slave. *Journal of Feminist Studies in Religion* 24, no. 1: 127–34.

Carter, B. 2007. For Fox's rivals, "American Idol" remains a "schoolyard bully." *The New York Times* (February 20). Available: http://www.nytimes.com. Accessed: October 5, 2008.

Chan, A. 2005. The French democracy. Machina.Com Pages. Available: http://www.machinima.com:80/film/view&id=1407. Accessed: November 20, 2005.

Chenzira, A. 2007. Home page. Ayoka Pages. Available: http://www.ayoka.com. Accessed: December 2, 2009.

Claire, K. 2008. "The eternal irony of the community": Prophecy, patriotism, and the Dixie Chicks. *Shofar: An Interdisciplinary Journal of Jewish Studies* 26, no. 4: 139–60.

Clare, E. 1999. *Exile and pride: Queerness, disability, and liberation.* Boston: South End Press.

Cohen, C. J. 2009. Punks, bulldaggers, and welfare queens: The radical potential of queer politics? In *Still brave: The evolution of black women's studies*, eds Stanlie M. James, Frances Smith Foster, and Beverly Guy-Sheftall, 240–67. New York: The Feminist Press.

———. 2011. Rebirthing the nation: The transformational and transnational politics of black desire. Keynote Address delivered at the Collegium for African American Research Conference in Paris, France, on April 7.

Collins, P. H. 1998a. It's all in the family: Intersections of gender, race, and nation." *Hypatia* 13, no. 3: 62–82.

————. 1998b. *Fighting words: Black women and the search for justice.* Philadelphia: Temple University Press.

————. 2004. *Black sexual politics: African-Americans, gender, and the new racism.* New York: Routledge.

Collins, S. 2010. American Idol's Christian connection. *LA Times* (May 23). Available: http://articles.latimes.com/2010/may/23/entertainment/la-ca-0523-idol-religion-20100523. Accessed: May 23, 2010.

Cooke, M. 2000. Multiple critique: Islamic feminist rhetorical strategies. *Nepantla: Views from South* I, no. I: 91–110.

Crane, D. 2000. *In medias* race: Filmic representation, networked communication, and racial intermediation. In *Race in cyberspace,* ed. Beth E. Kolko, Lisa Nakamura, and Gilbert B. Rodman, 87–115. New York: Routledge.

Crenshaw, K. 1995. Mapping the margins: Intersectionality, identity politics, and violence against women of color. In *Critical race theory: The key writings that formed the movement,* ed. Kimberly Crenshaw et al., 357–83. New York: New Press.

Los Cybrids. 1999. Los Cybrids: La Raza techno-critica pages. Available: http://www.cybrids.com. Accessed: April 5, 2004.

Daly, M. 1978. *Gyn/ecology: The metaethics of radical feminism.* Boston: Beacon Press.

Danticat, E. 2011. Edwidge Danticat speaks on Mac McClelland essay. *Essence* (July 9). Essence Pages. Available: http://www.essence.com/2011/07/09/edwidge-danticat-speaks-on-mac-mcclelland. Accessed: July 20, 2011.

Dash, J. 2000. The digital diva. Available: http://www.geechee.tv. Accessed: February 11, 2006.

Dean, J. 2001. From technocracy to technoculture. *Theory and Event* 5: I.

————. 2003. Why the Net is not a public sphere. *Constellations* 10, no. I: 95–112.

Dery, M., ed. 1994. *Flame wars: The discourse of cyberculture.* Durham: Duke University Press.

Dinerstein, J. 2007. Technology and its discontents: On the verge of the posthuman. In *Rewiring the "nation": The place of technology in American studies,* ed. Carolyn De la Pena and Siva Vaidhyanathan. Baltimore: The Johns Hopkins University Press.

Dreamgirls. 2006. Dir. Bill Condon. Perf. Jamie Fox, Beyoncé, and Jennifer Hudson. Dreamworks SKG.

DuCille, A. 2000. Where in the world is William Wells Brown? Thomas Jefferson, Sally Hemings, and the DNA of African-American literary history. *American Literary History* 12, no. 3: 443–62.

Dyer, R. 1986. *Heavenly bodies.* New York: Routledge.

————. 1997. *White.* New York: Routledge.

Ebert, R. 2008. Sarah Palin: The "American Idol" candidate." *Chicago Sun Times* (September 12). Available: http://www.suntimes.com. Accessed: October 5, 2008.

Ellison, R. (1947) 1995. *Invisible man.* New York: Vintage International.

Enloe, C. 1990. *Bananas, beaches, and bases: Making feminist sense of international politics.* Berkeley: University of California Press.

————. 2004. *The curious feminist: Searching for women in a new age of empire.* Berkeley: University of California Press.

Ensler, E. 1998. *The vagina monologues.* New York: Random House.

Essamba, A. E. 2009. Home page. Essamba Art Pages. Available: http://www.essamba-art.com. Accessed: September 25, 2009.

Eubanks, V. 2004a. Cyberfeminism meets NAFTAzteca: Recoding the technotext. In *Appropriating technology: Vernacular science and social power*, ed. Ron Eglash et al, 151–72. Minneapolis: University of Minnesota Press.

———. 2004b. Popular technology: Citizenship and inequality in the information economy. PhD diss., Rensselaer Polytechnic Institute.

———. 2011. *Digital dead end: Fighting for social justice in the information age.* Cambridge: MIT Press.

The Exorcist. 1973. Dir. William Friedkin. Perf. Max von Sydow, Ellen Burstyn. Warner Brothers.

Fanon, F. 1967. *Black skin, white masks.* New York: Grove Press.

Fiorenza, E. S. 2007. *The power of the word: Scripture and the rhetoric of empire.* Minneapolis: Fortress Press.

Foucault, M. (1977) 1995. *Discipline and punish: The birth of the prison.* Trans. Alan M. Sheridan. New York: Vintage Books.

The Fountain. 2006. Dir. Darren Aronofsky. Perf. Hugh Jackman, Rachel Weisz. Warner Bros.

Fusco, C. 1992. *English is broken here: Notes on cultural fusion.* New York: New Press.

———. 2001. *The bodies that were not ours and other writings.* New York: Routledge.

Gajjala, R., and A. Mamidipuni. 2002. Gendering processes within technological environments: A cyberfeminist issue. *Rhizomes.* Available: www.rhizomes.net/issue4/gajjala.html. Accessed: November 10, 2004.

Genz, S., and B. A. Brabon, eds. 2009. *Postfeminism: Cultural texts and theories.* Edinburgh: Edinburgh University Press.

Giddings, P. 1992. The last taboo. In *Race-ing justice, en-gendering power*, ed. Toni Morrison, 441–63. New York: Pantheon Books.

Gilman, S. 1985. *Difference and pathology: Stereotypes of sexuality, race, and madness.* Ithaca: Cornell University Press.

Gilroy, P. 2000. *Against race: Imagining political culture beyond the color line.* Cambridge: Harvard University Press.

Glee. 2009. Dir. Ryan Murphy. Fox Television.

Golden, T. 2002. A dialogue with Kara Walker. In *Kara Walker: Pictures from another time*, ed. Annette Dixon, 43–49. New York: Distributed Art Publishers.

Goldstein, B. 2007. The diaries of Facebook's founder. *Slate* (November 30). Available: http://www.slate.com/id/2178939. Accessed August 30, 2011.

González, J. 2000. The appended subject: Race and identity as digital assemblage. In *Race in cyberspace*, ed. Beth E. Kolko, Lisa Nakamura, and Gilbert B. Rodman, 27–50. New York: Routledge.

Goodman, A. 2008. Race and gender in presidential politics. *Democracy Now* on National Public Radio (January 14). Available: http://www.democracynow.org/2008/1/14/race_and_gender_in_presidential_politics. Accessed: January 14, 2008.

Grata. 2008. Is rape during war time unique to Africans? *The Village* (April 14). The Village Blogger Pages. Available: http://black-african-woman.blogspot.com. Accessed: April 15, 2008.

The Greatest Silence: Rape in the Congo. 2007. Dir. Lisa F. Jackson. HBO Films.

Griffin, F. J. 2004. When Malindy sings: A meditation on black women's vocality. In *Uptown conversations: The new jazz studies*, ed. Robert G. O'Meally, Brent Hayes Edwards, and Farah Jasmine Griffin, 102–25. New York: Columbia University Press.

Griffiths, A. 2002. *Wondrous difference: Cinema, anthropology, and turn-of-the-century visual culture.* New York: Columbia University Press.

Gross, M. J. 2008. Gay is the new black. *The Advocate* (November 16).

Gumbs, A. P. 2009. The revolution will be blogged. *Wire Tap.* Wire Tap Magazine Pages (November 9, 2009). Available: http://www.wiretapmag.org/stories/44638. Accessed: July 25, 2011.

———, and J. R. Wallace. 2009. A queer black Mobile homecoming. Available: http://mobilehomecoming.wordpress.com. Accessed: November 16, 2009.

Guy-Sheftall, B., and J. Cole, eds. 2010. *Who should be first? Feminists speak out on the 2008 presidential campaign.* Albany: State University of New York Press.

Hall, K. Q. 2005. Queerness, disability, and *The Vagina Monologues. Hypatia* 20, no. 1: 99–119.

Hammad, S. 1996. *Born Palestinian, born black.* New York: Writers and Readers Publishing.

Hammonds, E. M. 1997a. New technologies of race. In *Processed lives: Gender and technology in everyday life*, ed. Jennifer Terry and Melodie Calvert, 107–21. New York: Routledge.

———. 1997b. Toward a genealogy of black female sexuality: The problematic of silence. In *Feminist genealogies, colonial legacies, democratic futures*, ed. M. Jacqui Alexander and Chandra Talpade Mohanty, 170–82. New York: Routledge.

Haraway, D. 1991. *Simians, cyborgs, and women: The reinvention of nature.* New York: Routledge.

Hartman, S. 2007. *Lose your mother: A journey across the Atlantic slave route.* New York: Farrar, Straus, and Giroux.

Hill, C., and S. Jackson. 2004. The interstitial library. Ineradicable Stain Pages. Available: http://ineradicablestain.com/interstitiallibrary. Accessed: March 8, 2004.

Hine, D. C. 1995. Rape and the inner lives of black women in the Middle West: Ruminations on the culture of dissemblance. In *Words of fire: African American feminist thought*, ed. Beverly Guy-Sheftall, 380–87. New York: The New Press.

Hobson, J. 2005. *Venus in the dark: Blackness and beauty in popular culture.* New York: Routledge.

———. 2008. Everybody's protest song: Music as social protest in the performances of Marian Anderson and Billie Holiday. *Signs* 33, no. 2: 443–48.

Holland, S. P. 2007. No atheists in the fox hole: Toward a radical queer politics in a post-9/11 world. In *A companion to lesbian, gay, bisexual, transgender, and queer studies*, ed. George E. Haggerty, 318–40. Thousand Oaks: Sage.

Hooks, b. 1990. *Yearning: Race, gender, and cultural politics.* Boston: South End Press.

———. 1992. *Black looks: Race and representation.* Boston: South End Press.

Horsbugh, S. 2004. An interview with Shirin Neshat. *Erudition* Online Pages. Available: http://www.eruditiononline.com/04.04/shirin_neshat_interview.htm. Accessed: June 21, 2006.

Hossfeld, K. J. 2001. "Their logic against them": Contradictions in sex, race, and class in Silicon Valley. In *Technicolor: Race, technology, and everyday life*, ed. Alondra Nelson, Thuy Linh N. Tu, and Alicia Headlam Hines, 34–63. New York: NYU Press.

Hurston, Z. N. (1937) 1990. *Their eyes were watching God.* New York: Vintage Books.

Hustle and Flow. 2005. Dir. Craig Brewer. Perf. Terence Howard. Crunk Pictures.

I.Mirror. 2007. Dir. China Tracy, née Cao Fei. Available: http://www.youtube.com/user/ ChinaTracy. Accessed: December 2, 2009.

In the Cut. 2003. Dir. Jane Campion. Perf. Meg Ryan. Pathe Productions.

INCITE Women of Color Against Violence, eds. 2007. *The revolution will not be funded: Beyond the non-profit industrial complex.*Cambridge: South End Press.

Jackson, J. L. Jr. 2008. Knowles knows. *The Chronicle Review* (October 26). Available: http:// chronicle.com/blogPost/Knowles-Knows/6404. Accessed: October 29, 2008.

Jacobs, H. (1861) 1987. *Incidents in the life of a slave girl.* Cambridge: Harvard University Press.

Jameson, F. 1992. *Postmodernism, or, The cultural logic of late capitalism.* Durham: Duke University Press.

Kandahar. 2001. Dir. Mohsen Makhmalbaf. Perf. Nelofer Pazira. Avatar Films.

Kapsalis, T. 1997. *Public privates: Performing gynecology from both ends of the spectrum.* Durham: Duke University Press.

King Kong. (1933) 2005. Originally directed by M. C. Cooper and E. B. Schoedsack, distributed by RKO Radio Pictures. Remake directed by Peter Jackson, distributed by Universal Pictures.

Lerner, G. 1997. *Why history matters: Life and thought.* New York: Oxford University Press.

LeVande, M. 2008. Women, pop music, and pornography. *Meridians* 8. no. 1: 293–321.

Lin, M. 2001. *Boundaries.* New York: Simon and Schuster.

———. 2010. What is missing? (April 22). Available: http://whatismissing.net. Accessed: April 22, 2010.

Lorde, A. 1984. *Sister outsider: Essays and speeches.* Freedom, CA: The Crossing Press.

Lott, E. 1995. *Love and theft: Blackface minstrelsy and the American working class.* New York: Oxford University Press.

Lubiano, W. 2006. Perfect offenders, perfect victim: The limitations of spectacularity in the aftermath of the lacrosse team incident. In *A social disaster: Voices from Durham* Series on the Duke African and African American Studies Blogger Pages (April 13). Available: http://dukeaaas.blogspot.com/2006/04/social-diasater-voices-from-durham.html. Accessed: April 22, 2006.

Lyons, M. 2010. Mark Zuckerberg says "The Social Network" got his clothing right. *Pop Watch* (October 18). Available: http://popwatch.ew.com/2010/10/18/ mark-zuckerberg-social-network. Accessed: August 30, 2011.

Maathai, W. 2006. *Unbowed: A memoir.* New York: Random House.

Magowan, M. 2010. Disney's male execs to stop making movies starring girls. *Ms. Magazine Blog* (November 23). Available: http://msmagazine.com/blog/blog/2010/11/23/ disneys-male-execs-stop-movies-starring-girls. Accessed: November 23, 2010.

Mangum, C. G. 2008. *Last dance for grace: The Crystal Gail Mangum story,* with Vincent Clark. Raleigh: fire! Books.

The Matrix. 1999. Dirs. Andy and Larry Wachowski. Perf. Keanu Reeves, Laurence Fishburne. Warner Brothers.

The Matrix: Reloaded. 2003. Dirs. Andy and Larry Wachowski. Perf. Keanu Reeves, Laurence Fishburne. Warner Brothers.

Maya Lin: A Strong Clear Vision. 1995. Dir. Freida Lee Mock. American Film Foundation.

McCauley, G. 2007. Home page. What About Our Daughters Pages. Available: www. whataboutourdaughters.com. Accessed: June 1, 2007.

McGuire, D. L. 2010. *At the dark end of the street: Black women, rape, and resistance—A new history of the civil rights movement from Rosa Parks to the rise of black power.* New York: Random House.

McHugh, B. 2009. "Just a small town boy": Queering the quarterback, whitening the queer, re-othering the other. Paper delivered at the *Who's Queer? Whose Queer?* University at Albany Women's Studies Student Conference on December 4.

McWhorter, J. 2009. A blank slate. In the "What's Driving the Michael Jackson Mania?" Room for Debate Blog Series. *The New York Times* (July 7). Available: http://www.nytimes.com. Accessed: July 7, 2009.

Memento. 2001. Dir. Christopher Nolan. Perf. Guy Pearce. Newmarket Capital Group.

M. I. A. 2005. *Arular.* London: XI Beggars.

———. 2007. *Kala.* New York: Interscope Records.

Michelle Obama Watch. 2010. Michelle Obama Watch Pages. Available: http://www.michelleobamawatch.com. Accessed: April 30, 2010.

Miller, I. 2011. Who runs the world? Beyoncé, sampling, race, and power. *Racialicious* (June 2). Available: http://www.racialicious.com/2011/06/02/who-runs-the-world-on-beyonce-sampling-race-and-power. Accessed: June 3, 2011.

Miller, T., N. Govil, J. McMurria, and T. Wang, eds. 2005. *Global Hollywood 2.* London: British Film Institute.

Miller-Young, M. 2008. Hip-hop honeys and da hustlaz: Black sexualities in the new hip-hop pornography. *Meridians* 8, no. 1: 261–92.

Mohanty, C. 1991a. Cartographies of struggle: Third world women and the politics of feminism. In *Third world women and the politics of feminism,* ed. Chandra Mohanty, Ann Russo, and Lourdes Torres, 1–47. Bloomington: Indiana University Press.

———. 1991b. Under Western eyes: Feminist scholarship and colonial discourses. In *Third world women and the politics of feminism,* ed. Chandra Mohanty, Ann Russo, and Lourdes Torres, 51–80. Bloomington: Indiana University Press.

Monae, J. 2010. *The arch android.* Atlanta: Atlantic Records.

Moore, L. 2002. Frayed connections, fraught projections: The troubling work of Shirin Neshat. *Women: A Cultural Review* 13, no. 1: 1–17.

Morrison, T. 1970. *The bluest eye.* New York: Alfred A. Knopf.

———. 1987. *Beloved.* New York: Alfred A. Knopf.

———. 1992. *Playing in the dark: Whiteness and the literary imagination.* Cambridge: Harvard University Press.

———. 1998. *Paradise.* New York: Alfred A. Knopf.

Mottahedeh, N. 2003. After-images of a revolution. *Radical History Review* 86: 183–92.

Mulholland Drive. 2001. Dir. David Lynch. Perf. Naomi Watts, Laura Elena Harding. Les Films Alain Sarde.

Mulvey, L. 1975. Visual pleasure and narrative cinema. *Screen* 16, no. 3:6–18.

Murthy, P. 2005. Mythic hybrid search. Available: http://www.turbulence.org/Works/mythichybrid. Accessed: January 30, 2005.

———. 2005. Bindi Girl. Available: http://www.thing.net/~bindigrl. Accessed: January 30, 2005.

Muse, W. 2011. It's complicated: DJs, appropriation, and a whole host of other ish. *Racialicious* (April 13). Available: http://www.racialicious.com/2011/04/13/

it%e2%80%99s-complicated-djs-appropriation-and-a-whole-host-of-other-ish. Accessed: June 3, 2011.

Muslim girl shaves head over ban. 2004. *BBC News* Pages (October 1), Available: http://news.bbc.co.uk/2/hi/europe/3708444.stm. Accessed: May 1, 2011.

Naber, N. 2011. Imperial feminism, Islamophobia, and the Egyptian revolution. *Jadaliyya.* (February 7). Jadaliyya Pages. Available: http://www.jadaliyya.com/pages/index/616/imperial-feminism-islamophobia-and-the-egyptian-re. Accessed: June 3, 2011.

Nakamura, L. 2000. "Where do you want to go today?" Cybernetic tourism, the Internet, and transnationality. In *Race in cyberspace*, ed. Beth E. Kolko, Lisa Nakamura, and Gilbert B. Rodman, 15–26. New York: Routledge.

Narayan, U. 1997. *Dislocating culture: Identities, traditions, and third world feminism.* New York: Routledge.

Neal, M. A. 2003. *Songs in the key of black life: A rhythm and blues nation.* New York: Routledge.

———. 2007. Tyler Perry and the black Bible Belt. *Vibe's Critical Noire.* Available: http://www.vibe.com/blog/man/2007/05/tyler_perry_and_the_black_bibl.html. Accessed: May 30, 2007.

Nelson, A., T. L. N. Tu, and A. H. Hines, eds. 2001. *Technicolor: Race, technology, and everyday life.* New York: NYU Press.

Neve, L., and K. Pate. 2005. The criminalization of women who resist. In *Global Lockdown: Race, gender, and the prison-industrial complex*, ed. Julia Sudbury, 19–33. New York: Routledge.

Nevergold, B. A. S., and P. Brooks-Bertram. 2010. *Go tell Michelle: African American women write to the new first lady.* Albany: State University of New York Press.

Nguyen, M. 2001. From paper to pixels. In *Technicolor: Race, technology, and everyday life*, ed. Alondra Nelson, Thuy Linh N. Tu, and Alicia Headlam Hines, 154–75. New York: NYU Press.

———. 2005. Exoticize my fist. Available: http://www.exoticizemyfist.com Accessed: July 1, 2005.

Nicholson, R. 2008. Why Björk is right to stand up for female producers. *Guardian* Music Blogs. Available: http://www.guardian.co.uk/music/musicblog/2008/aug/27/whybjorkisrighttostickup. Accessed: June 3, 2009.

NO!: The Rape Documentary. 2007. Dir. Aishah Shahidah Simmons. Afro Lez Productions.

Nuestras Hijas de Regresso a Casa (Bring Our Daughters Home). 2004. Open letter to Eve Ensler. Coco Fusco Pages (January 16). Available: http://www.thing.net/~cocofusco/EnslerletterEng.htm. Accessed: February 24, 2004.

Nyong'o, T. 2009. The unforgivable transgression of being Caster Semenya. Bully Bloggers Pages (September 8). Available: http://bullybloggers.wordpress.com. Accessed: September 9, 2008.

Ong, A. 1999. *Flexible citizenship: The cultural logics of transnationality.* Durham: Duke University Press.

Oxford, C. G. 2005. Protectors and victims in the gender regime of asylum. *NWSA Journal* 17, no. 3: 18–38.

Oyewumi, O., ed. 2000. *African women and feminism: Reflecting on the politics of sisterhood.* Trenton: Africa World Press.

———. 2001. Alice in the motherland: Reading Alice Walker on Africa and screening the color "black." *Jenda: A Journal of Culture and African Women Studies* 1, no. 2. Available:

http://www.jendajournal.com/vol1.2/oyewumi.html. Accessed: December 1, 2005.

Pagels, E. 1988. *Adam, Eve, and the serpent.* New York: Random House.

Painter, N. 1997. *Sojourner Truth: A life, a symbol.* Princeton: Princeton University Press.

Paris is Burning. 1990. Dir. Jennie Livingston. Miramax Films.

Parker, L. 2010. Why Crystal Bowersox won't win "American Idol." *Reality Rocks* (May 20). Yahoo Music Blogs. Available: http://new.music.yahoo.com/blogs/realityrocks/351199/why-crystal-bowersox-wont-win-american-idol. Accessed: May 20, 2010.

PBS Station. *Art: 21, Kara Walker Biography.* (2003) Available: http://www.pbs.org/art21/artists/walker. Accessed: December 11, 2003.

Perez, D. R. 2003. Lost in the cinematic landscape: Chicanas as lloronas in contemporary film. In *Velvet barrios: Popular culture & Chicana/o sexualities,* ed. Alicia Gaspar de Alba, 229–47. New York: Palgrave Macmillan.

Performing the Border. 1999. Dir. Ursula Biemann. Women Make Movies.

Perdue, C. et al. 1976. *Weevils in the wheat: Interviews with Virginia ex-slaves.* Charlottesville: University of Virginia Press.

Pilar, P. 2005. Homepage. Praba Pilar Pages. Available: http://www.prabapilar.com. Accessed: April 30, 2005.

———. 2011. Script for *The church of nano info bio cogno,* as performed at the Multispecies Salon opening at the City University of New York Graduate Center (April 4).

Piper, A. 1998. Passing for white, passing for black. In *Talking visions: Multicultural feminism in a transnational age,* ed. Ella Shohat, 75–112. Cambridge: MIT Press.

———. 2011. Home Page. Adrian Piper Pages. Available: http://adrianpiper.com. Accessed: July 27, 2011.

Piper, K. 1997. Caught like a nigger in cyberspace. *Relocating the Remains* Interactive CD-Rom. London: IVA.

Planet of the Apes. 1968. Dir. Franklin J. Schaffner. Perf. Charlton Heston. 20th Century Fox.

Plant, S. 1997. Zeroes and ones: Digital women and the new technoculture. New York: Doubleday.

The Princess and the Frog. 2009. Dir. Ron Clements and John Musker. Walt Disney Studios.

Pumzi. 2009. Dir. Wanuri Kahiu. Perf. Kudzani Moswela, Chantelle Burger. Focus Features/Awali Entertainment.

Reassemblage. 1982. Dir. Trinh T. Minh-ha. Women Make Movies.

Return to Kandahar. 2003. Dir. Paul Jay and Nelofer Pazira. Bullfrog Films.

Richie, B. E. 1995. *Compelled to Crime: The Gender Entrapment of Battered, Black Women.* New York: Routledge.

Rise of the Planet of the Apes. 2011. Dir. Rupert Wyatt. James Franco, Andy Serkis. 20th Century Fox.

Roberts, D. 2011. *Fatal invention: How science, politics, and big business re-create race in the twenty-first century.* New York: The New Press.

Ross, L. 2011. Fighting the black anti-abortion campaign: Trusting black women. *On the Issues.* Available: http://ontheissuesmagazine.com/2011winter/2011_winter_Ross.php. Accessed: May 11, 2011.

Russo, A. 2002. White innocence, white accountability: Feminist movements and body politics. Plenary speech delivered at the National Women's Studies Association Conference.

Rydell, R. W., ed. (1893) 1999. *The reason why the colored American is not in the World's Columbian Exposition.* Urbana: University of Illinois Press.

Saadawi, N. el. 1990. *Woman at Point Zero.* London: Zed Books.

Said, E. W. 1979. *Orientalism.* New York: Random House.

Sandoval, C. 1995. New sciences: Cyborg feminism and the methodology of the oppressed. In *The cyborg handbook,* ed. Chris Hables Gray, 407–23. New York: Routledge.

Satrapi, M. 2003. *Persepolis.* New York: Random House.

Scott-Heron, G. 1974. *The revolution will not be televised.* New York: RCA Records.

Shange, N. (1976) 1997. *For colored girls who have considered suicide/ when the rainbow is enuf.* New York: Scribner.

Sharpley-Whiting, T. D. 2007. *Pimps up, ho's down: Hip hop's hold on young black women.* New York: NYU Press.

Sheehan, D. 2003. Baring witness pages. Available: http://www.baringwitness.org. Accessed: March 30, 2006.

Shiva, V. 2005. *Earth democracy: Justice, sustainability, and peace.* Boston: South End Press.

Shohat, E. 1991. Gender and culture of empire: Toward a feminist ethnography of the cinema." *Quarterly Review of Film and Video* 131: 45–84.

———. 2006. *Taboo memories, diasporic voices.* Durham: Duke University Press.

———, and R. Stam. 1994. *Unthinking Eurocentrism: Multiculturalism and the media.* New York: Routledge.

Skloot, R. 2010. *The immortal life of Henrietta Lacks.* New York: Random House.

Smith, A. 2005. *Conquest: Sexual violence and American Indian genocide.* Boston: South End Press.

———. 2006. Heteropatriarchy and the three pillars of white supremacy: Rethinking women of color organizing. In *Color of violence: The Incite! anthology,* ed. INCITE Women of Color Against Violence, 66–73. Cambridge: South End Press.

———. 2008. *Native Americans and the Christian Right: The gendered politics of unlikely alliances.* Durham: Duke University Press.

The Social Network. 2010. Dir. David Fincher. Perf. Jesse Eisenberg, Andrew Garfield, Justin Timberlake. Columbia Pictures.

Spigel, L. 1997. White flight. In *The revolution wasn't televised: Sixties television and social conflict,* ed. Lynn Spigel and Michael Curtin, 47–71. New York: Routledge.

Spillers, H. 1989. Interstices: A small drama of words. In *Pleasure and danger: exploring female sexuality,* ed. Carole Vance, 73—100. London: Pandora.

Spivak, G. 1988. Can the subaltern speak?" In *Marxism and the interpretation of culture,* ed. Cary Nelson and Lawrence Grossberg, 271–313. Urbana: University of Illinois Press.

Stavney, A. 1999. Cross-dressing Harlem, re-dressing race. *Women's Studies* 28: 127–56.

Stedman, J. G. 1796. *Narrative of a five years' expedition against the revolted negroes of Surinam.* London.<Publisher?>

Steinem, G. 2008. Women are never frontrunners. *The New York Times,* January 8. Available: http://www.nytimes.com. Accessed: January 8, 2008.

Stone, K. 2009. What the homosexuality debates really say about the Bible. In *Out of the shadows into the light: Christianity and homosexuality,* ed. Michael A. De La Torre, 19–38. Danvers: Chalice Press.

Story, R. 1990. And so I sing: African-American divas of opera and concert. New York: Warner Books.

Strange Days. 1995. Dir. Kathryn Bigelow. Perf. Ralph Fiennes, Angela Bassett. 20th Century Fox, 1995.

Studio Brussels. 2009. Eternal moonwalk: A tribute to Michael Jackson. Eternal Moonwalk Pages. Available: http://www.eternalmoonwalk.com. Accessed: July 31, 2009.

Sundar, P. 2008. Meri Awaaz Suno: Women, vocality, and nation in Hindi cinema." *Meridians* 8, no. 1: 144–79.

Sunshine. 2007. Dir. Danny Boyle. Perf. Cillian Murphy. DNA Films.

Thompson, P. 2007. M.I.A. confronts the haters. *Pitchfork*, August 3. Available: http://pitchfork.com/news/27349-mia-confronts-the-haters. Accessed: June 3, 2011.

Thomson, R. G. 1997. *Extraordinary bodies: Figuring disability in American literature and culture*. New York: Columbia University Press.

Tillet, S. 2009. Home page. A Long Walk Home Pages. Available: http://www.alongwalkhome.org. Accessed: July 15, 2009.

The Tree of Life. 2011. Dir. Terrence Malick. Perf. Brad Pitt, Sean Penn, Jessica Chastain. Fox Searchlight.

Trinh, T. M. 1990. *Woman, native, other: Writing postcoloniality and feminism*. Bloomington: Indiana University Press.

24. 2002. Dir. Jon Cassar. Perf. Kiefer Sutherland, Dennis Haysbert, Penny Johnson. Fox Television.

2001: A Space Odyssey. 1968. Dir. Stanley Kubrick. MGM.

Ulysse, G. A. 2010. When I wail for Haiti. Gina Athena Ulysse Pages. Available: http://www.ginaathenaulysse.com. Accessed: October 30, 2010.

———. 2011. Rising from the dust of Goudougoudou. *Ms.* (Winter 2011): 36–39.

Utley, E. 2010. Why all the silly devil talk should be taken seriously. *Religion Dispatches* (November 10). Available: http://www.relgiondispatches.org/archive/culture/3714/why_all_the_silly_devil_talk_should_be_taken_seriously_. Accessed: November 10, 2010.

Walker, A. 1982. *The color purple*. San Diego: Harcourt, Brace.

———. 1984. In search of our mothers' gardens: Womanist prose. San Diego: Harcourt, Brace.

Walker, R., ed. 1995. To be real: Telling the truth and changing the face of feminism. New York: Anchor Books.

Wallace, M. 2004. *Dark designs and visual culture*. Durham: Duke University Press.

Williams, B. 2001. Black secret technology: Detroit techno and the information age. In *Technicolor: Race, technology, and everyday life*, ed. Alondra Nelson, Thuy Linh N. Tu, and Alicia Headlam Hines, 154–75. New York: NYU Press.

Williams, E. 2010. Blonde beauties and black booties: Racial hierarchies in Brazil. *Ms. Magazine Blog* (June 11). Available: http://msmagazine.com/blog/blog/2010/06/11/blonde-beauties-and-black-booties-racial-hierarchies-in-brazil. Accessed: June 15, 2010.

Willis, D., and C. Williams. *The black female body: A photographic history*. Philadelphia: Temple University Press, 2002.

Wise, T. 2009. Between Barack and a hard place: Racism and white denial in the age of Obama. San Francisco: City Lights Publishers.

Woolf, V. 1929. *A room of one's own.* London, New York: Harcourt.

Young, W. S. 1855. *The black swan at home and abroad, or, A biographical sketch of Miss Elizabeth Taylor Greenfield.* Philadelphia: W. S. Young.

Yuan, D. D. 1996. The celebrity freak: Michael Jackson's "grotesque glory." In *Freakery: Cultural spectacles of the extraordinary body,* ed. Rosemarie Garland Thomson, 368–84. New York: NYU Press.

Zakaria, F. 2008. *The post-American world.* New York: W. W. Norton.

Zeichner, N. 2011. Diplowatch 2011 #7: Diplo vs. Venus Iceberg X and Ghe20 Goth1k. *The Fader* (March 29). Available: http://www.thefader.com/2011/03/29/diplowatch-2011-7-diplo-vs-venus-iceberg-x-and-ghe20-goth1k. Accessed: June 3, 2011.

Zizek, S. 2001. Welcome to the desert of the real. Slavoj Zizek Pages. Available: http://www.theglobalsite.ac.uk/times/109zizek.htm. Accessed: November 1, 2001.

Index